WOW . . . and WOW a̲ [barcode] .
brilliant photographs . . . enl..g! Enthralling . . . captivating! I
haven't enjoyed reading anything so much for ages. I digested every
word with thought. Written with a skeptical eye, this wonderful work
reveals startling evidence drawn from a vast number of sources and may
well contain the very answers to some of life's greatest mysteries. In a
word, marvelous!

The book was absolutely marvelous! You covered a great variety of
subjects and your abundance of research was outstanding! I especially
love your personable style of writing with your little dashes of humor.
After reading it, I feel that I have just had a long visit with you, and a
very pleasurable one with news of your husband, brother, grandson,
pets and even your recent journeys!

Dr. Sweet has presented a fascinating study of a phenomenon that
is beyond analysis and explanation by any means at the disposal of sci-
ence, but that only demonstrates a limitation of science, and does not
invalidate the possibilities presented by her study. What are the Orbs?
No one can tell, and wild speculation serves no purpose. But, an open-
minded reading of this book will certainly cause one to wonder—and
wonder again. Is it not exactly that kind of wonder that has created,
and continues to create, that greatest of wonders: the human mind,
and all that it can create as consciousness expands into an unfolding
Universe?

Your book is fabulous! You've covered so much, and the photos
look great! You've done a wonderful piece of work.

There is a burgeoning awareness of the presence of energies in our environment that in some cases can be photographed but not seen with the naked eye. They are not caused by light leaks or camera faults. The human eye is not accurate; the camera is. Dr. Sweet has done an absolutely magnificent job of putting it all together.

—*W. C. Levengood, Ph.D., Pinelandia Lab, biophysicist and America's foremost crop circle researcher*

Wonderful research work. Your dissertation is a masterpiece!

—*Carol of Lightworks Plasma Imaging and founder of http://orbstudy.com*

I've been reading your manuscript and it's quite amazing. You've raised some interesting questions and provided a lot of detail about the orb phenomenon. Your pictures are incredible.

—*Vicky Thompson, author of* The Jesus Path: 7 Steps to a Cosmic Awakening, *Red Wheel/Weiser, 2003*

Overall you have an excellent collection of photos. . . . We still have much to learn and everything published helps bring in more information. Your book will be a wonderful addition.

—*Chris Gunn, computer graphics guru and webmaster of www.orbstudy.com and www.bizynet.com*

How To
Photograph
THE
Paranormal

Leonore Sweet, Ph.D.

HAMPTON ROADS
PUBLISHING COMPANY, INC.

for the evolving human spirit

Cover design by Rosie Smith
Cover photograph © 2004 Peter Clemmer
Interior crop circle illustration © 2004 Anne Dunn Louque

Excerpts from *Harper's Encyclopedia of Mystical &
Paranormal Experience* by Rosemary Ellen Guiley,
copyright © 1991 by Rosemary Ellen Guiley. Reprinted by
permission of HarperCollins Publishers Inc.

Excerpts from *Encyclopedia of Ghosts and Spirits, Second Edition*
by Rosemary Ellen Guiley. Copyright © 2000 by Rosemary Ellen
Guiley. Reprinted by permission of Facts On File, Inc.

Excerpts from *Lost Secrets of Ancient Hawaiian Huna* by
Tad James, copyright © 1997 by Tad James. Reprinted by
permission of Advanced Neuro Dynamics.

Excerpt from *Psychic Self-Defense* by Dion Fortune with
permission of Red Wheel/Weiser, Boston, MA, and York
Beach, ME.

Hampton Roads Publishing Company, Inc.
1125 Stoney Ridge Road
Charlottesville, VA 22902

434-296-2772
fax: 434-296-5096
e-mail: hrpc@hrpub.com
www.hrpub.com

If you are unable to order this book from your local
bookseller, you may order directly from the publisher.
Call 1-800-766-8009, toll-free.

Library of Congress Cataloging-in-Publication Data

Sweet, Leonore, 1947-
How to photograph the paranormal / Leonore Sweet.
 p. cm.
Includes bibliographical references.
ISBN 1-57174-411-8 (tpbk. : alk. paper)
1. Spirit photography. I. Title.
 BF1381.S94 2005
133.9'2--dc22

2004020565

10 9 8 7 6 5 4 3 2 1
Printed on acid-free paper in the United States

Disclaimer

This book is intended to provide information regarding paranormal photography and related subject matter. Other than enhancing the color in some photographs to make the anomalies more visible, the photographers did not alter any of the photos in this book. The publisher blacked out some faces and added several arrows for reasons of privacy and clarity. Brand names of products are mentioned for informational purposes only. Identification of these pieces of equipment does not mean the manufacturers acknowledge the use of their products for this purpose. The author has no financial ties to these companies.

Dedicated to
Libby Lou and Max,
two stray pups who illuminated my path.

"Many things 'out there' don't exist for us, not because they are unreal, but because 'in here' we have not shaped the brain to perceive them."

—*Deepak Chopra, M.D.*

Table of Contents

List of Illustrations

Introduction

Seek and ye shall find. The world of paranormal photography is open to all who enter with an open mind. Photographing the paranormal is not difficult and does not require special training or complicated equipment. This book will increase your chances of success and teach you more than you ever wanted to know about the paranormal.

In 2000 I decided to seriously pursue the passion of my life—to find the answers to questions such as why we are here, what comes after death, and what at any given point is the "right" thing to do. A lifetime of seeking had persuaded me of nothing. I enrolled in American Pacific University's doctorate program in esoteric studies and was working on the core course books in March 2001 when a kind of light form I could not ignore appeared in two of my photographs. It seemed I had captured my sister's dog's spirit on film!

More lights introduced themselves into my photos and those of my brother Peter around deathbeds and loved ones; in cemeteries, churches, and movie theaters; above flowerbeds—in fact, practically everywhere. Peter and I both came alive with enthusiasm as we learned we could not only photograph our newfound friends, but interact with them as well. Life had never been so interesting.

Peter and I took thousands of pictures of everything, everywhere, to learn how to capture more glimpses into the mysterious world of orbs, vortexes, and ectoplasm. Herein you will find our pictures, and learn from our experiences and those of other orb hunters. We discuss cameras and equipment, as well as when, where, and how to photograph.

References to light forms began to leap from the pages of esoteric texts. They were mentioned on the Internet under myriad topics. I found them in mankind's earliest records; in modern-day religions; in long-lost ancient teachings; and on television, radio, and movies. The lights were something different to everyone. The movies my grandson and I watched persuaded me that Hollywood could not decide what orbs are either. In *Brother Bear,* the balls of light represent the spirits of the Indians' ancestors. The good witch in *The Wizard of Oz* flies away in an orb. In *Cocoon,* the orbs are aliens, and an alien and a human being leave Earth as orbs in *K-Pax.* Angels or guides in deep space appear as orbs watching the story unfold in *It's a Wonderful Life.* I became obsessed with the question: What are they?

You'll find that similar light forms are mentioned in literature on angels, UFOs, aliens, ghosts, interdimensional beings, magick, elementals, unidentified biological creatures, crop circles, and thought-forms. Inexplicable spheres and fogs appeared in some of the first photographs ever taken. Many psychics can see and communicate with these lights; channeled material frequently mentions light forms; and hypnotized subjects describe the lights as the forms we become between lives on Earth.

For centuries, ordinary folk have also seen visible lights worldwide and called them ghost lights, Will-o'-the-wisps, ball lightning, fairy lights, and hundreds of other names. Are these lights and the lights appearing in photographs the same phenomenon? Most recently, balls of light have been videotaped hovering around crop circles before and after they form. Do the orbs create these formations?

Why are there so many pictures of these invisible lights now? Ordinary cameras, especially digital cameras, can photograph spectra of light that are not visible to the human eye, and there is much we cannot see—our family pets see more than we do. These lights have apparently been cohabitating with mankind forever, and, like me, you may never have noticed.

I do not mean to present myself as an expert. I had the honor of knowing everything when I was seventeen, but nearly four decades later I realize the light forms have taught me I know next to nothing in the total scheme of things. Becoming convinced of the existence of an unseen world has left me in awe of how much there is for us to learn.

Although many psychics see orbs on a regular basis, I have never seen any light forms except when they became visible for an instant in the flash of a camera. I have never felt I had a direct link to God, Jesus, or any of the archangels. I cannot channel entities, do automatic writing, see visions, connect with my Higher Self, or even be hypnotized, try as I may. My glimpses of the mysterious have been mostly through the lens of a camera—a visual bridge created by digital technology. The camera enables us to see what only psychics could see before, but no one could prove.

The makings of this book came into my life as if by design, so I feel conscience-bound to share what I have found. I learned my greatest spiritual lesson from my search and found answers that I could embrace to countless questions. These questions and answers are the focus of this book:

• Are the anomalies airborne particles, moisture, lens flare, spiderwebs, or bugs?

• What are these orbs, vortexes, ectoplasm, shadow ghosts, and apparitions?

• Do the balls of light and clouds reported by alien abductees suggest that the light forms are UFOs or aliens?

• Practically every religion believes in angels. Could the light forms be guardian angels, guiding and protecting us?

• Are orbs the Bible's "eyes of the Lord" that are always upon us?

• Do we take the form of orbs between lives on Earth?

• Could orbs be the Jinn of Islam?

• Do orbs seem to exhibit a preference for one church, religion, or denomination over another?

• How do orbs figure in near-death experiences?

• Are the light forms ghosts? Spirits? Souls? Demons?

• Could balls of light be some form of unknown biology?

• Are the light anomalies from another dimension here on Earth?

• Are the lights thought-forms created by our unconscious minds? If so, are they whatever you think they are?

• Could the lights be all of the above?

• How do psychics see and communicate with orbs?

• Can you talk to orbs and receive answers?

• What makes light forms visible to the camera and to the human eye?

• Are shadow ghosts evil?

• Should we fear any of the light forms?

I do finally solve the mystery for myself but feel no need to force my belief upon anyone. I invite you to walk this path in your own moccasins and reach your own conclusions.

1 Libby Lou's Demise

The death of a stray dog named Libby Lou changed the course of my life. My sister Ellen had found Libby wandering about, deserted and hungry, in 1987. Ellen adopted the waif and they spent thirteen years adoring each other. Libby's only goal was to please, and she never caused an ounce of trouble. She seemed to understand every word and obeyed any command.

In February of 2001, Ellen noticed Libby's lymph nodes were badly swollen. Her veterinarian diagnosed lymphoma and said she had around three weeks to live. Libby went blind shortly thereafter and stopped eating. Ellen called me on March 1 wailing, "I think it's time to put Libby down!"

I offered to go with Ellen and, as I left the house, I saw my 35mm camera sitting on the edge of the kitchen desk and grabbed it. Having always been interested in everything spiritual, I suspected animals have spirits and hoped to get a picture of Libby's. I had no reason to believe I would, but suddenly I was bound and determined to try. I brazenly asked the veterinarian if I could try to capture a picture of her spirit. He didn't reply. He just looked at me as if I were quite mad and started the procedure.

It didn't go well. Three injections and twenty horrible minutes later, sweet Libby took her last breath and I took the last two pictures out of five and then ran out of film. Figures 1 and 2 were taken on the same roll just minutes before Libby's passing, figure 3 shows Libby just after she passed, and figure 4 was taken around fifteen seconds later. The final two shots featured the same funnel-like cloud but with slightly different edges. (The duplication of this cloud eliminates the possibility of a light leak

in the camera. Also, the mist did not extend past the frames of the pictures on the negatives.) No one was more surprised than I by these pictures. Ellen and I saw nothing in the room when Libby passed, and I had no intuitive feeling anything was in that room other than a lifeless dog and a veterinarian I hoped I would never see again.

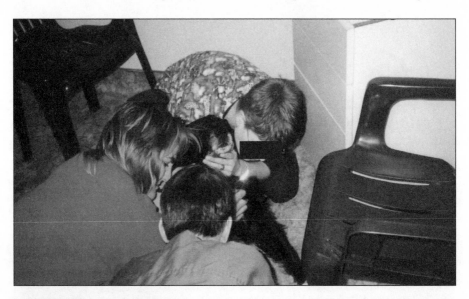

Figures 1 and 2: Before Libby's last breath.

Figures 3 and 4: After Libby's last breath. Both pictures taken May 1, 2001, from 9:15 to 9:30 P.M., with a 35mm camera. © 2001 by Leonore Sweet

To this day, I am not certain what that cloud and the black portion covering part of Ellen's face and sweatshirt represent. The mist seems to encircle Ellen and could be reaching towards her heart, as if comforting her. At first I was certain it was traveling upward. Now I wonder if it came down from above. Or both.

Libby's final pictures had a profound effect on members of my practical, down-to-earth family who had always tended to laugh at my spiritual leanings. They knew I was only capable of pushing the camera's shutter button and praying for the best. I am not known for my mechanical abilities. They also knew I could not and would not be inclined to alter the original photographs. It was a mystery. I thought it might even be the "proof" I had been seeking my entire life—proof, at the very least, there really are unknown forces at work on this planet.

Nearly two months later, my brother Peter shot a digital picture of his mother-in-law, Annabelle, seconds after she passed from cancer (see figures 5 and 6, center section). He expected another cloud and nearly missed the bubble above her body. (Later we found these bubbles are most commonly called orbs; the funnels like Libby's have been named vortexes; and the mist we were to capture later is most often labeled ectoplasm.) Our first orb brought to mind the twenty-one grams of weight humans reportedly lose the moment they pass on. The orb seemed a likely place for a little bit of Annabelle to go.

A few members of Annabelle's family objected to the use of her final picture, so I have obscured her face. I found it beautiful. Annabelle was a vibrant, lovely woman. It appears she left her cancer-ridden body and again became beautiful, colorful, and seemingly alive as an orb.

Since digital cameras don't waste film and money, frugal Peter began snapping pictures everywhere. He got pictures of orbs at the funeral home and in his family room. Figure 7 (center section) seems to be Annabelle's orb hiding behind her picture. The picture frame is casting a slight shadow on the orb. This picture appears grainy because it, like some others in this book, was lightened to make the orb and shadow more visible. Several times Peter spoke to the orb as if it were Annabelle, asking it where her friends were, and the next shot would be filled with fainter orbs. I didn't include those, however, lest skeptics call them pictures of dust. (We know, though, that Annabelle would not hang out with dusty friends!)

When Annabelle's brother-in-law, Chet, passed the next month, Peter found orbs in Chet's home, including one "sitting" in Chet's favorite chair where he spent most of his final days. This shot was our first clue that the orbs have a sense of humor. As Peter left the cemetery, orbs were posed at the entrance.

Now Peter, who feels discovery is what life is all about, was seriously hooked. I was delighted, because my big brother is the mechanical whiz of the family and I needed help with my new obsession. He led me into the world of digital cameras and processing my own pictures with my computer.

Most persons over forty years of age feel technology has left them in the dust. Digital cameras look and operate like normal cameras but require no film, and the pictures just taken, including any paranormal additions, appear instantly on the camera's view screen. The pictures are stored on a tiny disk (or some more recent invention) that can be placed in a device attached to the computer, or the camera itself can be connected to the computer to transfer the photos into a photo program.

Swallow your pride and ask one of your children or any neighbor kid how to do this. It is embarrassingly simple and getting easier all the time. Once you learn how to work with the software, you can edit and print your photos at home with no cost other than ink and paper.

Peter and I made the perfect investigative team for this endeavor. He flourishes in the worlds of science and science fiction. He is a tinkerer and builds everything—including his house, a television set, a cannon, and his furniture. On his tenth wedding anniversary, his wife commented he'd spent eight of those years in the garage.

I, on the other hand, enjoy writing and researching and studying anything religious or spiritual. Peter and I worked ten-hour days together in the family furniture

business with our father and sister Ellen. We somehow found time nearly every evening to experiment with our orb photography and broke the monotony of our jobs by discussing our discoveries among ourselves and sometimes with open-minded customers. (My father was a well-known eccentric. They expected something like this from his children.) When I could no longer bear the boredom of the retail world, I retired to write my esoteric studies dissertation and this book.

Why were we getting pictures of things we could not see except for a brief moment in the flash of the camera? As I explain in more detail in chapter 3, certain films in regular (analog) cameras are more sensitive to infrared and ultraviolet spectrums of light than the human eye, where these light anomalies evidently reside. Digital cameras generally photograph further into these invisible spectra than film cameras, making them better tools for paranormal photography, in my opinion anyway. Ironically, science, in the form of digital technology, has seemingly invented a machine that sees into the world previously known only to psychics.

The invention of digital cameras seems to be responsible for this apparently new discovery and thousands of pictures of these light anomalies are appearing worldwide, but similar light forms have appeared since photography was invented. I feel digitals capture a greater number because people take many more digital photos (Peter and I took thousands) and because digitals record more things that the human eye cannot see.

I cannot imagine paying to develop roll after roll of regular film from an orb hunt when nearly all of the prints could be less-than-inspiring pictures of darkness. (Paranormal pictures are easier to capture at night.) Digital cameras save us that embarrassment. The display monitors of digitals provide instant feedback as to where the orbs are.

I soon found that these anomalies in pictures are not entirely new. A search through my old photo albums uncovered a dozen or so shots I totally discounted at the time as some sort of camera problem. These photos are as inexplicable as any I've taken recently. They were taken with several different film cameras before I bought two digitals in 2001. Digital camera technology was invented in 1951 by the television industry, and the cameras were first introduced to the consumer market in the mid-1990s. (All pictures in this book that were not taken with a digital were taken with a 35mm camera before I was seeking light pictures.)

Peter and I took thousands of photos and accumulated hundreds of paranormal photographs in one year. "The Orbs and Company" never failed to entertain us, and they consistently amazed us with their intelligence, ingenuity, and sense of humor.

I had been putting off writing about my photographs until I could give a definitive answer as to who or what they are. I have since realized I may never have that

answer. So, instead, I have decided to investigate the theories, and there are many. The Internet is loaded with opinions, as are paranormal television shows, religious groups, spiritualists, UFO enthusiasts, ghost hunters, skeptics, crop circle watchers, and newly published books and videos.

The Internet has had some websites featuring one or two lonely, inexplicable pictures. There are also websites claiming that all of these shots are of camera straps, fingers, rain, snow, helium gas, light refractions, lens flare, spider silk, bugs, camera problems, airborne particles, or other natural phenomena.

I have been gathering information on light pictures for three years and regularly find new avenues of research. I remain convinced a great number, anywhere from 5 percent to 50 percent, of these photographs are unexplained mysteries. A growing number of persons around the world agree with me, but many of these same folks are at odds with each other. Some decided early on based on their own conclusions or were told (sometimes by supernatural sources) what these photographs were and cannot accept any other explanation. They believe all light anomalies can be attributed to any or all of the following:

- Pictures of dust, moisture, lens flare, spiderwebs, pollen, mold, breath, insects, hair, ash, fingers, lens spots, camera flaws, developing flaws, or camera straps

- Demons or the work of the Devil

- Earth lights, ghost lights, will-o'-the-wisps, ball lightning, or one of their many other names throughout history

- Thermal plasma

- A product of electromagnetic energy

- Aliens or UFOs

- Angels, guardian angels, nature spirits, or spirit guides

- Spiritual extensions or the higher selves of those existing on Earth

- Ghosts, spirits, incoming souls, or earthbound souls

- Crop circle creators bringing sacred geometry to raise human consciousness

- A form of unknown biology

- Interdimensional beings

- Thought-forms, elementals, or creations of the unconscious mind

There are seekers throughout the world attempting to explain these mysteries. Remember the old saying, "The mind is like an umbrella. It won't work unless it's open." We are trying on these different theories to see which ones fit. My hope is that scientists and theologians will eventually agree on what the Orbs and Company are. Albert Einstein, who became so spiritual near the end of his life that his last writings were discounted, wrote, "Science without religion is lame. Religion without science is blind." Perhaps another Einstein could solve this puzzle that many feel could finally unite science and religion, or at least science and spirituality. Maybe, as I will explain later, quantum physicists are on their way already. Traditional scientists would call most of my personally meaningful photos coincidences. I have come to believe there are no accidents, and coincidences are God's way of remaining anonymous.

There are so many pictures of light anomalies floating about these days that, once other causes are ruled out, I don't feel a need to prove their authenticity. My goal is to teach others how to take their own paranormal photographs. When people actually interact with these intelligent beings, even the most stubborn skeptics will think twice before debunking them. I believe they are real and "alive" because I have had intelligent interactions with them. At times they seem to read my thoughts, but, so far, they haven't answered my questions. In fact, my list of questions is growing faster than definitive answers. Please join me in my search.

2 "I'll Be Orbing by Sunday"

As for having premature theories, I was as guilty as the next guy. When I first laid eyes on Libby's photo, I immediately concluded that I had captured Libby's ghost on film. Peter's pictures of Annabelle's and Chet's orbs reinforced this belief, even though it seemed odd that a dog's spirit would be more impressive looking than a human ghost. Libby fought death tooth and nail, though, while Annabelle and Chet simply ran out of energy after their long bouts with cancer and heart disease, respectively. In time, I came to believe the immense amount of emotion generated by the five beings present provided the energy for Libby's anomaly . . . but I'm getting ahead of myself.

I was motivated to buy a digital camera so I could take many pictures without the expense of developing them. Peter had read that Olympus digital cameras were the most operator friendly, so naturally he recommended an Olympus to his mechanically challenged sister. I purchased an Olympus C860L digital, a camera the salesman claimed was essentially identical to Peter's Olympus D349R.

I thought all signs pointed towards ghosts, so I started haunting local graveyards with my feeble old dog Max and my new camera. The orbs came in droves, solidifying my belief that orbs were the forms the deceased take in the afterlife (see figures 8–11, center section). When I didn't feel like venturing away from the house, I would simply snap a few shots from our deck. At first, both Peter and I got mostly single-orb shots. The orbs seemed determined to keep us interested and brought out their bags of tricks one by one, becoming increasingly impressive.

For three months, I could only print unaltered 8" x 10" pictures of the entire frame—ridiculously huge pictures of one or two orbs I wouldn't bother to save now. During that time I couldn't seem to get orbs on the very edges to show up on the printed picture. So where did nearly every orb place itself? On the edge. It seemed to be their idea of fun and games. One night, after getting either nothing or more edge shots off my deck, I acted as though I were going into the house, then spun around and sneaked a shot. Only then did I catch an orb in the center of the picture!

My first indoor orb picture was taken when I held a wedding reception for my stepdaughter and placed dozens of white balloons on the white ceiling of the living room and took a picture of them. I captured one white orb hanging on the ceiling with its "cousins." It is this type of interaction that led to my affection for the orbs and the obsessive behavior I found many orb photographers display. My existence came to revolve around my new hobby, and my printer put my husband to sleep each night with its electronic lullaby.

I live in the suburbs of Portland, Oregon, once home to many slaughterhouses for family-raised pigs, cattle, sheep, rabbits, turkeys, and chickens. I tried to find a slaughterhouse nearby where Peter and I could see if these animals had photograph-able spirits. I learned most of the small slaughterhouses had been replaced by big business operations far away, yet I located one—a chicken processing plant just a mile from where Peter and I worked in our family's retail furniture store—so we planned a field trip there like a couple of eager kids. The owners, who dubbed me the "spirit lady," marveled at my pictures and cooperated, allowing us into their "killing fields" at 6 A.M. on a Monday morning.

Peter and I could barely see Doug, the owner's son, cut off the chickens' heads and hang the birds upside down to bleed out. The room was physically filled with a dense fog, which I found later should have at least produced orblike pictures of the mist. We took about one hundred orb-free shots and I announced to the "killers" not to worry—the chickens evidently did not have spirits, at least none that could be pho-tographed. (I was becoming concerned about the many animals my ex-husband had "murdered" and we had eaten for twenty years on our mini-farm and felt better then.) I suppose I will never know if our visit had anything to do with the picture of an angel that appeared in the slaughterhouse window a week or so later. Neither Peter nor I ever suggested taking another excursion to photograph dying animals.

I never captured as many orbs in my suburban neighborhood as Peter got around and in his quiet country home, surrounded by acres of nursery stock. While I ventured here and there for my photos, Peter methodically took pictures nearly every night in his back yard and gradually attracted quite a following of regular orb

visitors. The southeast corner of Peter's two-story home regularly produced such phenomenal shots that, for want of a better word, I started calling it his vortex. Figures 12 through 14 (center section) were all taken of the same corner of his house. Besides the unbelievable swirling vortex and the ectoplasms, Peter often found orbs hanging around that corner.

Also, from the very beginning, Peter got pictures of a noticeably larger orb resembling a little, fat spacecraft that he named Big Boy. Figure 15 (center section) shows nine of the clearest pictures of Big Boy taken by Peter in his yard over a period of several months in 2001. I should mention that there could be more than one Big Boy since I found several Big Boys in various sizes in many of Peter's photographs.

Big Boy also appeared in some pictures inside Peter's home, but not as clearly. Many orb photographers report having similar "personal" orbs that have distinctive features and seem to follow them about. (This type of orb is discussed in chapter 14.) I examined every photo I have taken in Peter's yard with virtually the same camera and the extra flash units he uses and found no evidence of Big Boy in my shots. So did Peter's camera somehow create Big Boy's intricate details, or did all the Big Boys hide when I arrived?

Months after the chicken escapade, I planned another field trip. In 1999, psychic Peggy Keating of West Linn, Oregon, founded a spiritual group, and my husband and I were two of its first members. On September 19, 2001, seven members of this group arrived at Peter's house, five of them armed with cameras, both digital and 35mm. It was a cool, clear evening with virtually no wind and minimal dust. Without question, the orbs performed best for Peter and me—or did our cameras happen to be timed just right to get better orb shots? I took figures 16, 17, and 18 (center section) as we walked through the young trees, and the orbs seem to be examining our group—even their hair. We had not been there long enough to kick up much dust, and dust orbs are not that colorful and dissimilar to each other. If there had been much pollen in the air, I would not have been able to see through my weeping, allergic eyes to photograph anything. One person, who had a film camera, shot an entire roll, but nothing abnormal appeared on the prints except for one large, swirly cloud in one shot. No one else that night got a picture of anything resembling ectoplasm.

Around that time I read that ghosts like to hang out where they were most emotional during life. There was no question which period of my life that was—high school. So I headed to my old Gresham High School at dusk, hoping to find its deceased alumni. I took pictures everywhere around the school, but practically every orb appeared in pictures of the grandstands and on the track and football field. Figures 19 through 23 (center section) are five pictures of orbs that struck me as

behaving like athletes and sports fans at two different high schools. It includes my first speeding orb, obviously the star, taken just after the crowds left from a football game. Moving orbs are among the most credible of all orbs since they cannot be attributed to any of the usual natural causes except rain, and it wasn't raining. I also captured what looked like one lonely orb that seemed to be rolling up to the front door of my alma mater on the sidewalk.

My father, the skeptic of all skeptics, paid close attention to what Peter and I were doing. Pa never failed to demand *proof* for any claim and did not accept any amount of circumstantial evidence for something he did not want to believe. I kept insisting these photos at the very least showed *something* unexplained was going on, but he always wanted more. My father became ill in 2002 and, just three weeks before he passed, he learned he had bone marrow cancer. All five of his children visited him nearly every day during this time, three of us armed with cameras. Pa was eager for us to take pictures and seemed disappointed that none of us got so much as one faint orb out of hundreds of pictures in the hospital. Even so, one of the last things he said was, "I'll be orbing by Sunday." Pa was comatose and barely alive by Sunday. Perhaps his spirit took leave of his body on Sunday as predicted, but his heart did not stop beating until Tuesday. His belief that he would live on as an orb was astounding and gave us comfort. It may have been the first definitive statement of belief in anything paranormal he had made in his lifetime.

Even though he was comatose, Dad chose to pass alone, as many do. My sister Ellen left his side Tuesday morning after she spent the night with him, took a few pictures of the room, and, when Peter arrived an hour or so later, our beloved father was gone. One of the pictures Ellen took revealed three orbs at the foot of his bed—the first to appear throughout the ordeal. When the family gathered at our childhood home with my mother, orbs appeared in at least half of the photos. Until then, we had never gotten any light forms in Mom and Dad's home, either. I often told him it was because he doubted their existence.

When the family met several days later in Peter's home, every camera in the house got its share of orbs and other light forms. Ellen's nine-year-old daughter, Lindsey, took the most special shot. She had made her grandfather a paper heart, and set it in front of his ashes. Just after Peter moved the ashes from the red cloth, Lindsey took figure 24 (center section), which I believe is the brightest orb any of us have captured indoors.

The light forms had definitely captured my family's attention. I have spent the past several years searching for information others have gathered on these anomalies and have made it the topic of my dissertation in esoteric studies through American

Pacific University. When I received my diploma in February of 2003, three orbs made an appearance in the picture, along with Dr. Tad James and Dr. Alex Docker, much to my delight. They were pale because it was a brightly lit room, but they were there, and I like to think they were the same three orbs that were at the foot of Daddy's bed three months earlier.

My research taught me that not only are these light anomalies everywhere, but they evidently have been with us forever. They are described in many of the ancient religious texts and have appeared on film since the camera was invented. I was embarrassed to discover I had initially limited my light forms to being ghosts on the basis of mere circumstantial evidence. Other photographers have been just as convinced they are something else entirely.

I believe orbs, vortexes, ectoplasms, and apparitions are all made of the same stuff, and most authorities say that is some sort of low-energy plasma. Plasma, called the fourth state of matter, is a collection of ionized particles that produces light from the movement of its atoms' electrons. (Plasma is discussed further in chapter 13.) The light forms are capable of taking different forms depending upon the energy available to them, just as water, ice, and steam are all water but their forms are dependent upon the temperature.

Physicist David Bohm discovered that electrons, while in the form of plasma, become "alive."[1] The September 17, 2003, edition of *New Scientist* featured a story called "Plasma blobs hint at new form of life." It describes how "physicists have created blobs of gaseous plasma that can grow, replicate, and communicate—fulfilling most of the traditional requirements for biological cells." Mircea Sanduloviciu at Cuza University in Romania reported that "cell-like self-organization can occur in a few microseconds." An electric spark caused ions and electrons to form *spheres* at a positively charged electrode. These spheres had two layers. The outer layer was composed of negatively charged electrons and the inner layer consisted of positively charged ions. Inside this double layer were gas atoms. Their lifetime and size depended upon the amount of energy in the initial spark.[2]

Living cells are defined by four main criteria:

1. a boundary separating the cell from its environment

2. the ability to duplicate

3. the ability to change and grow through metabolism

4. the ability to communicate

Sanduloviciu found these plasma spheres demonstrated all four criteria. They had an outer layer; could split in two; could grow larger; and could send electromagnetic energy to other spheres, causing them to vibrate at a particular frequency. Could these spheres of plasma be what serious orb photographers are capturing and describing as intelligent?

Before I reveal what else I have found through my research, I want you to believe in the existence of orbs, so I have provided tips for taking your own pictures in the next chapter. Many people have been skeptical before an orb meaningfully appeared in one of their shots. After a series of these "flukes" in your photos you may become a believer.

3 Orb-Hunting Tips

The Internet is inundated with pictures of orbs, vortexes, ectoplasms, and apparitions from all corners of the world. Websites with paranormal pictures have multiplied like mushrooms in the night of cyberspace. If you just want to see the pictures, search the Internet and bookstores. When you learn how many other phenomena can be responsible for these anomalies and how they can be closely reproduced on a computer with a good paint program, however, you may not believe they are real and intelligent. A few websites have deleted all orb pictures because they *could* be pictures of dust or such. If one learns how to spot the genuine anomalies and interact with them, one will come to believe in their existence and to experience their ingenuity and humor.

This chapter is a conglomeration of all the advice I have found from many sources. I included things that confirmed or contradicted my experience, plus interesting tips on things I have not had the time to try. If you abide by the following rules, you will at least know when your photos may *not* be of the paranormal.

Precious little of my information came from researchers with doctorates in physics. At this point, scientists would be risking their careers if they dared to give credence to the study of paranormal photography. My sources have spent many years studying this phenomenon. I found most orb-hunting tips in books and on websites concerning ghosts. Whether or not you believe orbs are the spirits of the dead, these rules may help you photograph anomalies. I include these tips to give beginners somewhere to start. We of the right-brain persuasion need to provide the left-brained with food for thought to fuel their calculators.

As you read, please keep this question in mind: Though there are counterfeit $10 bills floating all over the world, does that make every $10 bill worthless? There are too many legitimate, unexplained photos of light anomalies to ignore.

Cameras and Equipment

As with all enterprises involving equipment, you can go with the basics or you can go wild collecting all the newest devices on the market. I leave the accumulation of "toys" to my brother and others of his gender. My digital cameras and computer are enough for me to battle.

Great light photos have been taken with every type of camera and every kind of film. To increase your odds with film (analog) cameras, however, the following are recommended:

• Kodak Gold 400 or 800 Max film

• Fuji ASA 400 or 800 film

• Black and white film

• Infrared film for the experienced photographer

There are apparently many reasons why digital cameras capture more orbs than film cameras, besides allowing more pictures with less cost and capturing anomalies in light spectra we cannot see. One website claims a scientist tracked orbs with a digital video camera and determined the temperature of the orbs with a digital thermometer. He found orbs are approximately 10° F hotter than the surrounding area, and suggests that digital cameras use infrared technology and can detect temperature fluctuations. The idea is that orbs generate their own light and have no reflective surface. He claims film cameras record light entering the lens and imaging itself onto the film. If no light reflects off of the orb, it will be invisible. With the digital camera, the flash activates its infrared aspects and the camera "sees" the heat of the orb.

Another website says orbs are not hot, yet they heat objects through which they pass. It theorizes the "fluorescence" of the orbs becomes photographable when they have collected enough electrons or when they are exposed to many photons, such as from a camera flash. The electrons on the "mantle" (outside rim) of the orbs release electromagnetic radiation that a digital camera can photograph.

This site says the flash and shutter timing of the camera will determine how many orbs are photographed, since the light the orbs create is delayed a few milliseconds from their exposure to the flash, so some cameras' timing makes them better orb-detectors. They also contend the number of leaves on the shutter can affect the shapes of the orbs. Digital cameras do not have shutters, but I have learned digitals have up to nine blades in their diaphragms that are said to create the same effect.

If this is true, four leaves on the shutter or four blades in the diaphragm could chop off the edges of orbs in a photograph, causing them to appear square or diamond-shaped. Five leaves or blades would produce pentagons, etc. My question is why would the blades or leaves only affect the appearance of the orbs and not the rest of the picture?

As I understand it, the more megapixels a camera has, the higher resolution pictures it will take. One million pixels equal one megapixel, and a pixel is at once the "picture element" of a digital image and the light-detecting diode in the back of a digital camera that converts an image into digital information. One of the most common misconceptions in digital photography is that the higher the number of megapixels a camera has, the better-quality image it will produce. Not necessarily so. Some of the newest cameras today use eight megapixels but that does not guarantee a clearer image or more pictures of orbs. I have 1.3 and 4.0 megapixel cameras and am more successful photographing orbs at night with the 1.3.

Besides the number of pixels, lens quality, pixel size, sensor type, image processing, processing software, and heat can all affect a digital photograph. When you snap a picture, the camera lens focuses the image onto the pixels. The darker the image, the smaller the electrical charge and the fewer photons (bits of light that record the picture) captured in the pixel. Pixels are holes or "wells" into which the light energy falls (think of them as buckets catching raindrops). If the image is low quality, more pixels will not improve it unless there is also better lens quality. The more pixels or wells there are, the fewer photons each well can hold. Once the wells are full, they stop measuring photons, and picture quality declines. Also, the smaller the wells, the less chance there is of each well getting photons inside of it. This can make higher-pixel cameras less sensitive in low-light conditions, when orb photography is most successful. Hence, higher-megapixel cameras can capture lower-quality pictures of orbs.

Some reasons the digital camera is preferable to the film camera are:

• Digital is just as practical and reliable, even though the initial cost of equipment is usually higher than a "point-and-shoot" film camera. The expense of the camera seems to make little difference to the number of paranormal photos you will take, and you can process, lighten, and crop your pictures on your computer for much

less money than film developing. The resolution of the camera may not be as important as the way the camera behaves in low-light conditions. Low resolution is better for posting pictures on the Internet because they take up much less space.

• As mentioned, digitals are sensitive to infrared and possibly ultraviolet light, and most people claim orbs are in the infrared range. (A few claim they are in the ultraviolet range.)

• Film cameras work chemically. Digitals create images with electricity. Evidently, light anomalies are electromagnetically charged, so digitals are more likely to photograph them. Even minuscule bits of light produce a tiny electrical charge on the pixels of digital cameras.

• Film cameras are subject to developing flaws, and a bent or dirty negative can produce ghostly phenomena on the print. (An advantage of film cameras, however, is that they furnish a negative; digitals do not.)

• Digitals provide instant gratification with their viewing screens and proof that you are not drawing the orbs onto pictures with a paint program.

• With a digital, you won't waste film on a "dead" spot. You will know immediately where the orbs are hanging out by looking at the screen on the back of the camera after you have taken a shot. Then you can back up the digital camera with other types of cameras, and you may get that negative for the skeptics with your 35mm camera. Film cameras and digitals are best used as a team.

• You cannot take double exposures with a digital camera to get a ghostly effect on your picture, either fraudulently or accidentally.

• Digital stereoscopic cameras eliminate processing flaws and allow measurements of distance and size of orbs. Stereoscopic cameras produce two photographs five centimeters apart so that, when seen through a special viewer, the impression of three dimensions is created.

There are also problems with digital cameras:

• Not only do digitals photograph orbs and other anomalies better than other cameras, they also are notorious for photographing airborne particles such as dust, pollen, and moisture. Investigators are learning to tell the difference by sight, but pictures of dust and such that were prematurely labeled paranormal have done major damage to the integrity of the field of paranormal photography.

• Digital images can be manipulated with software programs, but producing the signature appearance of an orb would take many hours.

• Negatives from film cameras can be examined at much higher magnification than low megapixel digital images since they have higher resolution.

• Depending on whom you ask, digitals fill in black night, when no light photons reach a pixel, as a default red, white, or black pixel. This makes the pictures impossible to interpret. In other words, when no light falls into a well, the camera may produce red, black, or white spots.

Peter and I both use Olympus digital cameras. Peter owns a D-340R (1.3 megapixel) and a C-3040Z (3.3 megapixel). I have a C-860L (1.3 megapixel) and a D-40ZOOM (4.0 megapixel). Peter also uses extra flash units for large outdoor spaces. Any flash unit with a flash slave sensor attached and set on a tripod ahead of the main camera will provide more illumination for better pictures in the dark. These units are designed to flash at the same instant the camera flashes.

Digital video cameras produce even better evidence of orbs, for they can illustrate their erratic movements. Dr. Alan Meyer used infrared video cameras to produce persuasive evidence of the reality and personality of orbs in his excellent video *Ghostwalker: A Haunting Study,* which is available through his website (www.alanmeyer.com). It shows clearly that the orbs he photographed could not be dust, pollen, raindrops, snow, mist, or whatever. The orbs in this film travel through walls, follow the investigators around, congregate in groups, zip around every which way, and seem to have distinctive personalities and humanlike behavior. Dr. Meyer says the orbs are sensitive to the hot center of the infrared beam. He credits infrared technology for the proof of the existence of orbs, which he believes are ghosts.

The only requirement of your camera, if it is not infrared sensitive, is that it have a flash. Almost no orb pictures have been taken without one. Orbs are essentially invisible even to the camera without a flash or another light source behind the photographer. For extra flash power, bring a slave unit or extra flash equipment. Most built-in flash units are only effective within nine to fifteen feet from the camera, but slave units or extra flash equipment can extend this distance. The piece of equipment on top of the tripod pictured on the cover of this book is Peter's slave unit, which flashes at the same time as the flash unit in his camera. Some slave units attach to the camera itself.

If you prefer a video camera, many ghost hunters recommend the Sony "Nightshot" Camcorder because it can take decent pictures in the dark. Bring a tripod if you plan to use a video camera or photograph using a "night" setting.

Some "orbsters" use dowsing with rods or pendulums to locate orbs and other anomalies. Many have reported remarkable success by following these results. I am not adept at dowsing or pendulums, so I rely on my often-defective intuition. Do whatever works for you.

Professional ghost hunters use an impressive array of equipment to document the presence of what they sense are ghosts. I have been plenty busy just coping with my camera paraphernalia and have never used any of these tools. I need no extra proof for myself. I am convinced. I must admit, though, that getting positive readings from this equipment, along with pictures and the testimony of a sensitive or dowser who pointed out the spot, provides proof of the unexplainable that is impossible to deny. Ghost hunters use many variations of the following tools, among others:

• EMF (electromagnetic field) detectors, gauss meters, and digital infrared meters

• Oscilloscopes

• Electroscopes

• Temperature and humidity monitors

• Thermal scanners/digital thermometers

• Infrared viewers and infrared motion detectors

• Magnet Event Markers (MEMs), magnetic compasses, and magnetometers

• "Orbattractors" (a flashlight with a crystal on it)

• Pocket lasers (orbs reportedly react to laser beams)

• Ionizers

• Geiger counters

• Night vision scopes with infrared beams as detection devices

• Parabolic microphones ("bionic" ears) with a headset

• Walkie-talkies (for groups searching a large area)

• LED flashlights

• One- to three-million candlepower spotlights to reveal the number of small parti-cles suspended and floating in the air. (Beware, this light can damage the cornea and iris of the eye [see www.torontoghosts.org].)

Tape recorders can be used to record "ghost" voices or electronic voice phenomena (EVP) which cannot be heard with the human ear but can be recorded on tape. Always use fresh audiotapes. Dr. Dave Oester of the International Ghost Hunters Society recommends a 120-minute digital voice-activated recorder from Radio Shack, which sells for around $80. Oester uses Cool Edit and Acoustica 2.25, which can be downloaded from the Internet, for his EVP software. He and Dr. Sharon Gill offer a new book, *How to Record and Analyze Ghost Voices,* on their website, www.ghostweb.com. Also some ghost hunters now have computer programs that track the readings of several of these gadgets and display them on one computer screen for easy analysis.

Ghost hunters using high-tech equipment in haunted places have found that magnetic fields fluctuate sharply where ghost sightings are reported. With the normal background level being one or two milligauss, instruments have measured up to 100 milligauss in these places, according to Loyd Auerbach, author and director of the Office of Paranormal Investigations. Such electromagnetic fields, which range from the size of a baseball to a basketball, move about the room.[1]

Is There a Best Time to Photograph?

Most orb pictures are taken in the dark, between dusk and dawn. Indoor shots can be taken any time but produce more orbs when taken against a dark background. There are several reasons for this:

• Light anomalies are most easily seen against a dark background because their reflection is brighter than the background.

• During the day or against a light background, light anomalies, which are more often white than any other color, are very difficult to see.

• Few pictures exist of orbs that were not taken with a flash. With a flash, you can get indoor and outdoor shots, day and night. The darker the background, the more anomalies you will see.

Since day one of my research, I have heard that lunar cycles affect one's ability to photograph orbs. Magnetic fields are evidently stronger when a full moon is approaching. Others claim the best time is right before and after the full and new moons. The very day of the full moon, however, is nearly always a practically orbless day for myself and for others reporting on the Internet. There must be something to this moon business, but I haven't found what it is yet.

You are supposed to wait for weather that is calm and dry, but not too dry. If you take pictures in the rain, mist, fog, snow, wind, or in dusty conditions which can produce orblike spots, skeptics will discredit them, even if there are actual orbs among the phonies. Some investigators wait for fifteen minutes with as little movement as possible before taking pictures to allow dust to settle. Also avoid times of the year when there are great amounts of pollen floating in the air, as pollen may appear as yellow orbs in photos taken at night with a flash. If there is a thick coating of yellow dust on parked cars in the area, the pollen count is high. Dust and pollen caught up in a whirlwind can supposedly become electrostatically charged and glow.

Anyone who has spent day after day, month after month, or even year after year photographing everywhere in all types of conditions knows that most orbs cannot easily be explained away. Sometimes we do have our doubts, so, when I was in the throes of uncertainty, fellow orb photographer, Rob Port of England,[2] reminded me of these questions:

• Why do many orbs appear behind objects more than four inches from the lens where airborne particles do not appear as orbs?

• What is the Hessdalen Project in Norway scientifically observing and measuring if not orbs? (See chapter 5.)

• How can some people, especially psychics, see orbs and point them out for photographers?

• Why do so many report they did not get any orbs with their digital cameras before they sought them out?

• How can some orbs show up on photos taken without a flash? The flash must go off in order to illuminate dust.

• Why is talking to and using telepathy with orbs so often successful? (Rob says this may be a case of creating one's own reality, but certainly not of creating dust!)

• How, when there is no wind, can one picture have few or no orbs, and the next, taken just seconds later under identical conditions, display fifty diverse and colorful orbs, followed by another empty shot? There is dust in the air at all times. It seems orbs should appear in almost all digital photos at all times.

• When people are maniacally beating upon objects to make dust appear, who's to say the orbs are not in the picture also, watching in amusement?

Orb photographers begin to know their orbs and can identify a certain number of them that will appear under any conditions. I don't blame skeptics for doubting the unbelievable, especially since their skepticism seems to make them the least likely to have orbs appear in their photos. I believe the orbs choose which photos they will adorn, since those who would not believe in their existence or who would be frightened by the unknown do not normally get light forms in their pictures. I've seen it happen time and again. We orbsters become obsessed with the search because we have come to believe the unbelievable. Keep in mind, it wasn't very long ago that the idea the Earth is round was beyond belief.

If it is cold enough to see your breath, hold your breath whenever you take a picture or it will show up in the shot, resembling ectoplasm. Perhaps the most impressive camera-produced orbs are those made by photographing spider silk at close range. It can look like a vortex-type tube across the full length of the picture with orbs inside it. Human or animal hairs photographed close-up can look like high-speed orbs or what are sometimes called rods. They appear to be traveling at thousands of miles per hour. Even bugs with wings flapping have been mistaken for phenomenal orb pictures.

Ironically, stormy conditions produce lots of energy and magnetism for our orbs to "feed" on. Paranormal expert Hanz Holzer believes "moist air is a better psychic conductor than dry air."[3] Hence, indoor shots during a storm and outdoor photos taken right before the storm hits or just after it leaves can be very productive. Also, if you can find a perfectly dry spot outside, such as under a huge highway overpass or other structure, they may be there, presumably keeping dry!

Psychics have been telling us for years that spirit activity is associated with electromagnetic energy, and there is no doubt in my mind that storms increase your odds of photographing anomalies, even indoors where moisture is not a factor. Sylvia Browne wrote in *Blessings from the Other Side* that spirit activity increases during rainstorms and the early hours before dawn. She points out that rain, humidity, and dew are all conductors of energy, and spirits, after all, are energy, so moisture makes their trip between dimensions easier.[4]

Now, if you follow the ghost-hunter rules and should you find that perfect calm day, dry but not too dry, be wary of how the sunlight hits your lens. You may inadvertently get a "lens flare" from the sun and the camera lens that, when at just the right angle, will produce multiple geometrically shaped and colorful objects.

It helped me to deliberately take pictures of dust, pollen, rain, snow, fog, mist, bugs, and spiderwebs to see how they appear with my cameras. Peter and I had been discussing how we could conduct a dust test the very day the perfect opportunity

presented itself to me while walking outside a Dairy Queen. I had just taken a picture of the sky and a few lonely orbs when a car spun around wildly in the dusty parking lot, leaving clouds of dust so thick I had to keep my eyes closed and stop breathing while I took pictures. When I showed the shots to Peter, we both sank into depression. We had enough other pictures of what we thought were orbs that resembled these shots that we feared everyone would say all of our pictures were beautiful portraits of dust.

That evening Peter's favorite orb bolstered our spirits. Peter started photographing in his back yard as usual and Big Boy made a definite statement, and we think the statement was "I'm not dust!" (See cover photo and figures 25 and 25a, center section.) Big Boy not only flew nearly all the way across the screen, but also demonstrated how he could blink on and blink off along the way. In figure 25a, Peter adjusted the contrast to show more of the details in this incredible shot. He was in an open field, so the possibility of its being a spiderweb is nil. That photo cannot be explained away.

I believe far too many photos are discredited because they look somewhat like dust orbs. A bucket full of milk and a bucket full of white paint may look alike, but that does not make them identical. Many pictures of ectoplasm have faint, dustlike orbs inside and/or outside the ectoplasm, leading me to believe the orbs are changing their form into ectoplasm.

Many times I just aim the camera any which way and shoot without looking through the viewfinder. If I look down at the front of the camera as the flash goes off, I can see thousands of little particles in the air close to the lens, but, more often than not, dust orbs do not appear in the pictures. The dust pictures I have taken deliberately are more uniform in shape and color (nearly all white and grey) than orb shots that appear to be more genuine, but it takes experience to tell the difference, and, even then, the "experts" disagree. As in figure 36, Peter's moving orb, I maintain that some orbs that look identical to dust orbs can still be actual orbs. Hollywood can duplicate nearly everything these days so that you believe you are seeing the real thing. Do these similitudes make the originals unreal?

To test your camera quickly, sprinkle dust within four inches of the lens, then spray water in the same area, and, finally, sprinkle pollen around you in the dark, shooting all the while. You will then know what these culprits look like through your camera. Beyond four inches or so from the lens, these particles apparently do not appear as orbs.

The International Ghost Hunters Society (IGHS) recommends the colder months of October through February for the most productive vortex, ectoplasm, and apparition photographs. During those months, Dr. Dave Oester (www.ghostweb.com) claims the

23

electrostatic energy is at its highest and your odds for photographing them are greatly increased. Orbs, however, do not seem to be affected by seasonal changes and can be captured any time of the year.

There seems to be a general consensus that more orbs, vortexes, and ectoplasms appear in photographs taken during holidays, such as birthdays, anniversaries, Thanksgiving, and Christmas. There are also more holiday pictures taken because most people blow the dust off their cameras and start shooting only during holidays or on vacations. Groups of like-minded spiritual individuals who are accepting of and desiring their presence are known to attract orbs. Orbs also seem to congregate at fun or emotional occasions.

Where Are They?

Orbs are everywhere! I know of no place where they can never be found. It may even have more to do with who is taking the picture or who they are taking the picture of than where they are. Having said that, most of the best pictures are said to be taken:

• Near or on top of ley lines where so-called "power spots" such as ancient pyramids and sacred sites are located

• Near earthquake fault lines

• Around sensitives, psychics, or spiritually inclined persons

• In cemeteries—the older, the better. Some of our forefathers chose burial places that they felt were closer to God and they may well have instinctively chosen plots that had portals to the next dimension in or near them

• In and around schools with all their super-charged, youthful energy

• In theaters, old or new. They seem to like big screens and even big screen TVs and appear to prefer certain programs and movies to others

• On battlefields

• In churches, especially with good choirs and music

• In hotels, motels, and old boarding houses

• In historic locations

• At places that have high electromagnetic energy, such as near power lines and power-generating plants

- At places where ghosts have been sighted, heard, or felt in the past

- At scenes of fatal accidents and anywhere else a death has taken place

- At funerals and in funeral homes

- At happy or jovial occasions

- Around animals, especially pets (possibly because we take lots of pictures of our pets)

- At places with music or dancing

- During religious and spiritual ceremonies

- Near waterfalls, trees, and other natural settings with clean air and lots of negative ions

The preceding list includes nearly every place a camera was ever pointed, but it may be of some help. Since cemeteries get an inordinate amount of attention from orb hunters, researcher Nicholas A. Reiter and research assistant Lori L. Schillig of the Avalon Foundation in Ohio performed an experiment to see if more orbs could be photographed in cemeteries than in random places. Their results indicated cemeteries might actually harbor more orbs than the average location. All shots were taken in Ohio on the same night with calm, cold, clear, dry conditions from 9:00 to 9:40 P.M. Ten shots were taken of a tilled field; ten shots of the first cemetery; ten shots of the second cemetery; and ten random shots of fields, front yards, and a trash disposal center. Here are their results:

- Tilled field: 90 percent of shots had orbs with 4.4 average orbs per shot

- Cemetery #1: 100 percent of shots had orbs with 9 average orbs per shot

- Cemetery #2: 90 percent of shots had orbs with 6.1 average orbs per shot

- Random: 90 percent of shots had orbs with 4.2 average orbs per shot[5]

Before the Hunt

To discriminate against anyone in any way is against my nature. It is commonly agreed, however, that skeptical and closed-minded people will diminish results in an orb hunt. Also, people with little to no experience and those who would have the "boo-boo" scared out of them if they were to see anything spooky will put a damper

on a search for paranormal photos. I have read many accounts where hunts were disappointing until the one nonbeliever left. Then the activity picked up. Choose your team carefully. Negativity seems to weaken the energy field that the spirits need to make themselves known.

Some psychics can see orbs and carry on conversations with them, so drag your favorite psychic along.

I nearly always orb hunt in familiar places by myself (or with my dog Max, who is now on the "Other Side") and have suffered no ill effects from the orbs or human beings. Generally, though, it is safer to bring someone else along. Make certain the person you bring is in line with your purpose.

I took Max along for good reason. Figures 26, 27, and 28 are pictures I took immediately after asking, "Max, where are the orbs?" If he turned his head and I took a shot immediately, there was nearly always an orb in his line of sight. Max's talent was likely due to the fact that many animals, including dogs, cats, and horses, can see into the infrared and/or the ultraviolet range that is beyond human vision. Some animals can also see things we can see only in our peripheral field or out of the corner of the eye. Humans use rod cells, which see shades of black, white, and grey and wavelengths of light that are further into the ultraviolet, for peripheral vision, while dogs use rod cells for their frontal vision. We use cone cells, which are sensitive to color, for our frontal vision. Rod cell vision also seems to be faster, so that animals may see high-speed or "blinking" events that would be invisible to us if seen front-on.

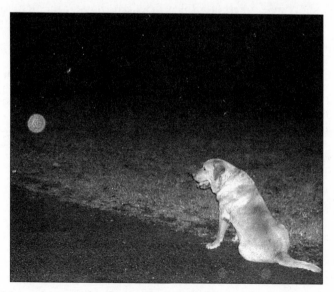

Figure 26: Max spies an orb after I asked, "Where are the orbs?"

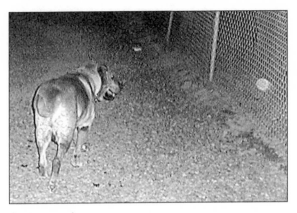

Figure 27: Max finds an orb.

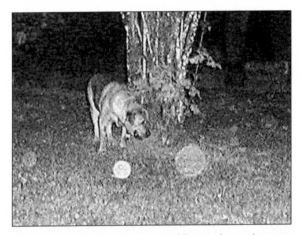

Figure 28: Max eyes another orb after I asked him where they were.

So, if you have an animal that is willing, take it along. Dogs can see, hear, and smell ten times better than you can. I am convinced that at least some dogs and cats can see orbs. Cats have minds of their own, and most cannot be trained, and it's a shame because cats have three times as many rods in their eyes as humans do, and we have 120 million per eye! Figure 29 is a picture I accidentally got of my cat Bhagwan staring at an orb. Who hasn't seen a cat staring at nothing or striking out at thin air and wondered why? Figure 30 is Peter's hunting dog Buddy tracking an anomalous light. My friend Donna, who calls herself the "horse lady," started getting orbs immediately with her new digital camera. Figure 31 was one of her very first photos. One horse may be looking at an orb, and the other horse may be listening to one.

Figure 29: Bhagwan contemplating an orb.

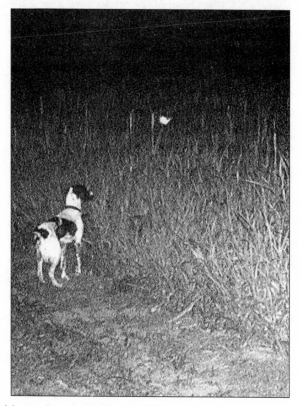

Figure 30: Buddy tracking an orb. © 2001 by Peter Clemmer

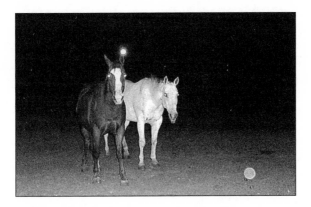

Figure 31: One horse watching; one listening? © 2001 by Donna Crawford

If ghosts are what you seek, seasoned ghost hunters say to choose your site and then research the history of the place you plan to photograph at your local library or county hall. Look for evidence of battles fought in the area, homicides, suicides, previous owners, and other incidents that may be connected to the current haunting.

If your camera has a strap, remove it. If it cannot be removed, secure it somehow. A camera strap can look like a vortex in a photograph. If there is a definite ending to the vortex, however, it cannot be a strap—unless your strap is chopped in half. Also, if it is in a horizontal position or if there are two or more vortexes in one picture, it is not a picture of your strap. Figure 32 (center section) is a picture of my mother on her sixtieth birthday. I took it with a 35mm camera and, according to the rules, the vortexes are not the camera strap, even though at the time I certainly thought they were.

Tie your hair back, as a stray hair in front of the lens can also produce seemingly paranormal effects.

Clean the dust, spots, and fingerprints off the lenses of all cameras, but never in the middle of a roll or you will not be able to see the same marks in consecutive pictures over the entire roll of film or digital batch. (If there is dust or water on the lens, it will show in every picture in the same relative spot.)

Bring extra batteries for every piece of equipment you take with you. Batteries often lose their charge mysteriously on orb hunts. Rumor has it that orbs use the batteries' energy to materialize for the camera. Others claim the high levels of electromagnetic energy in some areas cause equipment to malfunction. I have placed brand-new batteries in my camera on three different occasions, only to have them go dead after one shot.

Get pre-investigation readings from all the equipment you plan to use.

Bring a flashlight, most preferably a red-lens flashlight to preserve your night

vision (bright lights prevent your eyes from adjusting to darkness). Remember the extra batteries. Nickel-metal hydride rechargeable batteries are best for digital cameras.

Survey the area during daylight hours so you don't injure yourself in the dark. Also, look for any natural causes such as animals or construction that could explain noises and movement, drafts from broken or open windows that could cause temperature changes, and electrical wiring problems and overhead wires for normal electrical effects.

Do not trespass on private property to avoid fines or imprisonment. Have the owner accompany you or have the owner sign a permission slip to save yourself potential problems.

Most ghost busters recommend coming early and letting the orbs get used to your presence, asking their permission to take their picture, or talking to them for twenty minutes or so before shooting. Do those things if they feel right to you. In my experience, my most productive pictures are the very first as soon as I arrive and the very last picture after I tell the orbs, either mentally or verbally, that I'm leaving after that shot. I sense they telepathically know ahead of time that I am on my way and what my intentions are. If they don't want to have their pictures taken, they simply will not show up.

Before and during the hunt, send positive, loving thoughts and good feelings towards the Orbs and Company. I honestly love them, whoever or whatever they may be. Stay focused on your goal of photographing them. Fully *expect* to get some excellent photographs and you will. Some people use visualization, remote viewing, dowsing, calling them in, meditating, and flashing lights in the sky. To each his own. This is far from being a science. We need thousands of experimenters to help discover the truth.

Be well rested. Ed Vos, a Dutch professional photographer who runs a website called "Dutch Light Orbs" (see www.dutchlightorbs.nl./) and moderates The Yahoo! Group, "Universal-Orbs" (http://groups.YAHOO.com/group/universal-orbs), writes, "It seems [that] if the photographer is tired, the orbs don't appear." (This bolsters the theory that orbs use energy from you or some other source to manifest.)

Finally, bring a notepad and pen or a compact personal recorder to record the date, time, weather conditions, and your experiences.

During the Hunt

Now I will tell you that you don't need to follow any of the previous suggestions to get paranormal pictures. I didn't know any of that stuff when I started. These guidelines are just what some orbsters have generally agreed upon so far and they are highly flexible. Some of them may prove to be entirely wrong. There are no real experts in this field, so there is no gospel. To keep from getting caught in unproductive ruts, carry a camera

with you at all times and push the shutter button every once in a while, taking mental note of the circumstances as you go along. Then conjure up and test your own theories.

Now, finally, for the hunt itself:

Say a prayer for protection if you feel the need.

Again, if you feel you should, ask the orbs, ghosts, spirits, angels, or whatever for their permission to take their picture. Tell them when and where you will be shooting. You'll be surprised at their cooperation or their clever ways of defying you. I have heard many accounts where they even answer questions via their photos before they are asked. Keep talking to them, unless there is a mental health practitioner nearby. Tell them what you're doing, what you want to get, what you think you got, and anything else that pops into your head. Ask them to pose for a family photo and to smile!

Take off the lens cap. Duh. Make sure vehicle exhaust, fog, or lens condensation is not clouding your camera lens.

If your camera has a night setting, use it, but become familiar with the strange results you may get. Radio waves, gas particles, and UV rays are some of the phenomena from the world of the invisible that are said to cause anomalies on night-vision settings.

Avoid smoking, taking drugs, or using alcohol while on the hunt. Smoke can look like ectoplasm in a picture. Drugs and alcohol can affect your judgment, accuracy, and credibility. Some people say alcohol and drugs give spirits the opportunity to "possess" you. I don't buy into fear tactics, but, still, until proven wrong, these people may be right.

Leave the Ouija board at home and conduct no séances on site. Again, I don't think they would do harm unless you believe they would, but why tempt fate?

Think positively and have no fear. What people project emotionally is exactly what they attract. The only problems you are likely to encounter will be from the living.

Ross Hemsworth of The Phantom or Fraud Project (www.phantomorfraud.com) contends the pictures you get may depend upon what your thoughts are when taking the picture. He writes:

> If, for instance, you are in a negative mood and thinking of the "dark" you may get pictures of what appear to be "demons." If you are, however, thinking about the light and good, then you will get bright orbs and "rods" in the pictures.

Show respect for the dead and speak in a low voice for the sake of the living. Avoid needless chatting except for conversation meant for the orbs to hear. When you have to speak, do so in a positive manner.

If several people are taking pictures, let the others know when you are taking a shot so you do not get double flash photos that may mistakenly look paranormal.

Avoid stepping on graves. Not only is it considered disrespectful, but graves have been known to cave in. Do not pop out from behind a tree yelling, "BOO!" This can frighten the living ectoplasm out of someone in those circumstances and may even cause injury. Also, no running or horseplay in historical sites, battlefields, or cemeteries lest you be thrown out by the living powers-that-be. On the other hand, orbs seem to love fun times, music, and laughter. Create a fun event and invite the orbs to participate.

I have never encountered what would be called an "evil" spirit. You won't either, I suspect, unless you expect to or are deathly afraid of seeing one. I have come to believe you attract what you fear, either consciously or unconsciously. (Chapter 18 may explain to you why I feel this way.) There are only two emotions—love and fear. Love raises your spiritual vibrations and fear lowers them. Love attracts love and fear acts as a magnet to more fear. If you are concerned about evil ghosts or spirit attachment, you will be more likely to experience them. Keeping your vibrations high by sending out love instead of fear is your best protection, and I have found it also increases your chances for phenomenal photographs.

Even though the theme of too many churches is "Be very afraid," the command "fear not" is repeated 69 times in the Bible. Jesus' message was one of love, not fear. Lack of fear has always distinguished the true spiritual leaders from the chaff. What is there to fear about lights, the universal symbol for goodness? Everyone I know has had friendly, pleasant experiences with the playful orbs, except one, whose imagination went rampant after speaking to a minister. As noted in chapter 14, orbs have even been filmed comforting a child.

If you are frightened by anything, leave immediately. Do not ever even think about looking for an evil spirit, taking one home with you, or asking one to appear! Those intentions could actually create what you fear most (see chapter 18).

Do not wait to actually see anything. A psychic may see it, but the average photographer does not see the orb until the picture is taken. I have never seen a light form except when they appear for an instant as anything from tiny sparkles to huge flashes of light when the camera flashes. We do not actually see objects; we see the light they reflect.

Light anomalies are almost always photographed while using a flash. If you see distant lights in the air from your flash, take lots of pictures at that spot. Those lights are likely some sort of light anomaly. Many times, even bystanders will see your flash is reflecting off something they cannot see. These are especially convincing, since they could not be pictures of dust just inches from your lens. Occasionally you will see sparkles, but nothing will show in the picture. I have no explanation for this, but I

used to think the orbs were playing games with me. Skeptics claim the sparkles are dust, moisture, or pollen at a distance that do not show in the picture. Often I can see large balls of light or light formations up to about twelve feet away that were invisible before the flash illuminated them. I am certain these are not airborne particles.

Figure 33 is a picture of Neelima Courtney, Ph.D., taken after she spoke to our spiritual group about Hinduism in her native India. As usual, I took pictures throughout and after the meeting. Neelima and one other woman were the only members that evening with orbs literally clinging to them. When I took this shot, I saw a bright sparkle in front of her face, and she pointed in front of her forehead, saying, "I saw one there!" I just cannot be persuaded that was dust.

Figure 33: Dr. Neelima Courtney's orb that we both saw as the picture was taken.

Record any unusual feelings you have in any certain area. Also, pollen count, solar storm activity, temperature, humidity and the phase of the moon are all said to affect "ghost" activity, but if all this recordkeeping will spoil your fun, don't bother.

Always take more than one flash picture. Peter and I have found the orbs are attracted to the energy from the flash and we often will get more orbs with each consecutive shot.

Long-time ghost hunters advise taking twin shots, which are shots taken at the same time and place with two cameras. They often show subtle, informative differences. On the other hand, two pictures taken by two persons from different angles at the same time may or may not show the same configuration from a different angle. Even when another camera simultaneously captures the same orb, there still could be a natural cause. But still, no matter how many false images are recorded or how rare the genuine orb photograph may be, there are thousands, perhaps millions, of orb pictures that cannot be attributed to other causes.

I tried taking quadruple shots with three other persons using a total of four different cameras. We found we could not get the flashes to go off at anywhere near the

same time, so we couldn't compare photos of individual orbs. We did notice each photographer picked up different average numbers of orbs for the same almost-at-the-identical-time shots. Using identical cameras may be the best way to try this experiment.

Take lots of pictures in succession in the same spot. I suspect you will soon see how one picture can be blank, the next can be loaded with orbs, and the third could have one or two orbs. Once in a great while you will get a vortex. Even less often you will get a glimpse of ectoplasm, and consider yourself blessed if you capture an apparition. As soon as you get bored, these phantoms seem to know, and, just for your enjoyment, they perform some new stunt, like taking the shape of a shield or a heart, changing color, sprouting wings, or "smiling" at you. The pictures I took for the year before starting this book became more and more interesting and complicated as time went by. They seem to be able to show up when and for whom they choose.

Do not *think* about where the orbs may be. Use your intuition and *feel* where they are. M. F. "Chance" Wyatt is a sensitive in Melbourne, Florida, who can feel spiritual energy. He says it feels like holding your arm up to a television set while it's on, plus a cooling or warming sensation, or both. He says the spirits are in control of the sensations.

Wyatt says he evidently makes a difference in photographic results. "When I go to a cemetery with people who have not been having any luck photographing spiritual energy, they call after their film has been developed and tell me that they got much better results."[6] He is called a spirit catalyst, a medium, or a focus person.

Wyatt also gives tips on seeing spirits with peripheral vision in his book *Spirits Visit Earth*. From experience, he has found you cannot immediately turn your head and look. Instead, he writes:

> [Y]ou must learn to look and study what is in your peripheral vision for as long as you can. Then you can look directly at whatever it is and hope you are able to see it. If you're lucky, you might have a one- or two-second look-see. If you're real lucky it might be longer.[7]

Orbs are curious and sometimes follow people around, even when they are in moving cars. When Peter acquired new equipment and introduced it into his backyard sessions, he could count on getting shots of orbs hanging around the new toys. Take pictures of others in your group, leaving lots of room above and beside them for their invisible companions. Take a picture with your camera backwards over your shoulder and you may get a picture of an orb following you.

A camera can capture things outside our visual field. The camera's shutter is

actually slower than the time the human eye needs to see an image, so a very faint image, over time, has the chance to imprint film while our eyes see nothing.

Glass, mirrors, glossy tombstones, and other shiny surfaces can produce flashback or glare that looks like ectoplasm or orbs, especially if photographed head-on. Flashes can reflect off surfaces up to twelve feet away. They can also bounce, so avoid reflective surfaces. Taking the picture at an angle is supposed to minimize reflections if you insist upon photographing around shiny surfaces. Do not take pictures through glass, either, especially old glass. Also avoid taking pictures in the direction of the sun or any other direct light source to avoid lens flare. Try to have all light sources away from you or behind you when photographing.

Keep natural light sources out of your pictures as much as possible, such as from airplanes, cars, flashlights, lanterns, streetlights, the sun, and the moon. Document all lights that can be explained within each picture.

Figure 34 (center section) is probably an example of lens flare. I was showing my son Ben how to hunt for orbs even though it was broad daylight and not likely we would succeed. We didn't. We decided to take some pictures of him with his new Jeep. In just one of the shots his Jeep appears to be towing two huge, rainbow-colored orbs. The sun was behind my home, and I was at least ten feet away from Ben. The examples of lens flare I have seen are series of identical, geometric shapes. It doesn't look like typical lens flare, but it also does not resemble any orbs I have photographed. They could be the most spectacular orbs I have photographed, but odds are they were caused by lens flare. The anomaly in figure 35 is definitely a reflection from the television about ten feet in front of our grandson, Christian.

Keep the area in front of your lens clear. A finger near the lens will produce a reddish blob or look like a

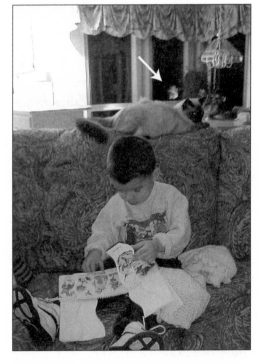

Figure 35: The "ghost" directly above Christian and the cat's neck is a reflection from our television.

huge pink vortex or ectoplasm on the edge of the picture. Anything sufficiently close to the lens will bleach out and look like a strange streak of light or dark. Any lace or string on your clothing will look anomalous in front of the lens.

Include some object in the picture, such as a tombstone, fence, or person, to serve as a point of reference. Then you may be able to determine the size of the formation and its distance from the camera.

Don't give up on your first try. You may be dealing with shy orbs and it will take a while for them to reveal themselves. They don't always show up on film, even when they are present.

Thank your light friends, and they may invite their friends along next time.

After the Hunt

Use any film processor. Local discount stores and mail order are fine. Just remember to request they process all the shots, no matter how defective they appear, or they are bound to throw away a prize photograph. Compare the negative to the prints with anomalies pictured in them to eliminate possible creases or dirt that may have been processed into the picture.

In shots that could possibly be something other than orbs, look for a border of light around the edge and for some substance within the orb itself. Some have specific flaws, holes, circles, and other distinguishing features and are seen over and over again, sometimes around the same person. There are those who say specific cameras cause this, and I have noticed certain cameras are prone to produce the same shapes on a regular basis while other cameras photographing at the same time record other shapes. I don't know enough about the workings of a camera to comment on this.

The average photographer is said to get one or two orb pictures out of about fifty shots. During the first year, my brother and I found we got orbs in up to 25 percent of our pictures if we were deliberately looking for them. When we were not, we almost never got any orbs *or* pictures of dust, pollen, rain, snow, fog, mist, spiderwebs, or insects. Now that I seldom go on orb hunts, I get far fewer orbs, even though I am using the same two cameras.

If you react as my brother and I did at first, you will blow up every orb picture into an 8 x 10 print and show it off as if it were your firstborn. Since then, my brother and I have both erased hundreds of single orb prints. They were so plentiful that we thought keeping them all would be like preserving a collection of dirt. This may have been a mistake in judgment, though, since some websites now say orbs are only legit-

imate when they are alone or with one other orb. I disagree. I can see no reason why they couldn't travel in groups.

The lights seem to allow us to take their picture, not because we happened to be at the right place at precisely the right time, but because they have decided for whatever reason to let us take their picture. Some theorize they could even be placing their image directly onto the film or into the digital works of the camera without ever being physically in front of the lens, since ghosts are reportedly electromagnetic and could control the electrical charges that make an image on a digital camera. If this were so, it seems I wouldn't have seen most of my anomalies in the viewfinder as I took the pictures. I suspect they don't show for anyone they think would be frightened to death from seeing anything unknown or for those who refuse to believe in their existence.

Not all anomalies cast a shadow, but if one does, it is an indication of authenticity. Another good sign is a three-dimensional appearance. Some of the most convincing of orb shots are those that moved during the shot. Figure 36 is a self-portrait Peter took in his family room with a theatrical, speeding orb trying to get either into or out of the picture. Or I suppose it could be a series of orbs in a blurred line.

Figure 36: Self-portrait by Peter Clemmer either with an orb getting into or out of the picture or with an orb lineup. (See lower left corner.) By most definitions, these would be labeled dust orbs, but I think this photo demonstrates that genuine orbs can look like dust orbs and still be legitimate. © 2001 by Peter Clemmer

Dust, pollen, moisture, and most insects cannot move faster than the shutter of the camera. If there is no possibility of a spiderweb being in the vicinity, there can be no explanation other than someone fraudulently tampering with the picture using a photo editing or paint program. But why would they spend countless hours doing such a thing? So their friends and families would question their sanity? Why would they expend so much effort creating a fraudulent picture that an experienced eye can detect? I don't know how to use a paint program, but it must be far easier to go outside and get a genuine picture than trying to dummy one up.

Do not throw away or erase orb pictures that another person thinks are not genuine. There is still too much disagreement about the characteristics of "real" orbs. The orb(s) in the preceding shot, if examined separately, would be dismissed by most critics as dust, but the placement of the orb or orbs makes that seem impossible. Some people are just as sure orbs must be dense and bright as the next person is certain they have to be transparent and pale to pass the test. Others feel they must be brightly colored with inner and outer perimeters and their own auras to be legitimate. I have even heard that the colored orbs, especially with an outline around the orb, are certainly of dust or pollen and that silver orbs are the only true ones. In other words, no one knows.

Eliminating pictures you think may be of dust can be especially foolish. Nicholas Reiter and Lori Schillig reported an experiment they conducted to see if the orbs they were getting were actually dust close to the camera reflecting the flash. They placed a fine-grain, 8"x6" black felt card between 18 and 24 inches in front of the camera lens to detect which orbs were caused by particles in front of the card. Those orbs should have been seen against the backdrop of the black card. Out of 34 pictures in which the card was used, 100 percent had orbs in them. None of the orbs contrasted against the dark background. In one shot, half of an orb, determined to be the size of a medium-sized marble, was hidden behind the card. It was very cold and dry at 5 degrees F, about 25 percent RH, clear, still, and with an old snow layer present. These conditions have a low probability of suspended particulates such as dust, insects, and pollen being present.[8]

Everyone wants to know exactly what a dust orb looks like. Most of my attempts to photograph dust and moisture were unsuccessful, but I have one picture in which I am certain at least most of the anomalies are dust orbs. I asked my ever-patient husband, Stan, to beat upon our sofa with a broom and I started snapping. In the first several shots nothing appeared. When the dust had time to reach the camera, I took figure 37. I admit I vacuum my furniture about as often as I clip my nose hairs (like, never), so there was a considerable amount of dust. The results made me feel ill. They proved to me this type of orb can indeed be dust very close to the lens, but I still believe genuine orbs can look identical to these when the orbs have not switched on their power.

Figure 37: Stan beating the upholstery and containing his excitement over my dust experiment. Photographs are two-dimensional, so there is no way to tell if these dust orbs are very close to the camera lens, but they did not appear until the dust had time to reach my camera.

I have not sent my photos to any camera manufacturers because I have read of others who have done so, and the responses they got are all over the board. Camera companies, as of this writing, definitely do not have their stories straight, which leads me to believe they do not know. Many digital camera companies cannot explain how these anomalies appear on the pictures, but agree the cameras do not cause these images. Others say it's a fluke caused by the flash units now being put closer to the lenses than they were in the past.

Skeptic Troy Taylor, president of the American Ghost Society (www.ghost research.org), asked three digital camera companies about his orb pictures and all three replied their digitals were having problems in low-light conditions. When pictures are taken in dark or nearly dark circumstances, he writes, "the resulting images were plagued with spots that appeared white or light-colored where not all of the digital pixels had filled in." Taylor admitted, however, that "the technicians at these three companies really knew nothing about taking ghost photos and would, of course, offer a skeptical viewpoint about the images in question."

New Jersey ghost investigator Randy Liebeck sent ten pictures of light smudges, orbs, and vortexes to his camera's headquarters for analysis. That company determined that electromagnetic fields or fogging effects due to ionization caused the images.

It seems the answers from the camera manufacturers depend upon how the question is presented to them and whether the companies think it is more important to defend their product or to deny the existence of the paranormal. Human nature being what it is, any answer that will make the question go away is normally the most popular.

Ed Vos from the Netherlands, who runs several websites concerning light anomalies and crop circles, has earned his living as a professional photographer for over thirty years and is familiar with every type of natural photographic anomaly. Orbs, however, show up regularly on private pictures taken by him and his partner Nel, but have never appeared in shots he has taken professionally.

Another phenomenon often mistaken for orbs is moisture in the form of rain, snow, mist, fog, and hail.

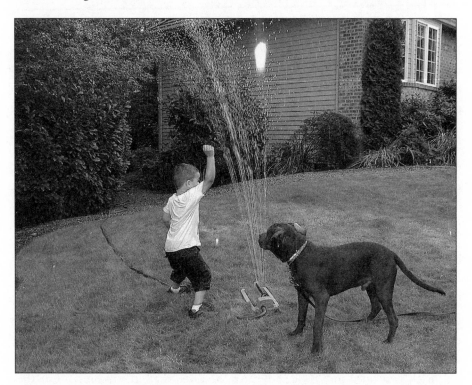

Figure 38: This is Christian playing in a sprinkler with Max's replacement, Remax. The large white spot (top center) and the small spot in front of Christian are reportedly what water drops or rain can look like with a digital camera.

Figure 39: Rain often appears as though it is traveling upwards with both of my Olympus cameras, but not all cameras record rain in the same way. The orb to the right of the bird feeder is bluish in the color print and is probably not a raindrop. The larger orb below it may also be legitimate.

Dave Juliano, the co-director of South Jersey Ghost Research and creator of the website the Shadowlands (www.theshadowlands.net), was skeptical that the orbs appearing on websites were ghosts, so he tried it himself. He took a 35mm camera he had used for six years and had never gotten an orb or anything similar to it in all types of weather and lighting. He went to a cemetery with some experienced investigators, one of whom was a psychic. She pointed out some likely spots and he got his first orb pictures there. He heard footsteps behind him, turned, and took some photos of the air behind him. Those shots showed orbs and ectoplasm. All the other shots he took that night were normal. Juliano didn't think it was a coincidence. Do you?

4 An Orb by Any Other Name . . .

. . . is still an orb. My first problem was determining what the rest of the world called these light anomalies. There was hardly a shortage of names for the "invisible" lights that are currently being caught with cameras throughout the world. It didn't take long to accumulate the following alphabetical list, which keeps growing as more cameras capture them:

After-life matter

Airborne protoplasm

Angel lights

Anomalous Luminous Phenomena, or ALPs

Astral beings

Bubbles from extraterrestrials sent to clean our atmosphere

Balls of light

Circle luminosities

Consciousness existing outside the brain

Craft of the Brotherhood of Light

Crop circle balls of light

Crop circle light anomalies

Energy consciousnesses

Ghost orbs

Ghosts

Globes

Globulars

Globules

Holy spirit (by Buddhists and other religions)

Interdimensional viewers or beings

Life-lights

Life-static

Light bodies

Light forms

Light orbs

Luminosities

Manifestations of consciousness

Merkabahs

Multidimensional beings

Nature beings

Nature spirits

Orb viewers

Orbs

ORBs (Other Reality Beings)

Plasmas

Rods

Self-luminous anomalies

Soliton discs

Soul energy (both incoming and outgoing)

Species of Fine Vibrations (SOFVs)

Spheres

Spirit orbs

Star visitor energy beings

Thought spheres

Unified field plasmoids

These are merely the names for the invisible lights. An even longer list of names for visible orbs can be found in chapter 5, but there may be no difference between the two other than their visibility to the human eye.

Out of this list the term "orbs" seems to be the most prevalent, at least on the Internet and in the media. Some people dislike that Hollywood term, along with "vortex" and "ectoplasm," but, just to simplify this particular project, I will call at least most of the simple lights of many shapes and colors that are usually invisible to the human eye orbs. This name becomes oxymoronic when it's used to describe six-sided orbs, diamond-shaped orbs, and such, but it is the most widely used. I will deal with vortexes, ectoplasms, and apparitions later, but I sense they are made of the same stuff only in different forms. The appearance of orbs varies as much as the way we humans vary in appearance, but many look alike until you become familiar with the differences.

Orbs are described as being anything from transparent to solid, translucent to opaque, faint to bright. Some contain an inner substance and a spot (perhaps a nucleus or brain) within the substance. One website calls that spot proof you have photographed pollen. There can be inner circles appearing to create a spiral or form random patterns. One other website claims these circles are created by orbs moving rings of electrons so they can move away or that the rings are caused by multistrobed electronic flashes. Some orbs have illuminated edges of energy; some have tendrils.

Shutters, diaphragms, and lenses on specific cameras are sometimes blamed for the many variations in the appearances of orbs. I often get some strangely deformed orbs on the edges of pictures; these squished orbs are caused by improper curvature of the lens. As mentioned earlier, film cameras can have one to six leaves in the shutter, and a digital can have up to nine blades in its diaphragm. If the flash is not synchronized with the shutter, or if the shutter leaves stick for even a nanosecond, the orbs can appear pie-shaped, flat-bottomed, or many-sided, depending on the camera. Five leaves or blades can supposedly slice equidistant pieces from orbs, causing them to appear as

pentagons; eight leaves would create the shape of an octagon, etc. This chopping effect is said to happen only with the orbs and not with other items in the picture. Why, if the diaphragm causes some orbs (but not all, even in the same shot) to have six sides, would only the orbs in the picture be affected? I'll leave that question to the techies.

In all of my photo taking, I got orbs with six droopy sides in only one location—the Oregon Vortex in Gold Hill, Oregon, an incredible three-quarters of an acre the Native Americans called "The Forbidden Ground." Mike, our guide, said Albert Einstein had studied the vortex and concluded people and things actually change size within the vortex. Had the strange forces in the vortex affected the blades in my camera's diaphragm? Or were the orbs shaped differently within the vortex?

Geographical vortexes such as the Oregon Vortex are often given the same definition as vortexes found in photographs—whirlpools of force that may serve as portals or tunnels to transport energy or entities from elsewhere into our reality. Vortexes may be the tunnels near-death experiencers claim to travel through to the "light" and another existence.

Figure 40: This orb with six droopy sides appeared in a picture taken within the Oregon Vortex. The bright white circle is a ping-pong ball which appeared to be moving uphill.

Peter and I have photographed lots of irregularly shaped orbs: orbs in motion with and without contrails (like the trails behind flying jet aircraft) and orbs in the shapes of spheres, eggs, strings of lights, footballs, butterflies, rods, cocoons, cylinders, and discs. I have seen pictures of orbs that are shaped like diamonds, squares,

computer chips, octagons, shields, hearts, tetrahedrons, rectangles, triangular wedges, and even cameras and umbrellas. Lens flare and other camera problems can create some of these forms under certain conditions, and some orbsters discount all orbs except for their list of certain, specified shapes and luminosities.

The problem is everyone's list is different, so I think it is too early to rule out any shape completely, especially since many of these same people feel orbs can assume any shape that suits them. The sphere is the most energy-efficient form, though, and that seems to be the reason that shape is photographed so often. Small orbs are assumed to take the least amount of energy to maintain. Any other shape seems to require the expenditure of more energy to assume.

Orbs are photographed more often at night than during the day in practically every color and shape. Their size can be anything from a tiny speck to an orb that fills most of the picture. It is difficult to determine the actual size of orbs since the size is dependent upon how close the orb is to the camera when the picture is taken. When the orbs hide behind or between objects, the size can be estimated objectively, but even when measured in this way, they range from tiny to huge.

Videos of the movement of orbs are becoming plentiful. They show orbs hovering for short periods, then traveling erratically every which way, against gravity and wind currents. It is common for the orbs to travel completely across the length of the photograph in the time it takes a normal camera shutter to open and close. Orbs have been videotaped as they pass through thick walls, multiply into several orbs and reunite, appear interested in the activities of humans and react to our presence, demonstrate many forms of "intelligent" behavior, and disappear into thin air. Without any exception known to me, their behavior is harmless, and they seem to be limited in the activities they are able to carry out.

Orb photographers find that orbs repeatedly appear in the same locations and can be photographed simultaneously with different cameras. They say they sense, hear, and communicate with orbs telepathically far too often to disregard the evidence. Another frequent observation is that orbs are extremely photogenic, but only when they want to be. The orbs, rather than the photographer, appear to control when they allow themselves to be photographed. Some people claim orbs make a super-high tone they hear inside their heads, since the sound is beyond the normal hearing range.

The Psychic Connection

Many psychics say they can see orbs at least briefly and claim to communicate with them on a regular basis. Ross Hemsworth wrote on www.phantomorfraud.com

in February 2002 that clairvoyants were able to point out the location of orbs and successfully request their presence in photos during a test while filming the TV series, *Ghost Detectives,* with Paul Hanrahan. Psychic Cathe Curtis took pictures of their team and asked her "spirit friends" to join them. Using two different cameras, eight to ten orbs were photographed hovering above their heads in all of the photos.

Hemsworth commented that clairvoyants have told him orbs prefer to be called "life-lights." He is convinced that clairvoyants can "tune in" to orbs and communicate with them. The intelligence orbs often display rules out dust, pollen, moisture, and camera phenomena as the possible causes.

Spiritual medium James Van Praagh says he has seen colored lights around people since his childhood. He seems to be describing orbs and vortexes when he defines "spirit lights" as luminous matter in his book *Heaven and Earth.* He claims they appear as "dots, balls, or gauzy strips of light, and range in color from white, yellow, and orange to blue or even violet."[1] He says the lights can flash and change colors upon observation, are seen "to the side of a person's vision," and sometimes make a humming sound. Van Praagh wrote he has seen sparks of light and a light that danced in front of him and seemed to smile at him during a séance. Van Praagh and other psychics refer to those who photograph these lights as mediums.

A rerun of the *Beyond with James Van Praagh* program shown on April 3, 2003, featured a message from a "dead" loved one delivered by Van Praagh to an audience member. The message was for this person to examine a specific photograph taken at a family event. He said to look for a ball of light in the photo and said this light was he, the deceased.

On a March 2003 television broadcast of the Montel Williams show, psychic Sylvia Browne pointed to what she called orbs around a girl in the audience. She said these balls of light can be either guides or angels and that some people can see them.

Medium and author Carrie Hart channels meaningful messages from "Quado" daily on her website, www.carriehart.com, which sometimes refers to balls of light to which we are connected. On August 15, 2003, Quado described the "soul self" as

> [A] glowing golden ball of energy, whole, entire, and unique, glowing golden next to the other balls of energy, which are soul selves of all the people you have ever known and ever will know. All are there beside you, communicating with you, being with you, connecting with you, and all are extending themselves down into the shadow world, which is this physical world.

Quado, however, calls these balls of light metaphorical. On May 13, 2004, he explained through Carrie Hart, "Everything is a metaphor for what you cannot

understand, for what you will never understand, because what is passes beyond your ability to comprehend."

A channeled message entitled "Spirit Speaks: Afterlife & Transition," posted on www.angelfire.com, claimed the departed live in the spirit realms but leave "sparks of their spirit" on Earth. Spirit said: "These sparks of light are often seen by mediums and referred to as being and looking like spiritual orbs or pearls approximately the size of a marble." More psychic connections can be found in chapter 18.

Most sensitives claim orbs are the human soul or life force that once inhabited a physical body. Psychics also seem to be most likely to see figures or faces inside the orbs. Dr. Dave Oester of the International Ghost Hunters Society wrote about faces in orbs in his January 27, 2002, newsletter. He claimed faces appear only when a low-resolution camera is used. With 1600 x 1200 or higher resolution, the faces disappear and fade into the pixel background.

I use both a low-resolution and a high-resolution camera and do not see what I would call faces with either. Yes, some of my orbs do have what could be interpreted as eyes, mouths and noses, I suppose, but they are just as likely to appear upside down or sideways as they are to be situated like a normal face. Of course, I don't expect to see faces in orbs; no matter what orbs might be, I don't feel they must be in any way similar to us. I would be more likely to look for entire bodies within orbs than to imagine they float around as decapitated heads.

Some of the orb pioneers who have become tired of photographing plain orbs for years on end are into reading all sorts of things into what they imagine they see within light forms. Once someone posted a picture she thought was clearly a photograph of an alien abduction! I stared at it for some time and saw nothing other than an ordinary orb in some bushes. False effects created by random patterns in vegetation, backgrounds, shadows, or light anomalies are called "simulacra," a term coined by English author John Michell. Attributing meaning to this illusion is called "pareidolia."[2]

Again, I may be wrong, since some traditions consider the head the focus of consciousness, but I cannot believe finding faces in orbs is any different than saying a cloud that looks like an elephant is actually a floating pachyderm. I have seen a few pictures that looked like floating human faces, but I am not convinced they were truly weightless heads—just orbs that looked like faces, with or without intention.

Orbs in Near-Death Experiences

Have you ever noticed how many authors of this type of book have had near-death experiences? Many of them subsequently became psychics, prophets, humanitarians,

and visionaries. I "died" for about two minutes more than thirty years ago and saw the Light, as they say, and now I wonder if the spiritual gift I received from the visit somehow aided me in taking paranormal photos.

When I was 20 years old, a drunk driver hit the side of the car I was in, smashing a metal dashboard into my face and hurling me onto the street. My heart and breathing stopped for about two minutes. I had one of those "near-death experiences" they talk openly about now but I had not heard of at the time. I told my fiancé, now my ex-husband, and he thought I had brain damage. Years later, my well-meaning, beloved Lutheran pastor said it was Satan's work because persons of *all* faiths experience the same thing and, of course, only Christians, and possibly only Missouri Synod Lutherans, could have a good experience after death. *Say what?!*

That peace, that feeling of safety radiating from the most brilliant, loving light, that knowing I had been there before and would be there again—from Satan? I think not. I so wanted to stay there in that miraculous nature scene where I found myself, but I awoke in a hospital bed—bloody, broken, and disappointed I was back. The message I was given telepathically during my brush with the Other Side was, "Do not fear death," and, since then, I have had no fear of dying.

I do not remember seeing a tunnel or any messenger, common elements in near-death experiences, but there is no doubt in my mind that I visited a magnificent place that bore no similarity to the world I had temporarily left.

I do not recall anything resembling an orb from my near-death experience, but it seems I actually may have been one. Dr. Raymond Moody found many others did recall being orbs in his book *Life After Life*, a case study of more than 100 near-death experiences. This book was published in 1975, long before orb photography made its appearance on the Internet in the late 1990s. With difficulty putting it into words, subjects described becoming:

• "more or less circular"

• "a ball of light . . . no more than twelve to fifteen inches in diameter"

• "some kind of like a capsule"

• "sort of like just a little ball of energy"

• "a round ball and almost maybe like I might have been a little sphere—like a BB, on the inside of this round ball"

• "like a cloud in its own encasement"

• "circular with no rigid outlines to it"[3]

Some NDEers felt as if they were pure consciousness, invisible, inaudible, without solidity, weightless, telepathic, and able to move through objects. Almost without exception, near-death experiencers describe the same sense of unsurpassed peacefulness, calmness, and serenity I felt during my own glorious visit with "death" (see chapter 11).

Research in 2003 by the Institute of Psychiatry, a school of King's College in London, suggests the human mind may exist outside the body like an "invisible magnetic field." Within 37 seconds after a heart attack, as Dr. Peter Fenwick explains, the brain cannot create any semblance of the world. No blood is circulating in the brain, yet "dead" patients can accurately describe what was going on in the room after that point. He concludes, "Consciousness would appear to exist outside the brain."[4] In the form of an orb, I query?

Lights that can be seen with the naked eye, which look and behave like orbs, have been sighted throughout history. They are examined in the next chapter. Most of the invisible forms other than orbs are discussed in chapters 6 through 9.

5 Visible Lights

I discovered another set of names for inexplicable lights that have been seen with the naked eye throughout history on every continent. Some cultures have identified balls of light as their ancestors. Before the invention of electricity, anomalous lights surely would have been an event worthy of note. Whole communities sometimes would see the lights on a regular basis and the lights became the stuff of countless folk tales. I found the similarities between these independently developed tales around the world a good argument for their authenticity.

The following 196 names may seem considerably different, but the folklore attached to them is surprisingly like explanations offered for orbs today. This is not a complete list. Keep in mind these lights were seen often enough to be named.

Anomalous Luminous Phenomena (ALP)
Amber Gamblers
Amber Lights
Anson Lights (Abilene, Texas)
Bailey's Light (near Angleton, Texas)
Ball Lightning
Ball of Wildfire
Ball Plasma
Balls of Light (BOLs)
Belfast Light (Belfast, Virginia)
Big Thicket Ghost Light (Texas)
Bingham Light (Dillon, South Carolina)

Blazing Stars
Blud
Blue Jets
Blue Lights
Bob-a-Longs
Bodhisattva Lights
Bragg Road or Big Thicket or Saratoga Ghost Light (located between Saratoga and Bragg, Texas)
Bramaracokh
British Columbia Light (British Columbia, Canada)

Brown Mountain Light (near Morganton, North Carolina)
Burning Shields
Candelas
Canwll Corfe
Cemetery Lights
Chapel Hill Light (Chapel Hill, Tennessee)
Clanogrian (English)
Codgell Spooklight (Codgell, Georgia)
Cohoke Light (West Point, Virginia)
Corposant
Corpo Santos
Corpse Candles
Corpse Lights
Crossett Light (Crossett, Arkansas)
Dead Candles
Dead Man's Candles
Death Light
Devil's Bonfires
Dickepoten
Dovedale Light (Dovedale, UK)
Dover Lights (Dover, Arkansas)
Dragon
Earth Lights
Earthquake Lights (EQLs)
Electroforms
Electromagnetic Vehicles (EMVs)
Elf Fire
Elf Lights
Eskuddit'
Fair Maid of Ireland
Fairy Death Lantern
Fairy Fire
Fairy-Lantern
Fairy or Faerie Lights
Falling Lights
Fata Morgana
Fetch Candles
Fetch Lights
Feu Follet
Fiery Coruscations
Fiery Dragon
Fiery Drakes
Fireball

Fire Creature or Fire Demon (Native American)
Fire of Destiny
Fire Elemental
Fire Faeries
Flaming Torch
Flickering Fire
Fluffy Fire
Flying Flame
Foo Fighters (of World War II)
Foolish Fire
Fool's fire
Formless fire
Foxfire
Friar Rush with a Lantern
Friar's Lantern
Geophysical Meteors
Ghost Beacons
Ghost Fire
Ghost Lights
Ghostly Lanterns
Ghostly Lights
Going Fire
Gurdon Light (Gurdon, Arkansas)
Haldeman Light (Haldeman, Kentucky)
Hansel Road Light (Bucks County, Pennsylvania)
Hebron Light (Hebron, Maryland)
Hessdalen Valley Lights (Roros, Norway)
Hessdalen Phenomenon
High Strangeness Residuals (Hessdalen Project)
Hito Dama
Hob-Lantern
Hobbedy's Lantern
Hornet Spooklight (Northeast Oklahoma)
Huckpoten
Hunky Punky
Ignis Fatuus ("foolish fire")
Irrbloss
Irrlicht
Jack of the Bright Light
Jack-o-Lanterns or Jacky Lanterns
Jenny Burnt-Tail
Joplin Spooklight (Northeast Oklahoma)

Kerr Magneto Optic Effect (lights produced in a magnetic field where reflected light becomes polarized)
Kit-in-the-Candlesticks
Kraut Fireballs (World War II)
Lambent Flame
Lantern Man
Lanterns of Earth Spirits
Leaders
Les Eclaireux
Life Consciousness (Hindu)
Lum'eres de la Terra
Luminosities (Buddhist)
Luminous Clouds
Luminous Columns
Luminous Serpents
Luminous UFO
Luminous Vapours
Lyktgubbar
Maco Light (west of Wilmington, North Carolina)
Magnetophosphenes (lights produced when brain is irradiated by magnetic fields)
Maple Lights
Marfa Lights (in Mitchell Flat, approximately nine miles east of Marfa, Texas)
Marsh Gas
Meg of the Lantern
Min-min
Mobile Luminous Spheres
Money Lights
Montana Lights (Montana)
Mysterious Flares
Mystery Lights (MLs)
Night Orbs
Night Suns
Night Whispers
Nocturnal Lights
Ontario Lights (Ontario, Canada)
Orbs
Oxford Light (Oxford, Ohio)
Paukding Light (Watersmeet, Michigan)
Peg-a-Lantern

Peggy with a Lantern
Phantom Effluence
Pixie Lights
Plasma Beings
Plasma Blobs
Plasma Vortex
Prairie Light
Puck-Lantern
Rich Mountain Lights (near Mena, Arkansas)
Ridge Light (California)
Robin Goodfellow
Rocket Lightning
Ruskaly
St. Albans Light (England)
St. Elmo's Fire
St. Louis Light (Saskatchewan, Canada)
Scugog Island Light (Ontario, Canada)
Sean na Gealaige
Sebath Light (Abryrd, Missouri)
Silver Cliff Cemetery Lights (Silver Cliff, Colorado)
Sparking Fires
Spirit Echoes of the Dead
Spirit Lantern
Spirit Lights
Spook Lights
Sprites
Spunky
Strange Lightning
Strange Lights
Strange Meteors
Sun Boats (by ancient Egyptians)
Surrency Spooklight (Surrency, Georgia)
Swamp Ghost
Teine Side
Teine Sionnii
Teine Sith
Treasure Lights
Tri-State Spooklight (Northeast Oklahoma)
Unctuous Vapor
Unidentified Atmospheric Phenomena (UAP)
Unidentified Flying Object (UFO)

Unknown Light
Vessel of the Dryad Faerie (tree fairy)
Walking Fire
Wildfire
William with the Little Light
Will-o-Lights

Will-o'-the-Wisp
Will-o'-the-Wykes
Willowisps
Wimberly Lights (Wimberly, Texas)
Wisp
Witch-Fire (Africa)

Gradually these names began to fall into general categories, in my mind at least, but they were impossible to separate completely. Although nearly every "expert" in the field agrees that several types of phenomena are involved, characteristics for each category are so intermingled and entwined that coming up with a definition for each type of light is impossible with these terms. Orbologists simply need to get their nomenclature in order before distinctions can be made. There is good and bad in everything, though, and the good news with all these names is the indication that these lights have been seen all over the world and for a very long time. To deny the existence of these lights or to label the witnesses loony would be foolish, but there are always volunteers who eagerly assume the role of making witnesses of anything paranormal appear dimwitted. Fear of the unknown does horrible things to common sense.

These lights, aside from a few accounts where some witnesses saw them while others present did not, are normally visible to human beings. For simplicity, I placed them very loosely into five categories: ball lightning, earth lights, ghost lights, will-o'-the-wisps, and UFOs. Everything I read broke them down differently, but I chose these five categories to point out the differences and the similarities between the five types of visible lights and the invisible orbs. Hopefully, you will see there are more similarities than differences, but each category has such enormous latitude, the five types are bound to seem alike. Please note how often the descriptions of these age-old lights have also been used to describe the "new" orb phenomenon. I suspect the difference between visible and invisible spheres is a matter of energy or where they fit into the light spectrum.

These descriptions are not intended to be taken as the final word. They are my impressions of these phenomena based upon reading hundreds of descriptions in everything from quasi-scientific studies to folklore. Rather than define them clearly, the definitions serve to illustrate how poorly defined these lights are.

Ball Lightning

Ball lightning is most often called opaque, fiery, and bright but is sometimes described as transparent, translucent, or cloudy. It is strongly associated with electrical

and thunderstorms, high-voltage power lines, or high-power television transmitters. Most ball lightning seems to be highly charged with electricity and is said to last less than five seconds. It consists of up to a dozen brilliant spheres (or discoid, ellipsoid, cylindrical, or dumbbell-shaped, or spheres with protrusions) of glowing, hovering light. Ball lightning moves slowly near the ground, then disappears or explodes. It can also hang in mid-air, fall or float languidly down from a cloud, remain stationary, or move purposefully. Some balls spin and rotate as they move.

Sometimes ball lightning is accompanied by sound, odor, and material damage, and a mist or residue may remain. It can crackle, hiss, whirr, and roar, and has a sharp and repugnant odor resembling ozone, burning sulfur, or nitric oxide. It can blink or even be dark as long as it is observed, or it can light up a room or the whole sky. Ball lightning seems to be cool, but it has also been known to burn and cause tubs of water to boil. It can penetrate solid walls and bounce off the ground and solid objects. As for size, I have seen estimates of anywhere from .01 meters to 100 meters, with the sizes of oranges and grapefruit being noted most frequently. Scientists have found ball lightning difficult if not impossible to reproduce in a laboratory. Generally, ball lightning is not considered as "intelligent" as other light categories, but it has been said to avoid people and follow cemetery paths.

Danny Kingsley of ABC Science Online claims there are more than ten thousand scientific reports of ball lightning. I found an abundance of conflicting theories concerning the makeup of ball lightning, including:

- An optical illusion or after-image on the retina of the eye from the lightning flash (sometimes a group hallucination)

- Anti-matter meteorites

- A manifestation of earth lights

- Nitrogen plasma, since a nitrogen laser is red at low energy and blue at high energy

- Slowly burning gas

- Chemical reactions involving dust, soot, etc.

- Spheres of heated air at atmospheric pressure

- High-density plasma which exhibits quantum mechanical properties characteristic of the solid state

- Some sort of air vortex (like a smoke ring) containing luminous gases

- A microwave radiation field found within a thin sphere of plasma

• Nothing more than a psychological phenomenon

• The ions of a highly ionized gas forming small spheres, with the solid particles inside the ball and the electric field at the surface of the ball

• Globules of liquid fire formed with argon gas

• The same phenomenon as tornadoes, only different size

• A plasmoid phenomenon

A publication called "Letters on Od and Magnetism," published in 1926, wrote about ball lightning seen in cemeteries as follows:

> It is a carbonate of ammonium phosphuretted hydrogen and other products of putrefaction, known and unknown, which liberate odic light in the course of evaporation. When the putrefaction comes to an end, the lights are quenched—the dead have atoned.[1]

ABC Science Online (www.abc.net.au/science/news/stories) cited a New Zealand professor of chemical engineering named John Abrahamson for the most recent explanation. He proposes there must first be regular lightning and this lightning must hit something with a metallic or an oxide component, such as a building, the ground, or a tree. The lightning produces a silicon vapor, which condenses to form silicon nanospheres. These collect together in long strings. If there are also fulgerides present (long sausagelike holes in the soil full of hot vapor created by the lightning striking the ground), the silicon vapor can then come back out of the soil as a vortex ring, which forms a sphere. This is the ball lightning, and it can travel long distances, staying hot and visible. Abrahamson thinks ball lightning carries very high levels of energy that can burn and even kill people.

In other words, there is no consensus in the scientific or any other community as to what ball lightning is. Several researchers speculate that if ball lightning exists, it should blow people's heads apart once in a while or at least do some major damage—perhaps it explains spontaneous combustion. Equally as many insist ball lightning is harmless.

Earth Lights

Earth lights also could be several types of phenomena and are nearly synonymous with earthquake lights. Some sources describe earth lights as translucent and structured, as opposed to ball lightning, which is more opaque, bright, or fiery. Yet

others describe earth lights as very bright or with light issuing in one direction. Earth lights may or may not pulse, buzz, hum, or whistle; be visible by radar; or cause magnetic fluctuations or emit electromagnetic radiation. They are highly maneuverable and can assume many shapes, sizes, colors, speeds, and luminosities. These lights are sometimes accompanied by columns of gaseous material resembling the ectoplasm associated with manifestations of ghosts.

Witnesses have claimed to see what they interpreted as "white ladies" by night or "black monks" by day. Skeptics believe these apparitions could also be the modern-day silver-suited aliens. Earth light sightings often correlate with reports of poltergeist, UFO, and other paranormal activity.

Earth lights are those lights that seem to be terrain-based or are somehow produced through the "sea of forces"—the electrical and gravitational powers of the Earth, sun, moon, and stars that are far too complex for today's science to understand completely. They are often seen in the same area for generations, but have also been known to move to nearby locations. Many claim the phenomenon is somehow linked to lunar cycles and solar activities.

C. G. Jung was one of the first to say earth lights could be some kind of pure electromagnetic life-form.[2] Today, earth lights are often defined as "electromagnetic plasma generated by the Earth," but some scientists claim they cannot be plasmas since earth lights lack microwave emanations and radiation, and plasmas are usually invisible.[3] Ionized gas coming from earthquake faults, unidentified electromagnetic energy, and other natural Earth energies are often given as their source.

Earth lights are seen near quarries, rocky ridges, mines, caves, power lines, transmitter towers, mountain peaks, isolated buildings, roads, metallic vehicles, railroad tracks, and bodies of water. Some lights seen along railroad tracks for decades are no longer seen when the tracks are removed. Others seen near railway lines were seen there for generations before the tracks were constructed.

Paul Devereux's *Earth Lights Revelation* (1989) revealed that nine out of sixteen somewhat randomly selected anomalous nocturnal lights in America were noted precisely at, or within a few miles of, medium-intensity earthquake epicenters. The lights he selected were Ada, Bailey's Bragg Road, Brown Mountain, Chimney Pass, Hornet, Hudson Valley, Maco Station, Marfa Piedmont, Pine Bush, Pinnacles, Silver Cliff, Uintah Basin, Yakima Reservation, and Washington Township. Twelve of the sixteen were located at or within fifty miles of seismic influence.[4] Devereux reported that bodies of water trigger numerous tiny "microquakes," which could explain the earth light sightings near lakes, reservoirs, rivers, and waterfalls. Devereux admits, however, that earthquakes do not necessarily produce light phenomena, just as ball light-

ning is not produced in most thunderstorms. "It seems that a delicate balance of conditions have to come together for lights to appear."[5]

Devereux's theory didn't compute after I inquired about earthquake insurance. The greatest recorded number of the United States' earth lights I have found are in the states of Texas, Arkansas, and Oklahoma. If earth lights are in any way associated with earthquakes or fault lines, it seems Washington, Oregon, and California, where many insurance companies do not offer earthquake insurance, would be in that list. James Bunnell (james@nightorbs.net), retired scientist and author of *Night Orbs* agrees. He writes:

> [S]eismic fault lines can be found just about anywhere around the globe. Someone wanting to associate fault lines with the occurrence of hailstorms could probably find a similar association as long as we are willing to ignore the fact that fault lines also occur in locations that have not experienced hailstorms.[6]

Any rock is capable of producing light phenomena if enough stress is applied to it. When crushed with extremely high forces in the laboratory, normal minerals and especially crystals can produce little glowing sparks or small balls of light. Rock can produce light when exposed to friction, pressure, or heat. Devereux writes that some American Indian shamans produced "magic fire" by "shaking quartz pieces in a leather rattle device containing holes—the friction caused by the shaking created light from the crystal pieces, which shone out through the holes."[7] However, these lights are measured in microseconds, not in minutes as are some earth lights.

The Hessdalen Valley Lights near Roros, Norway, have been reported since 1981 and have been scientifically studied in earnest. These lights regularly appear near an area of Norway once mined for iron and copper and which is packed with minerals of all kinds. Recently, however, the frequency of the lights has decreased to about 20 observations per year, down from as many as 20 reports per week. The magnetic field at Hessdalen is the strongest in all of Norway.[8] As of August 2001, Italian physicists and Norwegian engineers had reached the following conclusions about the lights at Hessdalen:

• The lights are thermal plasmas.

• The light-balls are composed of many small parts that vibrate around a common barycenter (center of gravity). They are not single objects.

• The light-balls constantly change shape.

• The lights can eject smaller light-balls.[9]

I found what could be an example of orbs inside of orbs in one of Peter's photos. Figure 41 (center section) is what looks to me like Big Boy with smaller orbs inside his body—before ejection? Could they possibly be reproducing themselves? Or is this just an interesting picture of orbs behind or in front of a larger orb? Another of Peter's shots (figure 42, center section) looks more like a pile-up than a birth.

The 2002 report from the Hessdalen Project report revealed some additional conclusions. The scientists determined the balls of light could produce a luminous power of up to 100 kW. The phenomenon can be seen nearly every day (especially between 10 P.M. and midnight) and has "no 'ufological' relevance," according to the scientists, led by astrophysicist Massimo Teodorani, Ph.D. Samples of the earth in the Hessdalen area exhibit higher levels of radioactivity than average. Scientists found that the lights can pulsate and blink irregularly even when they are not moving. They turn on and off constantly and their movement is jerky, organized around a barycenter. The lights are visible for an average of five seconds per cycle and do not exhibit what the scientists would call intelligent behavior, but they found them to be highly elusive and unpredictable. The balls are usually white and sometimes red.

Even when the lights are not visible or are very faint, the Hessdalen scientists said they could show strong radar tracks, but sometimes the visible lights had no radar tracks. They determined the lights look like balls of light from a distance but closer up and at low light levels, the lights can be geometric structures.[10] In my mind, the Hessdalen group comes closer each year to describing the characteristics of my orbs, as I understand them.

Reports of UFO sightings increase for weeks or months before a seismic event such as an earthquake, according to Dr. Michael Persinger, professor of psychology at Laurentian University in Sudbury, Ontario. He claims the strain creates short-lived luminosities (balls of light). Researchers in Japan have confirmed that earthquakes can produce unusual lights. Rocks under pressure can even produce radio waves. Regarding visible UFOs, however, their visibility normally lasts longer than any known phenomena such as earthquake lights or ball lightning.[11]

Lights tend to be dubbed earth lights when they are seen around megalithic sites, that is, ancient stone circles and monuments once revered as "power" spots. These locations are associated with energy lines (ley lines) and are said to hold mystical powers. Many ancient civilizations built their roadways in alignment with ley lines, Earth's natural pathways. These Earth energies are thought to provide an outlet for paranormal activity, are usually linked to the presence of water, and are dowsable.

Some people suggest these locations, the homes of many of the legitimate crop

circles, were chosen as sacred sites because of the presence of the mysterious lights. Many ancient cultures believed, and some still do believe, that there are portals or doorways to the "Other World" where communication with gods, ancestors, or spirits is easier than in other places, and they situated their cemeteries and ceremonial sites accordingly. In Europe, the Church Christianized the old Celtic holy places. Today, ghost hunters frequent these same old graveyards and sacred sites to photograph that "Other World" and light anomalies.

This "portal" theory may help explain why so many witnesses claim the lights have intelligence and even seem to be able to read their thoughts. Devereux claims the "piezoelectric effect" of rocks containing crystal producing electrically charged plasma under pressure could interact with the temporal lobe of the brain, creating empathy between the light and the witness. Others go so far as to call this "empathy" a hallucination. One person's hallucination, however, is another person's experience of an alternate reality in another dimension.

Devereux claims the electromagnetic fields of the lights, if they are close enough, produce tingling sensations, goose bumps, raised hairs, and a heavy feeling in the chest. Temporal lobe areas in the brain are the most electrically sensitive parts. Temporal lobe epilepsy causes dreamy states, hearing voices, seeing apparitions, and compulsions.[12] The victim sometimes receives messages from disembodied voices, experiences out-of-body states, and observes "supernatural" figures.[13] Devereux, who edited *The Ley Hunter,* the only journal concerned with ley lines for twenty years, wrote on www.arcmake.com:

> . . . [W]hat is talked about in New Age journals, workshops and groups today about "leylines" is mainly a combination of misunderstanding, old falsehoods, wishful thinking, and downright fantasy.

Dr. Andrew Nicholes, professor of psychology and parapsychology in Gainesville, Florida, and founder of the Florida Psychical Research Foundation, says energy anomalies can be traced not only to the geomagnetic fields of the Earth itself, but to faulty electrical wiring or high-voltage power lines. These electromagnetic and geomagnetic energy fields may cause hallucinations in people, but, then again, they also could be opening doors between the physical and spirit worlds.[14]

Light forms may appear in these energy or power spots simply because they must use energy in order to make an appearance and to be able to move. John Zaffis, founder of the Paranormal Research Society of New England, stated:

> I agree that certain areas have energy fields associated with them that

somehow allow ghosts to appear. I also believe that some ghosts have the ability to pull energy from locations and individuals in order to make themselves known.[15]

Imagine earth lights as being visible to the human eye only when they can easily absorb an abundance of earth energy in certain areas of the world. Suppose they are everywhere and would be visible to everyone if only they had enough energy to materialize. Devereux speculates these conditions may provide enough energy for aliens to manifest at a location. The scientific community does not yet know how earth lights are produced. Devereux says this energy manifestation in the form of lights is either some type of electromagnetism or something unknown that interacts with some of the electromagnetic spectrum. He writes:

> Such a secret force has long been assumed by traditional societies. In old China, it was *chi*; to the Australian aborigines it is *kurunba,* a primary sea of force that underpins the manifestation of energy effects and matter in the material world.[16]

In the end, Devereux, like many others, could not ignore the esoteric nature of the lights. He concludes these lights are so sensitive they can "react to consciousness itself." The witness's consciousness affects the larger consciousness field, which then affects the earth lights. He says the electromagnetic force could increase the effect on the witness's brain and on the field of consciousness.[17] I discuss this universal interconnectedness in chapters 17 and 18.

Ghost Lights

Ghost lights seem to be essentially the same phenomena as earth lights. The main difference is what the witnesses interpret the lights to be. They have been reported for centuries worldwide, appearing randomly or regularly at particular sites, sometimes for decades and usually in remote areas. They are most often seen near the ground or on the horizon, glowing with an eerie, soft color. Usually spherical, they can also be irregular patches of light. These light forms of many changing colors and shapes sometimes pulse and dance about, spin, rise, fall, flicker, dart or bob from right to left like a lantern carried by an unseen person. Like ball lightning and earth lights, they may be accompanied by humming, buzzing, or gaseous material.

If light forms could take an intelligence test, the ghost lights would qualify for the talented and gifted program. They are especially elusive and sometimes can only be seen from certain angles. They recede from noise and light and disappear when approached. Folklore all over the world links them to tragedies or hauntings. Historically thought to be the manifestation of ghosts or harbingers of death, they are reported to be anything from playful to menacing. They have been known to play "hide and seek" and have appeared inside vehicles. They may hug the ground, float in the air, bob, hover above roofs, or, legend has it, appear on the chests of those about to die. Folk tales warn travelers not to follow the lights, or they will be led astray.

Most often called ghost lights or spook lights in America, other names are corpse candles, corpse lights, dead candles, *ignis fatuus* (meaning "foolish fire" because anyone who follows it is foolish), fetch candles, fetch lights, Hobbedy's lantern, Jack-o-lanterns, jacky lanterns, Jenny Burnt-Tail, Kit-in-the-candlesticks, and spirit echoes of the dead. In 1956, adept Franz Bardon could have been describing ghost lights when he wrote:

> [E]very Earth spirit carries a small lantern and each lantern has a different luminosity. The lantern helps these Earth spirits find their way in the subterranean kingdom.[18]

The United States alone has a long list of famous ghost lights that appear or have appeared with regularity in certain places. The lights I found listed most often are:

- Bailey's Light near Highway 354, five miles west of Angleton, south of Houston and close to the Gulf of Mexico shoreline in Texas. A basketball-sized glowing orb is said to be the ghost of a nineteenth-century settler called Brit Bailey, searching for a jug of whiskey.

- Big Thicket Ghost Light, Texas. This starts as a pinpoint of pumpkin-colored light among the swamp trees and grows to the brightness of a flashlight, then fades away.

- Bragg Road Light, Bragg, Texas. This is seen along an eight-mile-long straight road that links Highway 787 with 1293 near Saratoga, northwest of Beaumont. For decades people have seen a strange, dull yellow, white, or red light moving down this road. It has been known to appear ahead of a car, disappear, and reappear behind the car. It is said to be the ghost of a brakeman who worked on a former rail line and was decapitated in an accident, wandering with a lantern in search of his head; it is also identified as the ghost of a Spaniard guarding his treasure.

- Brown Mountain Lights, Brown Mountain, North Carolina, near Morganton and Lenoir. These have been reportedly seen for 300 to 800 years. The Cherokee thought they were the spirits of slain warriors or tribeswomen searching for slain menfolk. The lights are usually white, yellow, or red and about 20 inches in diameter. They are very bright, appear near the ground, and sometimes make a sizzling sound. At times they line up and "march" across the ridge, then disappear over the top. They can be stationary or move erratically, and have been known to respond to lasers, light, radio waves, and telepathic messages.

- The Gurdon Light, Gurdon, Arkansas. Seen along railroad tracks, it is white, blue, or orange, and has a distinctive border to it.

- The Marfa Lights, Marfa, Texas. For more than 150 years, floating yellowish-green balls of light have been seen above the horizon after sunset. The lights sometimes separate into two parts. They change color and brightness, move, and display intelligent behavior by following cars and people. Witnesses say the lights seem to know exactly where they are and appear to be daring them to chase the elusive lights. The Apache called them stars that had dropped to Earth or the spirit of Chief Alstate condemned to wandering the area after he offended a tribal god. Early settlers called them the lanterns of families lost in the 1860s.

- Silver Cliff Cemetery Lights, Silver Cliff, Colorado, about 60 miles southwest of Colorado Springs. Silver-dollar- to basketball-sized, these blue-white lights were first recorded in 1956. They appear alone or in groups of two to four, dance among the headstones, and then fade away when people try to approach them; they may reappear in another spot. They hover, glow on the ground, or fly around at head height. They have not been seen for some time.

- Surrency Spooklight, Surrency, Georgia. A bright yellow ball has been seen along the railroad tracks since the early 1900s. It has been attributed to a geologic anomaly under the town of Surrency—a unique convex-shaped pocket of liquid, nine miles underground.

Will-o'-the-Wisps

Even though some say will-o'-the-wisps are yet another name for ball lightning seen outdoors, will-o'-the-wisps seem to carry more of a spiritual connotation and are more often credited with intelligent behavior than ball lightning. Most legends place them in swamps and marshes after sunset, in meadows, cemeteries, and around ships before storms. They are usually blue and can be one ball or many tiny flickers.

They have been called fairies, spirits, or ignited pockets of swamp gas (usually methane or phosphene) which hover over swampy areas. The problem with this gas theory is that a blue flame would be a high-intensity flame, not the cold, blue lights these anomalies are reported to be. Also, both gases produce a hot, yellow flame. Folklore credits will-o'-the-wisps with mineral-locating abilities.

Parapsychology writer Brad Steiger discovered:

> A folklore at least 2,000 years old links these mysterious globes of light with the nature spirits: the devas, the elves, the fairies. . . . Some say that the balls of light are themselves an intelligence that can manifest the physical appearance most compatible with the level of understanding of each individual witness.[19]

Legend speaks of lights following people and mimicking their movements. Will-o'-the-wisps enticed travelers to try to catch them, only to lead them over cliffs or to drown in marshes. They have been known as the ghostly lanterns of trains and deceased train conductors, trooping fairies, mischievous spirits banished to the woods, wandering souls of discarnate humans, portents of bad luck, and bringers of death. They are mentioned in the works of Shakespeare and in Bram Stoker's *Dracula.*[20] The website www.ghosts.monstrous.com claims there are more than 100,000 records of will-o'-the-wisps in existence.

Gene D. Matlock, a life-after-death researcher, writes at www.mysterylights.com that he agrees with the Hindu conception of these lights as "life-consciousness." Matlock's parents remember seeing the lights throughout their lives. They credited the lights with free will and decision-making skills and said the lights hid during the day and came out at night at a definite time. Like orbs, their actions were predictable and they could be easily found if you knew where to look for them. In parts of Mexico, where it is common to bury treasure as a personal legacy, Matlock has heard the same type of light hovers over the spot where a deceased person's treasure is hidden.

I will mention lights regularly seen in Thailand here only because I have no idea where they belong, given these categories. For hundreds of years, when the moon is full during the eleventh lunar month (October), the "Naga Fireballs" rise from the Mekong River in Thailand. The event coincides with the end of the Buddhist Lent. Local legend credits Naga, a mythical serpent that lives in the Mekong River, as the source of the lights. Hundreds to thousands of red, pink, and orange balls of light come out of the river and float up twenty to thirty meters into the sky and disappear. They are reported to be anywhere from thumb-sized to as large as beach balls. The

event is an annual tourist attraction and has been videotaped repeatedly. Similar lights are seen in the Nong Suang and Nong Torn swamps and the Pak Pae River, a tributary of the Mekong. Scientists claim these fireballs are a natural phenomenon, but the cause has not been found.[21]

As you must be realizing by now, the distinctions between the many names for the many lights seen on Earth throughout history are not at all clear. But before I forsake this impossible task of categorizing the lights, I will discuss my fifth category, one that pops up frequently—visible Unidentified Flying Objects (UFOs).

Visible UFOs

Until someone absolutely identifies precisely what the balls of light are, these light balls must fall into the category of Unidentified Flying Objects, just as rainbows were UFOs until they were identified and defined. Up to ninety-five percent of UFOs are eventually written off by government agencies as IFOs (Identified Flying Objects). Some of what are often mistaken as UFOs are Venus, Mars, Jupiter, the Moon, meteors, space junk reentering the atmosphere and burning up, birds, insects, headlights on unlit roads crossing hills, chemical factories, electricity-generating stations, balloons, and aircraft.[22]

I for one am convinced governments are privy to far more information about everything from orbs to giant spacecraft than even the most knowledgeable UFO buffs. Astronauts on all the early space missions reported seeing and photographing anomalous lights near their spacecraft. At least five astronauts have gone public with these reports, but the government dismisses the lights as space debris or spatial anomalies.

An article entitled "UFO Sightings by NASA Astronauts" posted March 18, 2004, from http://perso.wanadoo.fr/metasystems/UFOSightings.html reported some of the astronauts' accounts. Major Gordon Cooper, one of the original Mercury astronauts, sighted metallic, saucer-shaped discs in 1951; a flowing, greenish UFO in 1963 during his last of 22 orbits in a Mercury capsule; and a UFO landing site in Florida recently. Major Cooper says all specialists in astronautics were sworn to secrecy but he can now reveal that "every day, in the U.S.A., our radar instruments capture objects of form and composition unknown to us." Cooper claims the authorities are hiding the evidence to prevent mass panic. Decades ago Major Cooper testified to the United Nations: "I believe that these extraterrestrial vehicles and their crews are visiting this planet from other planets."

Another Mercury astronaut, Donald Slayton, saw a three-foot-wide grey disc at about 10,000 feet. It traveled at least 300 mph, made a 45-degree climbing turn, accelerated, and disappeared.

NASA pilot Joseph A. Walker filmed five or six UFOs during his 1962 50-mile-high X-15 flight. Astronauts Ed White and James McDivitt photographed a UFO over Hawaii in 1965 from a Gemini spacecraft, but the photos were never released.

When astronauts Neil Armstrong and Edwin Aldrin landed on the moon on July 21, 1969, Armstrong says they found an alien base and were told to leave and not to return to the moon. Dr. Vladimir Azhazha reported: "Neil Armstrong relayed the message to Mission Control that two large, mysterious objects were watching them after having landed near the moon module. But this message was never heard by the public because NASA censored it."

Maurice Chatelain, former chief of NASA Communications, confirmed this story in 1979. He said that "all Apollo and Gemini flights were followed, both at a distance and sometimes also quite closely, by space vehicles of extraterrestrial origin. . . . Every time it occurred, the astronauts informed Mission Control, who then ordered absolute silence."

Astronaut Scott Carpenter is also quoted as saying, "At no time, when the astronauts were in space were they alone: There was a constant surveillance by UFOs."[23]

During World War II, pilots began seeing glowing balls of light, usually orange, red, or metallic, and sometimes as large as a small car, following their aircraft despite elaborate maneuvers on the part of the pilots to try to lose them. The vibrating lights could fly circles around the planes and also followed military ships at sea. Then the lights would suddenly disappear. Pilots reported this so often the lights were dubbed "foo fighters" after a comic strip character, Smoky Stover, who often said, "Where there's foo there's fire." (The objects appeared fiery.) Many suspected they were advanced German weapons, but German pilots had been seeing the same balls of light and attributing them to the Allies. The term "Kraut fireballs" described the same plane-chasing lights.[24] Actual military photographs of foo fighters can be found at www.ufoartwork.com.

Since I have become aware of orbs, I have noticed just as many alien abduction accounts refer to balls of light as they do to spacecraft as the first recollection of the encounter. These lights are described in nearly every color and size. They can hover or maneuver abruptly, going every which way, including traveling through solid surfaces and disappearing into thin air. An increasing number of witnesses and researchers are toying with the idea that UFOs are actually living creatures rather than craft loaded with aliens.

UFOs have been sighted for centuries, but the question of what they are is still unresolved. Clearly the similarities between actual UFOs and anomalous lights are much stronger than those between a Hollywood-type craft and a mysterious light in the sky. According to the data reported, UFOs are:

- Generally in the same wide range of colors as orbs: amber, blue, gold, green, grey/silvery, orange, purple, transparent, white, and yellow

- A variety of shapes

- Known to split apart, move erratically, and even to turn into peculiar misty clouds

- Known to follow cars and people and affect engines, batteries, and lights

- Known to display intelligence

- Sometimes invisible to the naked eye but caught on camera; others are visible for seconds, minutes, or hours in the sky

- Known to fade into and out of reality in the fraction of a second the shutter of the camera was open (like the quantum behavior of particles fading into and out of reality)

- Most often seen in rural areas (perhaps because the sky is more visible there)

- Often seen near fault lines, seismic activity, quarries, waterfalls, power lines, power stations, electricity pylons, dams, new road excavations, after bad weather, or during a full moon

- Said to be natural electrical phenomena or thought to draw their energy from electrical sources

- Seen most often at places thought to be power spots, vortexes, or "interdimensional doorways" such as Sedona, Arizona (Sedona is known as a site where UFOs are often sighted. Lately, however, "balls of light" are seen more frequently there than objects resembling metallic craft.)

- Sometimes reported to have "beings" inside of them

- Thought to be here to study us, to use us, or to help mankind

Jenny Randles lists the six most common types of UFOs in her book *UFOs & How to See Them*. The following are abbreviated descriptions of the six types. I have italicized those words and phrases frequently used to describe ball lightning, earth lights, ghost lights, will-o'-the-wisps, or orbs:

1. Accounting for 22 percent of all sightings, the "amber gambler" is *a small but distinct ball of light, larger than a star and usually orange, yellow, or red*. It is *visible for seconds to minutes* and *has appeared all over the world*. It *often hovers over power lines*.

2. The "flying football" accounts for 14 percent of all sightings and is *egg or oval shaped*. At night it is *white, deep red, yellow, deep blue, or purple*. By day, it is *dull grey or translucent white*. Usually *seen for several minutes*, it is *related to vehicle interference*, physical illness, *and energy emissions such as buzzing sounds*. It seems to be *attracted to metal*, *such as cars, power stations, and bridges*. It usually *hovers, then moves away extremely fast or disappears on the spot*.

3. The "cigar tube" accounts for 16 percent of sightings, is usually seen during the day, and is *silvery* or like polished metal. It is sometimes reported to have lines of windows or portholes and jet flames coming from the rear. It can be seen anywhere and *is visible for several minutes or longer*. Sometimes *other UFOs enter its body*, so it is often referred to as a "mother ship."

4. The "upturned plate" resembles a metallic dish turned upside down, may have lights on the base, and it often lands. It accounts for 8 percent of sightings, but hardly any pictures have been taken of this type since 1970. Several observers have noticed "*balls*" on the underside of this type.

5. The "Saturn shape" resembles an *oval-shaped* version of the planet Saturn with a central ring around it. It is most often seen in daylight as *dark or silvery* metallic. At night it is said to *emit light from the inside*. Pictures of it are fuzzy, possibly due to an *ionization field*. Eleven percent of UFO sightings are of this shape and it is *often seen near or over water*. It commonly *rotates, buzzes, discharges electricity*, and *glows on the rim*.

6. The final type, the "triangle" or conical object, accounts for 8 percent of UFO cases. It is most often seen at night as three *lights* in a triangular formation. *Colors vary at night*; during the day it is seen as *silvery* or dark. It moves slowly and can be *visible for several minutes*. It is often thought to be a new type of secret stealth aircraft.[25] (Dr. Lynne Kitei, a well-respected physician, repeatedly photographed a formation over Phoenix, Arizona, and recently published *The Phoenix Lights* to chronicle the mass sightings.)

Given all these similarities, it is not surprising many people believe orbs are alien craft. Alex Cavallari, UFO researcher and founder of UFO Paranormal Media, said on the website www.crystalinks.com that the orb "craft" come through electrical portals. Cavallari said UFOs first appear as orbs when they enter our reality. Then they can appear in any form they wish, since they can "shape-shift." These craft have electrical plasma overlays which enable them to travel through space and time. "These orbs do have intelligence and can communicate. They are there for everyone to experience."

Every day it seems we discover something else that illustrates how little we know. Scientists now think it is possible to send subatomic particles thousands of light years to other universes in a second through quantum wormholes. Given that and the growing number of eyewitnesses claiming to have seen lights morphing into spacecraft, I cannot eliminate the possibility that light anomalies are actually aliens visiting Earth.

Commonalities among the Five Categories

There are some characteristics I have noticed all five categories of visible anomalous lights and the invisible orbs share almost without exception. All of these lights:

• Have evidently existed longer than recorded history

• Can change colors, size, shape, and luminosity while being watched or photographed

• Are highly maneuverable; speed, height, and direction can vary drastically

• Are sighted most often at night and are seen occasionally during daylight, possibly due to higher visibility of lights in the dark

• Are seen in certain places more than in others

• Have been described as elusive; they move or disappear when approached

• Have been credited with *intelligent behavior*

Colors

Color was one property the many types of visible lights and invisible orbs did not seem to share. For instance, earth lights seemed to be described as warmer in color (red, orange, yellow), while will-o'-the-wisps were usually cooler (blue and purple). I found this was not always the case. I made note of the colors of each category of lights I found in my search and prepared a chart, hoping in vain to find some type of pattern. The only conclusion I was able to draw is that orbs come in the largest variety of colors. Orbs are invisible to most human eyes, though, so the colors may be a product of the various cameras rather than the orbs. As Troy Taylor, author of 30 books on ghosts and president of the American Ghost Society, wrote at www.prairieghosts.com: "Despite the sometimes entertaining notions that different colors of orbs are created by what mood the ghost is in (I'm not kidding here), these colored orbs are actually just dependent on what light refractions were present when the photos were taken."

	Ball Lightning	Earth Lights	Ghost Lights	Will-o'-the-Wisps	UFOs	Orbs
Amber		X			X	X
Blue	X	X	X	X		X
Bluish-white	X		X			X
Copper						X
Dark	X				X	X
Gold			X		X	X
Green	X	X	X		X	X
Grey/silvery					X	X
Orange	X	X	X		X	X
Pink		X	X			X
Purple	X			X	X	X
Purplish-red	X					X
Rainbow/ multicolored						X
Red	X	X	X	X	X	X
Transparent	X				X	X
White	X	X	X		X	X
Yellow	X	X	X	X	X	X
Yellowish-green			X			X

I considered comparing these colors to the colors of the rainbow or of the chakras, but I ran into the same problem with orb colors that I had years ago with the colors found in auras—everyone has a definite opinion about the meanings of the colors, and no two opinions are identical. In fact, many are not even similar. Nevertheless, most of my sources thought colors were of utmost significance. Psychic Chance Wyatt believes spirits can take on any shape but not any color except for their true color. He wrote: "[C]olor plays a very important role in both the earth world and the spirit world. However, the role is most important in the spirit world. In the spirit world, color is the main awareness symbol."[26]

Wyatt ranked transparent "globulars," his name for spirits in the shape of orbs, as the least aware. (He maintains that all light forms should be called globulars, since that name implies they can change shape.) Wyatt said the transparent orbs are not evolved to the level of the colored globulars but are progressing. Yellow globulars were on the lowest level of the evolutionary scale and in the stage of learning or intellect. Pink, gold, and red were the next three colors, but it was difficult to tell in which order he placed them. He called pink the level of compassion; gold indicates they are well along in their evolution; and red is the color of strength. He ranked blue as the most aware, saying these globulars had lived many lifetimes and were very high on the evolutionary scale.[27]

Franz Bardon, occultist, magician, healer, and author, called orbs "spheres" and thought they were elementaries or thought-forms created with the elements (see chapter 18). When making an elementary from the fire element, he wrote, you create a fiery sphere. (Occultists create elementaries to perform prescribed missions.) The water element's sphere will look like glass. The air element will create a bluish-green sphere, and the earth element's sphere will be the color of clay.[28]

As strange as this sounded to me when I first read it, I later realized the majority of the orbs Peter and I have photographed have been white, red, clear, blue, or clay-colored. This type of coincidence I have run into with regularity is what has kept me passionately interested in the mystery of these lights.

There is also some research being done by Carol Gist of GhostLabs Research Society (www.ghostlabs.com) that seems to indicate the fluorescent images of spirits of particular people take on specific colors related to their cause of death.

Later, in chapter 11, I explain how the Tibetan Buddhists believe one takes on a "body of light" at death. This light takes on a color depending upon where you will be reborn. The choices are the dull white light of the gods, the red light of the pre-tans, the blue light of the humans, the green light of the animals, the yellow light of the hungry ghosts, or the dull smoky light of the hells.[29]

Michael Newton, Ph.D., holds a doctorate in counseling and is a state-certified Master Hypnotherapist in California. Through his age-regression techniques, he has learned how to take his clients into the time spent *between* lives on Earth when they assumed the shape of orbs. Dr. Newton stresses that no soul is considered of less value than any other soul in the spirit world, but he found the colors of souls meaningful:

> These colors relate to a soul's state of advancement. . . . I found that typically, pure white denotes a younger soul and with advancement soul energy becomes more dense, moving into orange, yellow, green, and finally the blue ranges.[30]

Dr. Newton learned from his subjects that the blue colors are the highest levels being incarnated at this time. Deep blue with purple, purple, and deep indigo are the most highly evolved. He describes these as soul colors, not human auras. Human auras are determined by one's physical and mental health.[31] In the spirit world, Dr. Newton's patients describe teachers as yellow or blue spheres. Some are reddish, but none are green. The more knowledge a spirit has, the darker the color of his light.[32] One subject described white as the base color for all souls, and the other colors mixed with white identified each soul.[33]

Newton's colors rang true to me because they resembled the order of colors in the rainbow and chakra colors—well, at least some of the chakra color charts. Rainbows and chakras may have nothing in common with orbs, but finding any similarities of any type in this orb search of mine is like comfort food to me. I found some other color breakdowns in books and on the Internet, but these will serve to show how confusing the interpretation of orb colors can be.

Colors become more interesting when you add all the other wavelengths of light that are not visible to the human eye. "Invisible" rainbows exist within the infrared spectrum, and became visible to us when infrared-sensitive cameras were invented.[34] Light is measured according to the length of its emissions or rays. The typical human eye can detect light from 390 to 770 nm (nanometers) and we see this energy as colors, from violet at one end to red at the other. We cannot see a whole other world of lights with wavelengths above and below the magic numbers of 390 and 770.

The Electromagnetic Spectrum

"Invisible" Light	Visible Light	Notes
Gamma rays		
X-rays		
Ultraviolet rays		
	Violet rays	390 nm
	Blue rays	
	Green rays	
	Yellow rays	
	Orange rays	
	Red rays	770 nm
EHF (Extreme High Frequency)		Satellites, LMDS short-range TV systems, microwaves
SHF (Super High Frequency)		Microwaves
UHF (Ultra High Frequency)		Microwaves, radio waves
VHF (Very High Frequency)		Radio waves, TVs
HF (High Frequency)		Shortwave radio waves
MF (Medium Frequency)		AM radio waves
LF (Low Frequency)		Early radio waves
VLF (Very Low Frequency)		Undersea communications
ELF (Extremely Low Frequency)		Telephones

Supposedly, you can test your ability to see infrared light by looking at the end of your television remote control as you change channels. The remote communicates with the TV through an infrared beam of light. If you looked at it with a night vision scope, a night shot video camera, or an infrared monitor, however, you should see the

little red flashes. I tested this by taking many pictures of our TV remote control as my husband changed channels constantly. My camera did not capture any light coming from the remote. I did notice, though, that in a few of the pictures, our dog was staring where the light was expected to be.

Some commercial films are less sensitive and detect a smaller range of light than the human eye. For instance, our eyes can detect wavelengths of light that a camera using slow 50 ASA film would miss. Hence, faster 400 or 800 ASA films are recommended if paranormal results are your goal. Digital cameras can reach into the infrared light range where orbs at that wavelength would be invisible to us. Camcorders designed for low-light conditions and night scopes make it possible to photograph the "invisible." There are so many lights we cannot see in the ultraviolet and infrared spectrums that for every light we *can* see, there may be dozens that we cannot see.

If I am not missing something obvious, it seems most if not all of the lights described in the last two chapters, visible or invisible, could be the same lights but radiating different wavelengths. Some discount any lights that can be shown to be from natural causes, but think about it: Everything has a natural cause.

Orb photographers are constantly amazed at how orbs can change position, shape, and color instantaneously, disappearing and reappearing at will. Rather than retreating into some other dimension, as many others, including myself, have suspected, perhaps they merely change the length of their light waves.

Also, psychic ability could be the result of sensitivity to wavelengths of energy above or below the usual visual spectrum. Auras, which can be seen by some psychics, are unique electromagnetic fields which some people can detect more readily than others.[35] Like germs, what we cannot see could be affecting our lives more than we know.

6 Vortexes

The vortex, essentially a whirlpool of force, is the basic form of the universe. The rotating, spiraling motion of toilet water going down the drain is a common vortex. The swirling funnel formation that my camera captured when Libby Lou was put to sleep is most commonly called a vortex by paranormal photographers. Like orbs, vortexes (the plural form of vortex can be either vortexes or vortices) are thought to be electromagnetic in nature.

Other names used to describe the same phenomenon are funnel ghost, dryer hose, wormhole, spiritual ley, and dimensional portal. The funnels can be of varying sizes and lengths and are usually white or white and black, but have also been grey, pink, yellow, blue, or purple. They can appear to be solid, opaque, clear, transparent, or translucent, and are caught on film far less often than orbs.

Pictures of camera straps are most likely to be mistaken as vortexes. Most camera straps appear as white or black funnels on one side of the frame with lines inside it. If you can see the end of the vortex in the picture or if there is more than one vortex in the shot, it is not a camera strap.

Many times it is difficult to determine whether long streaks of light are vortexes, orbs moving at a very high speed, or a host of baby orbs attending a convention. All three scenarios can look like a solid white line and can have a treadlike design within their body. A vortex can lie horizontally or vertically in the picture and may or may not cast a shadow. They are almost always detected inside homes and old buildings and are rarely photographed outdoors (other than in Peter's backyard apparently).

Recall figure 12, a head-on, inside view of what appears to be a vortex taken at the mysterious southeast corner of Peter's house.

Ghost hunters seem to agree that spirits and ghosts come through some sort of portal or vortex into our dimension. In his *The Everything Ghost Book*, Jason Rich defines vortexes as concentrated forms of energy that can make your hair stand at attention. He writes:

> A vortex is a mass of air, water, or in this case energy, that spins around very fast and pulls objects into its empty center. Some believe that energy-based vortices have paranormal origins.[1]

The International Ghost Hunters Society (IGHS) defines a vortex as the vehicle orbs use to travel collectively. They contend the orbs swirl together into the shape of a vortex like a tornado. Dr. Sharon Gill wrote in the November 10, 2001, *IGHS Newsletter:*

> We found orbs and vortices had mass and density; they cast shadows. Upon looking more closely at the patterns within the vortices, we started to see that at a higher resolution, the vortices contained orbs within them. It appeared to be multiple orbs within a "wormhole" or tube of intense energy and moving at an incredible speed.

Most of the definitions I found gave vortexes some sort of role in transporting spirits between dimensions. The tunnel many near-death experiencers remember passing through could be a vortex or portal that leads to the Light nearly every experiencer recalls. *The Encyclopedia of Ghosts and Spirits* says of portals:

> An explanation for at least some hauntings favored by many ghost investigators is that of the "portal," an opening to other dimensions that allows spirits to enter the physical world. Belief in portals is ancient and universal. Certain places that are sacred serve as natural portals. Wells have often been recognized as natural entryways for spirits. Other portals can open at places associated with the dead, such as cemeteries, battlefields, and natural disaster sites; places associated with trauma and intense emotions, such as hospitals, hotels, schools, churches, and theaters; and lonely places such as lighthouses.[2]

Various new-age sources claim there is a strong deviation in the Earth's magnetic field in such areas as Mount Shasta in California; the Teton Mountain Range in northwest Wyoming and southeast Idaho; the Oregon Vortex in Gold Hill, Oregon; the Black Hills of South Dakota; four "vortexes" in Sedona, Arizona; the Great Pyramids in Egypt; Stonehenge in England; Machu Picchu and the Nasca lines of Peru; Mount Fuji in Japan; and parts of the Yucatán in Mexico. These places are often called power spots and are thought to be conducive to all manner of paranormal activity. Ancient cultures are known to have chosen these locations as sacred pagan worship sites and are said to have constructed all of the Earth's pyramids on such power spots.

Vortexes around the world are given credit for spontaneous healings, enlightenment, deformed vegetation, the disappearance of planes and ships in the Bermuda Triangle, equipment failure in airplanes flying over the Great Pyramid of Giza, and paranormal photographs.

Human chakras are said to constantly spin like an energy vortex, which could be why they are said to be used to transcend this ordinary dimension. Libby's vortex does seem to connect dimensions. Figure 43 (center section) is the only picture I have taken where orbs, a vortex, and ectoplasm all appeared in the same shot, and it is hard to distinguish which is which. Also notice that the brightest orb on the ceiling is partially hidden behind a fluorescent light (see figure 43a, center section). I saw the whole formation in the viewfinder as I took the shot, just as I did with figure 50, which caught a strikingly similar formation. Figure 43 was taken between the first and second of three Sunday services at the Living Enrichment Center in Wilsonville, Oregon, on December 29, 2001. Orbs appear to be inside the vortex and may even be coming out the lower end of it.

There are two or three pictures on the Internet in which you can vaguely see a humanoid form inside a cloudy "tube." Those humanoids bear a slight resemblance to the shape at the top of my picture, only, instead of traveling inside a vortex, mine has orbs inside the figure. So is the form in figure 43 an ectoplasm or a lot of little vortexes? Or were my orbs staging one of their demonstrations just to let me know they cannot and will not be defined?

When I looked through my old photos, I found an old 35mm shot (figure 44, center section) that clearly shows a swoosh as my granddaughter Ryenne fell off her toy horse and her other grandparents scrambled to catch her. I cannot decide if this one is one of my fingers or a vortex. Please compare it to figure 45 (center section), which cannot be a finger photo and decide for yourself. The puppy in the picture was also in a crisis of sorts. Peter's Aunt Pat took it just after her husband Chet fell ill, and, fearing Chet might step on the pup, they decided to take their new puppy back

to its original owner. These two formations and Libby's vortex all appeared at a time of crisis and emotional need.

Witnesses have felt and scientifically measured cold spots where vortexes are sighted or photographed. Dr. Dave Oester of IGHS has measured the opening and closing of these interdimensional portals with frequency counters that detect radio signals in the air. He says a person inside this portal can suffer from migraines, light-headedness, and a significant drain of energy.

I felt nothing extraordinary while in the room with Libby's vortex or when photographing other vortexes, and neither has Peter. I just may be an insensitive clod, or all persons nearby may not always feel the energy from a vortex. Perhaps one needs to be inside or touching the vortex to feel the effects.

A large percentage of vortex photographs seem to have spirals circling within the vortex. The spiral has historically been a very spiritual sign. I read on www.crystalinks.com/ghosts.html: "The more detailed the rings are on the spirit image—the more evolved the ghost/spirit."

It seems whenever someone tries to set up a "grading system" for spirituality, there is another theory floating around that contradicts it. In this case, I found sources who just as adamantly insisted the older the spirit, the more solid its vortex, and a solid vortex does not have visible rings or spirals.

Reverend Dorothy Leon was raised as a Jehovah's Witness. She told me the Witnesses believe there are thirty-three spirals in one's ascension to heaven. I've been counting spirals in vortexes ever since.

Westinghouse Laboratories found that artificially produced lightning flashes actually formed spirals rather than zigzags. The ancients may have known this as well, for the Chaldean Oracles of Zoroaster speak of the Supreme Spirit as "the God who energizes a spiral force."[3]

Shortly after Libby's passing, my sister Ellen read *Beyond Obedience* by April Frost and Rondi Lightmark. In the final chapter, April Frost described putting her beloved dog Strut to sleep with her Reiki class members gathered around. She wrote:

> We were amazed when a number of us recounted that, just as Strut's soul left, it had looked as though a *wisp of smoke* had risen up from his chest, taken the form of a bird, and disappeared into the sky.[4] (Emphasis is mine.)

This account did so much to validate the spiritual significance of Libby's passing that I sought out and found many similar stories of vortexes or ectoplasm rising from people who had just died.

In the chapter entitled "Bride of Nob Hill" in Hans Holzer's *Haunted America*, Gwen Hinzie saw her father die in 1941. When he stopped breathing, his hand relaxed and a white vapor ascended from the opening hand and disappeared. She understood it to be the release of the soul from the body.[5]

Chance Wyatt writes in *Spirits Visit Earth*:

> There are some people who were fortunate to see the spirit of one who just died. At first they appeared as faint smoke. The spirit then took on their human appearance and left with the take-away spirit or spirits.[6]

In her workshops, Vicky Thompson, author of *The Jesus Path,* has said:

> [I]t's easy to understand why some people have seen white light or images of doves rising from a dying person. When we die, our emotional, mental, and spiritual bodies join together energetically as spirit and move into the spiritual realm.[7]

Among the Pueblo Native Americans of the southwestern United States, a Kachina is a supernatural being or spirit of the ancestral dead who serves as an intermediary to the gods. The Hopi believe their dead go to the sacred mountains, where they become Kachinas and are transformed into clouds. The Zuni call Kachinas *Koko.* The Koko, according to legend, visit the living as clouds.

Beth Pinzok wrote in an article on www.ghostweb.com that she has been a nurse in nursing homes for eight years and has seen many patients pass on. One lady had a white "wisp" come out of her forehead at death. She said it looked like a "tiny white tornado." Another nurse with her, however, saw nothing. She has seen what she thinks is the soul leaving the body a few other times. She writes:

> Sometimes it's a spark and sometimes it's just a sluggish white form. I know that it has to be the soul because immediately after I see it, the person takes their last breath, maybe one more reflex breath, but it's always right after I see it.

Pinzok has found that a dim room is the best place to see the soul leave the body. She says to "just look right at the forehead."

The Encyclopedic Psychic Dictionary by June G. Bletzer defines "death hormone" as "an invisible substance emitted by the endocrine glands during the process of death"

and "death glow" as "emanations of light that seem to glow from the top of the head of the individual who is going through the process of death." This light, Bletzer claims, "can be perceived clairvoyantly by those close by."[8]

The Encyclopedia of Ghosts and Spirits says under "Deathbed Visions":

> Related to a deathbed vision of the dying is a deathbed vision seen by the living who are in attendance to the dying. As the person dies, *clouds of silvery energy* are sometimes reported floating over the body. In some cases the energy is seen to clearly form into the astral body of the dying one, connected by a silvery cord which severs at the moment of death.[9] (Emphasis is mine.)

The same encyclopedia says of "Spirit":

> Medium Arthur Ford defined spirit as "nothing more than the stream of consciousness of a personality with which we are familiar in every human being." This, said Ford, is what survives death, not as a spiritual wraith, but as an *"oblong blur."* Ford drew his views from the writings of St. Paul, who wrote of a spiritual body. Ford's own control, Fletcher, called the spirit the "risen" body which one takes up after death, and which does not age and has no physical defects. After death, the spirit takes a perfect spirit body that is mature: the old grow young and the young mature. The spirit body has no clothes in earthly sense, but is a *garment of light and a projection of thought.*[10] (Emphasis is mine.)

My mother had a significant deathbed experience. She was present when her grandmother died almost seventy years ago. Mom remembers seeing her spirit in the form of a sort of swirling mist that rose above the body and floated out of the room through a closed window. She looked at two other relatives in the room to see if they saw the same thing. They were eating chocolate covered cherries and chatting as though nothing had happened, so Mom didn't mention it.

My mother and I have always had a silent understanding of such things—silent because any mention of the paranormal sent my father (bless his negative little heart) into a name-calling snit we preferred to avoid. Mom has promised to appear to me when she passes and (this was her idea) say, "Boo!" I never want to lose my dear mom, but I suppose I must, at least temporarily. I just hope I have a camera in hand when she comes back!

I can see why some people are extremely sensitive about cameras being at deathbed scenes, accidents, and funerals because they don't want to remember loved ones in that condition. One branch of my family is horrified when Peter, Ellen, and I arrive at hospitals and funerals with cameras in hand. But cameras capture so many more light anomalies than the naked eye can see that I can't help feeling if there were more pictures taken just before, during, and after death, we would have far more believers in an existence after death and a more spiritual and civil society as a result.

7 Ectoplasm

"Man is in the process of changing, to forms that are not of this world; grows he in time to the formless, a plane on the cycle above. Know ye, ye must become formless before ye are with the light."

—*The Emerald Tablets of Thoth, Tablet 8*[1]

Ectoplasm is the most Hollywoodized term of them all, but it seems to be a permanent fixture in the vocabulary of paranormal fans. During the Spiritualist movement in the early twentieth century, ectoplasm was the word used for the "stuff" that came from the stomachs, hearts, mouths, ears, throats, or noses of mediums when they contacted the spirit world, or it was seen as a yellow-green hue around a ghost's body. Breathing or exuding it was considered a sign of being in contact with the supernatural world.

Charles Richet, French professor and Nobel Prize winner, coined the word from the Greek *ecto* (exteriorized) and *plasma* (substance). It has also been called Substance X and teleplasm. Richet spent thirty years studying mediums in the early twentieth century and concluded spirits took ectoplasm from the medium and the sitters and returned it to their bodies after the contact.

Ectoplasm is described as a solid or vaporous, dense but liquid, cold and moist milky-white substance that smells like ozone. Richet concluded that even when ectoplasm is initially invisible, it can be weighed and photographed with infrared rays and seen with infrared viewers. It then becomes liquid, solid, or vaporous before it

can be seen and felt. Richet found ectoplasm is extremely sensitive to light and its temperature is usually around 40° F. The low temperature of the ectoplasm theoretically causes it to form a mist as it enters our warmer atmosphere. Richet's experiments have been subsequently verified hundreds of times.[2]

Other researchers determined the mediums actually lost weight when materializations formed. Early infrared photographs captured ectoplasmic voice boxes or trumpets fully formed on mediums such as Leslie Flint, Leonard Stott, and "Margery," the wife of a surgeon.[3]

Accusations that some of this "spirit residue" was faked for the public in séances and divining rooms, that mediums swallowed and regurgitated cheesecloth and such, cast all ectoplasm into serious doubt. Moving through ectoplasm was once said to be the cause of illness or possession. And as if that weren't damaging enough to ectoplasm's reputation, the movie *Ghostbusters* portrayed ectoplasm as slimy goop that ghosts slop everywhere.

The ectoplasm seen in today's photographs is also called ecto-mist, vapor, and ghostly mist, and sometimes it resembles some of the less impressive photos of ectoplasm from the Spiritualist era (see figure 54 in chapter 10), when pictures of full-bodied ghosts got all of the attention.

Ectoplasm is a cloudy, vaporous fog or mist, with or without swirls, that resembles cigarette smoke or a person's breath in very cold weather. It is almost always grey, white, or black. While vortexes are normally seen indoors, ectoplasm is usually seen outdoors. Ectoplasm sometimes takes on the vague shape of all or part of a person or animal (see figures 43, 47, 48, and 50). In many pictures, orbs appear amidst, through, and around the ectoplasmic mist. Some think the ectoplasm changes shape to make orbs, while others think orbs expand to form ectoplasm, and still others believe ectoplasm is a formation of speeding orbs. Spirits are thought to take on a vaporous form before becoming full-bodied apparitions.

Dr. Raymond Moody's book *Reunions: Visionary Encounters with Departed Loved Ones* deals with learning to contact the deceased by gazing into reflective surfaces. Over and over, different subjects described seeing what I would call ectoplasm in the mirror they were contemplating:

"I saw many clouds and lights and movement from one side of the mirror to the other. There were lights in the clouds that were changing colors also."

". . . as I gazed into the mirror, a sort of filmy, smoky substance came across the glass. Then out of this mist there was a figure forming and sitting on a sofa of some sort."

"I saw this mist in there . . . it looked like smoke to me."

"I saw this big mist just come in and fill up the whole mirror, just like a big fog blowing right up over the window, and after the mist was a bright light."

". . . the mirror was clouding up with mist, like swirls of fine dust."

"There were colors mostly at first and pretty clouds."

"There was a kind of smokiness around her."

". . . the whole scene turned to a fine mist and she disappeared."[4]

In *Heaven and Earth,* psychic James Van Praagh describes the materialization of a spirit onstage at a healing in Brazil. He saw "a small, wispy cloud take shape in the center of the stage." After what seemed like hours to him, the cloud took the shape of a man he was eventually able to touch and Van Praagh found the "man" was as solid as any human.[5]

Citta tattva, described in the Yogic tradition, is the part of the mind where perception and memories are stored. The *citta* (mind-stuff) is described as ectoplasm, made of mental and biological waves. When focused, it can reportedly create what is often perceived as a ghost or vision.[6]

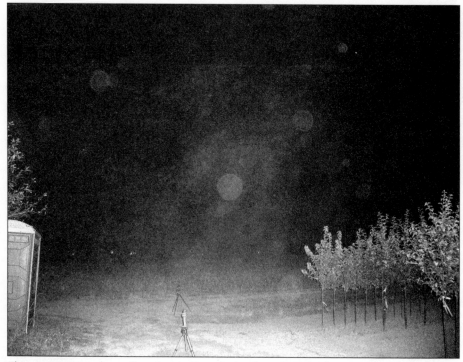

Figure 46: Ectoplasm forming in Peter's backyard. Ectoplasms seem to me to be made of orbs that look very much like dust orbs before the ectoplasm forms. © 2001 by Peter Clemmer

Figures 46, 47, and 48 show three of the ectoplasms that appeared for Peter's camera in his backyard. His ectoplasms were nearly always preceded and followed by masses of faint orbs.

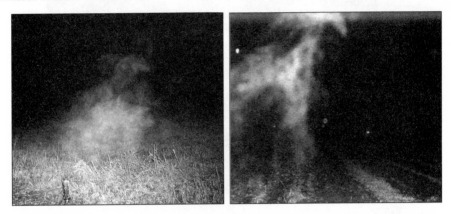

Figures 47 and 48: Ectoplasms in Peter's backyard. For reasons unknown to me, many of our ectoplasms resembled animals. © 2001 by Peter Clemmer

Figure 49 is an ectoplasm that formed in my front yard with Max and my grandson Christian just seconds before the formation in figure 50 developed. Max may even be watching it form.

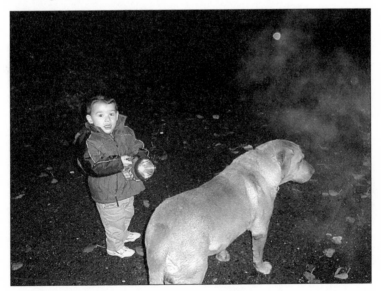

Figure 49: Ectoplasm forming with Christian and Max.

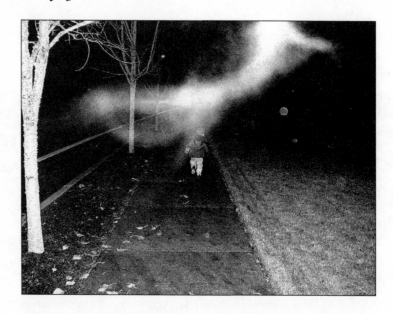

Figure 50: Ectoplasm with Christian, taken seconds after figure 49. Note the intriguing similarities between figures 43 and 50.

Figure 51 is the only photo of an ectoplasm that I possess taken with a 35mm camera. Jacque and Aubrey are members of our spiritual group. Aubrey took this photo of Jacque and baby Joey on a warm, clear day.

Figure 51: Joey and Jacque Harley on warm, clear day with ectoplasm. Taken with 35mm camera. © 2002 by Aubrey Harley

The similar shapes of Peter's and my more concentrated ectoplasms are intriguing. Peter's tended to resemble vaguely reptilian animals (figures 47 and 48) while mine (figures 43 and 50) look like animals or angels, depending on the viewer. I cannot speculate on the meanings of these shapes, or lack thereof.

Most paranormal photographers I've communicated with consider ectoplasm and orbs to be animals of a different stripe. They feel orbs represent one type of anomaly and ectoplasm a totally different phenomenon. Peter and I took too many pictures where orbs seemed to be changing form into ectoplasm to agree. Whatever orbs may be, I suspect they are capable of shape-shifting into any form they wish—ectoplasm, vortexes, shadow ghosts, or apparitions.

8 Shadow Ghosts

"Darkness and light are both of one nature, different only in seeming, for each arose from the source of all. Darkness is disorder, light is order; darkness transmuted is light of the light."
—*The Emerald Tablets of Thoth,* Tablet 15[1]

I tried to squeeze shadow ghosts in with another category, but they seem to be a separate mystery and deserve their own space. They are sometimes called shadow people, dark entities, or dark matter, and are easy to confuse with actual shadows in pictures. They look like a form of ectoplasm or perhaps a vortex, but they are more like a shadow. They may even be the shadow cast by a vortex or ectoplasm. I have read that people have seen them out of the corner of their eyes, in a mirror, or as they dart through a wall.

I know shadow ghosts exist because, unlike most of these anomalies, I have seen one with my own eyes and, besides the black spot in Libby's vortex, I have also taken a picture of another one that no one saw at the time. In 1984 my ex-husband's 38-year-old cousin Jake died at our house from his second massive heart attack. Jake was a guy who loved people and thoroughly enjoyed life. You couldn't help but like Jake. He insisted on riding one of our son's motorcycles in our pasture and collapsed from a heart attack far from the house. As my ex-husband and I performed CPR, the other people on our party line—some kids—refused to hang up for my sons to call for help. Finally, the ambulance arrived and became hopelessly stuck in our field. Jake never

regained consciousness. His wife and two of his daughters witnessed the scene and that day was possibly the most horrible of all of our lives.

I was exhausted by the time I got to bed but couldn't sleep. I looked into the hallway and distinctly saw what I could only describe as a grey shadow about Jake's height, slightly elevated off the floor. It was in middle of the hallway and moving towards our bedroom! The spiritual potential of the moment escaped me. Instead of seizing this chance to "see beyond the veil," I hid under the covers for a very long time, and, when I came up for air, the shadow was gone.

After the funeral several days later, I took a picture of my ex-husband holding a plant from the funeral and a portion of a light grey vortex appeared in the upper right-hand corner of the developed print. The sun at that time would have been far to the left side and much lower than the upper corner, and it was even hidden behind trees. I immediately thought the shadow was Jake.

I didn't say much to my sons, who were eleven and twelve at the time. It wasn't until a couple of years later that my oldest son, Dan, said he, too, saw Jake in that same hallway that night, only he got up and talked to him telepathically. Dan described Jake as a shadow.

Two weeks before his death, Jake caught his first two salmon in our boat and shocked everyone by saying, "I've finally caught some salmon. Now I'm ready to die." I didn't write a date on the back of the next picture (see figure 52), but I can tell by the order in the album that it was taken on our next fishing trip after Jake's funeral. We were in the middle of Timothy Lake. There was no possible source for that shadow anywhere near us. It appears that Jake came along for one more fishing trip with us—as a shadow ghost that looked much like the other two, only darker.

I didn't connect that photo with Jake until very recently. I must admit my first thought when I discovered that shadow picture was that it possibly portrayed something evil. Shadow ghosts are often considered demonic because they are dark, but there is no evidence of this. We are conditioned to think of white in terms of light and goodness and black as evil and foreboding. Rationally, we know this has no foundation in truth. Our egos are always urging us to label everything either "good" or "bad" and trying to find a way to feel we are "better" than the next guy. Black is just a color, not an evil condition.

I have read that most shadow ghosts appear in homes. Some are found outdoors but usually at a distance. As usual, rebellious Jake didn't follow the rules.

Figure 52: My son Ben and his father on Timothy Lake in 1984 with brook trout and shadow ghost. Taken with a 35mm camera.

Peter has also taken pictures of shadow ghosts, all in the presence of his granddaughter McKenzie, at least up until this writing. Figure 53 pictures McKenzie with her neighbors and a shadow ghost playing on Easter 2002.

Figure 53: Shadow ghost joins the fun on Easter 2002. © 2002 by Peter Clemmer

9 Apparitions

Also called disembodied spirits, ghosts, specters, residue, and wraiths, apparitions can be anything from a real-appearing human form wearing clothes from another time period to transparent, incomplete, fuzzy, luminous, wispy, disfigured, headless, or bodiless human or animal forms that usually appear for just a second, then fade away.

A photograph of an apparition is what every ghost photographer aspires to but seldom gets. They are extremely rare and few pictures of apparitions are considered authentic. (I can't think of any that are accepted without doubt worldwide.) Even when witnesses claim to see an apparition, it will not normally appear in a picture. They are more often sensed, felt, smelled, or heard, and are more likely to appear as streaks, balls, or patches of light (which would fit into the previous categories) than as recognizable human figures.

Apparitions are indistinguishable from other light formations, except for their form. According to *Harper's Encyclopedia of Mystical and Paranormal Experience:* "Some apparitions seem corporeal, while others are luminous, transparent, or ill-defined. Apparitions move through solid matter and appear and disappear abruptly. They can cast shadows and be reflected in mirrors."[1]

Crisis Apparitions

Apparitions are usually seen only once. Those that appear again and again are more often called ghosts than apparitions. Surprisingly, apparitions of the living,

called *doppelgängers* or doubles, are seen more often than apparitions of the dead. Tens of thousands of cases have been studied by psychical researchers, parapsychologists, and others since the late nineteenth century and 82 percent of apparitions have been found to manifest in order to deliver a message or warning to a living person. These are called "crisis apparitions."

The Christian religion has had its crisis apparitions of religious figures, such as angels, saints, the Virgin Mary, and Jesus. Some were collectively seen by hundreds. These figures, who appeared with warnings and messages, are considered holy and sent from God. All other apparitions, however, including spirits of the dead, are judged by most Christians to be delusions created by Satan or his demons to tempt or confuse people.[2]

Collective Apparitions

The same figure seen by two or more persons is called a "collective apparition," and there have definitely been enough of these to suggest they actually exist. Approximately one-third of apparitions are seen collectively. Even dogs and cats are said to be frequent "witnesses." Every civilization throughout history has had its own accounts of apparitions and sightings. Séances were fashionable at the end of the nineteenth century and are becoming popular again today. A true sign of a successful séance is the materialization of an apparition.

Hans Holzer, who has written more books on ghosts than anyone I know of, wrote in *Ghosts: True Encounters with the World Beyond* that materializations are three-dimensional and physically substantial. He says ghosts reside in a duplicate "inner body" or etheric body. When there is enough energy to cover the etheric body with the ectoplasm mysteriously taken from the glands of the medium or others in the room during a séance, an apparition can appear. They look and feel like actual bodies, but Holzer says touch or bright lights can make the apparition disappear and even harm the medium. The ectoplasm must return from whence it came to prevent shock and illness to the originating person.[3]

Finding that explanation helped me understand why some "psychics" have a deathly fear of being photographed while in a trance. *Harper's Encyclopedia* says:

> Another similarity between shamanic and Western séances is the belief that to disturb the shaman/medium before the séance is over, such as by turning on a light or interfering with the spirits, will jeopardize his or her life.[4]

However, I have witnessed several trance mediums, evidently unaware or unaccepting of this superstition, who have conducted entire sessions in bright light with cameras flashing and with no apparent ill effects to the medium. I must admit, though, that none of these sessions produced any materializations. Holzer claims ghosts are harmless and that only our own fear of them will hurt us. I suspect these rules about light came from the fraudulent mediums who did not want anyone seeing, touching, or photographing their living, breathing accomplices or ectoplasm made of cheesecloth. The human eye in darkness is easier to fool than the eye of the camera or the sense of touch.

Haunts

A place where independent witnesses see the same ghost is called a "haunt." Older homes, hotels, theaters, historical sites, and cemeteries are thought to be haunted more frequently than other places. Some ghosts seem not to notice living people, others delight in scaring the living, and still others seek help or guidance. The ghosts who seem oblivious to their surroundings are often called "psychic imprints." Eastern mystical philosophers believe all events, thoughts, emotions, and desires are recorded forever on an invisible substance called the "Akasha." (Edgar Cayce and others call it the Akashic Records.) If this is true, then psychically tuned individuals could conceivably glimpse into this record and see "playbacks" of emotionally charged events. "Psychic ether," which is often given as the cause of apparitions appearing on film, could be just another name for ectoplasm.

HOPE (the Hartford Office of Paranormal Exploration in Connecticut, www.haunt.net) describes the formation of an apparition as a process that begins with many orbs forming a "light rod." It then becomes a dense, white fog as the entity becomes stronger, and a form will take shape. The group has taken pictures of human arms and torsos amidst a fog. They claim ghosts can be as substantial and real-looking as a living person.

There usually is, however, a telltale glow surrounding the entity which helps differentiate it from the living. Although usually white in color, we have seen photographs of red-, black-, and gold-colored energy. . . . [O]n a single roll of film we have observed color changes where all other factors remained constant.

There does seem to be enough in common among orbs, vortexes, ectoplasm, shadow ghosts, and apparitions for them to be different stages of the same process.

Their appearance seems to be dependent upon the amount of energy available to them in their surroundings and their skill or determination in making themselves visible.

As with every topic in this field, there are more theories than proofs about apparitions. Some propose that apparitions are merely etheric images produced by the subconscious mind of the living, with or without the cooperation of the witness(es). Or they may be the astral bodies of the witnesses themselves. (Astral bodies are nonsolid duplicates of a physical body that serve as vehicles of consciousness in near-death and out-of-body experiences.) Or they may be pictures of tragic events trapped in the psychic ether between reality as we know it and the world of spirit. They could be projections of an unresolved feeling of guilt or an unconscious wish of the witness's unconscious needs, thought-forms created by concentration (more widely believed than you might think), or just maybe they could actually be spirits of the dead who are trying to communicate with the living.[5]

10 History of Paranormal Photography

Paranormal photography, also called spirit, ghost, or psychic photography, is nearly as old as photography itself. Nicephore Neipce took the first, nonparanormal photo in 1822. This was followed closely by the serious study of parapsychology in the late 1830s and 1840s, when photography was gaining popularity.

An engraver named Richard Mumler is generally accepted as the first spirit photographer since a New York City court dropped charges of fraud against him in 1869. Beyond that, every account I have read about Mumler has been so contradictory, I have no idea if his photographs of ghosts appearing along with the picture's subject were legitimate or fraudulent. As in everything paranormal, there are the believers and there are the nonbelievers and it seems never the twain shall meet.

I have no firsthand knowledge of the conditions under which any early spirit photographs were taken, so I am not qualified to judge them. I just know I have never gotten any humanlike additions in my photos. Personally, I would have pronounced one of many photographs taken before Mumler as the "first." On March 8, 1855, a daguerreotypist from New Orleans took a picture of his two-month-old son on his grandmother's knee. German author Dr. Dr. (yes, Dr. Dr.) Rolf H. Krauss writes in *Beyond Light and Shadow:*

> A broad patch of light issuing from a point resembling a cloud appeared on the photograph and extended up to the child's shoulder. No plausible explanation could be found for this phenomenon.[1]

At about the same time, a New Yorker named Henry Hebbard photographed his ten-year-old son. In this photo, a bright light in an elliptical shape stretched across the boy's chest and ended on his right arm.[2]

Why would I choose those pictures over Mumler's? Because they more closely resemble the photographs I have taken and know to be genuine. The earlier photos that got the most attention, and were often found to be fraudulent, were those in which figures of recognizable deceased people that looked like cutout paper dolls appeared in the pictures.

Arthur Conan Doyle, of Sherlock Holmes fame, investigated the most famous of the early photos. Five photographs of the Cottingley Fairies, taken by two young English girls in 1917 and 1920, were evidently pictures from *The Princess Mary's Gift Book*, published five years before the pictures were taken, and owned by one of the girls. As a prank that got out of hand, the pair had copied the drawings, added wings, glued them onto cardboard, cut the fairies out, fastened them to the grass with hatpins, and taken pictures of each other with the cutouts.[3]

From here on in, I am limiting this history to the few photographers whose photos resemble the orbs and ectoplasm of pictures being taken today. This chapter will be brief.

Most spirit photographs that have withstood the test of time are foggy, ill-defined pictures of parts of bodies rather than clear, head-to-toe photos of fully clothed ghosts. Pictures of spheres and mists like mine did not get the consideration they deserved because they were not as dramatic and clear-cut as the lifelike figures of so-called ghosts and fairies.

Peter Underwood is the life president of the Ghost Club Society and author of 45 books, mostly concerning ghosts and the occult. Underwood, possibly the most celebrated British ghost hunter, found most nineteenth-century spirit photographs were underexposures, double exposures, and photographs of paper reproductions and balls of cotton. Underwood writes:

> [F]raud and malobservation have long been so prevalent in the field of so-called psychic photography that serious attention has been diverted from those rare examples that may well be genuine photographs of spontaneous ghosts.[4]

In my research I also found accusations of using accomplices, making invisible sketches with quinine sulfite, and regurgitating cheesecloth that was swallowed before séances. Eventually, only ministers, doctors, and the wealthy were accepted as

legitimate paranormal photographers. Others, many of whom were undoubtedly just as honorable but lacking money or honors, were labeled fraudulent.

John Beattie of Bristol, England, carried out a series of experiments in 1872 and 1873 which passed all requirements of the times regarding character and methods. He gathered four men, including a trance medium, at a table and took pictures of them more or less weekly. The eighteenth attempt produced the first ectoplasm-like clouds in front of the men. These light forms became more and more complex over time (see figure 54).

In my opinion, Beattie was photographing ectoplasm. He concluded:

> In my case all that has been proven is simply the following: That, in nature, there is a fluid or a kind of ether that becomes dense under certain conditions and, in this dense state, is visible to sensitives. When its emissions hit a chemically sensitized plate the oscillations from its vibrations are such that they set off a powerful chemical activity as is comparable only to the most intense effects of sunlight. . . . This substance is absorbed by intelligent invisible beings who make shapes from it just like clay in the hands of an artist. These shapes, which can be photographed when caught by a lens, could be images of human beings or of something completely different. A person whose retina is sensitive to these forms can give an exact description of them before they become visible to the normal eye after being developed as photographs.[5]

William Hope (1863–1933) worked in a bleach and dye works in England when he discovered his ability to produce paranormal photographs. Controlled experiments done with Hope inspired two books, Sir Arthur Conan Doyle's *The Case for Spirit Photography* and Dr. G. L. Johnson's *The Great Problem: Does Man Survive?* When several photographs were taken of Hope with different cameras, photographic paper reportedly never touched by Hope revealed a profusion of faces of people dead or alive, clouds of ectoplasm, flower shapes, and written messages. While I have no faces in my photos, I have perhaps received a written message (consisting of one measly letter) in one of my photos. Figure 55 is one of my first photos taken in a cemetery with my new camera with a night setting. So many strange things appeared on my photos on that setting that I eventually stopped using it. I just could not believe what I was getting. Someone else noticed this picture has a scripted "L," the first letter of my name, written on it. Movement may have caused the lines, but I cannot believe it could have written the letter.

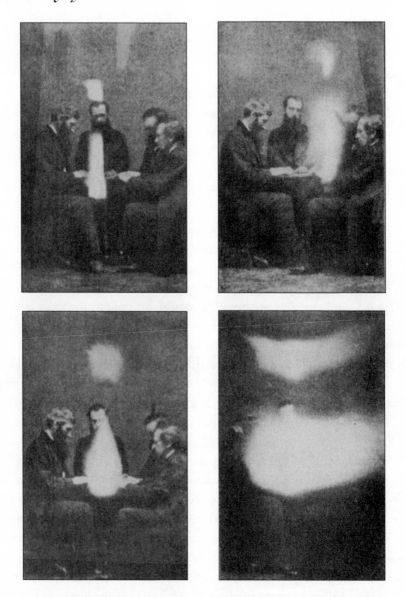

Figure 54: Photographs of ectoplasmic materializations in daylight. John Beattie, 1872.

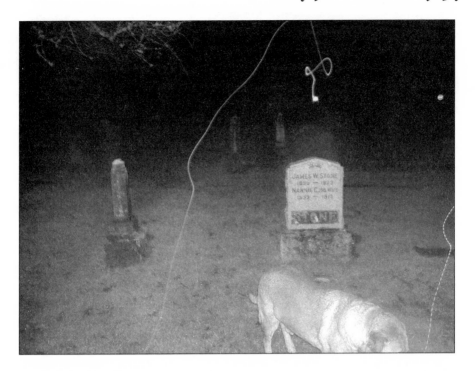

Figure 55: I took this picture on the night setting in a cemetery with Max without a tripod to steady the camera. Could movement or an insect have written the "L," the first letter of my name? The light on the right-hand side is a stop sign.

Nineteenth-century German philosopher Eduard von Hartmann described mediumistic nervous energy as a physical force such as light or heat that must have acted directly on the photographic plate.[6]

Pictures similar to the orbs and vortexes of today were also produced through "thought photography" or "iconography" beginning at the end of the nineteenth century by photographers such as French Dr. Hippolyte Baraduc; a French commander Darget (first name unknown) around 1882; Polish philosopher and psychologist Julian Ochorowicz from 1908 through 1917; and an American vagrant named Ted Serios in the 1960s. Since their methods were so dissimilar to the photographic techniques used today, I was more impressed by how they thought paranormal pictures were produced than by the pictures themselves. Baraduc felt the "movements of the living soul were being made visible in a kind of graphic signature with the aid of photography of the fluidal invisible."[7]

Darget felt he was photographing a radiation (vital or life rays) equivalent to Mesmer's magnetic fluid. (Franz Mesmer thought healers could direct an

electromagnetic force from their bodies to the patients' bodies that could heal the patients.) Darget said this fluid exuded in the largest quantities from mesmerists (hypnotists) and mediums and was controlled by emotions. He said strong emotions such as love and hate caused turmoil in the "fluidal brain." The vibrations from these feelings were then transmitted to the "fleshly brain," which sent the "storm of passions outward as a whirling mass of etheric material." Then, if one concentrated their thoughts upon a simple object such as a bottle, the "thought-image" came through the subject's eyes and produced a picture on the photographic plate with radiation.[8]

Darget determined more than one hundred years ago that the success of his experiments somehow depended on where they were performed. I have also found that the more pictures I take at a specific location over a period of time, the more anomalies I get on film in the same area. Darget obtained less satisfactory results when he had been away from his home in France for weeks or when he tried photographic experiments in other people's homes. He concluded his home was filled with his own particular "fluid," which seemed to be more conducive to psychic phenomena.[9]

Julian Ochorowicz worked with a medium named Stanislava Tomczyk, who channeled "Little Stasia" and obtained many invisible lights and streaks or "medianim lights" during séances in total darkness, and spherical formations when the medium held her hands at a moderate distance over the photographic plate, either in the dark or placed in a plate holder or box. Ochorowicz believed this was unconscious thought-photography, since the medium seldom if ever produced what she was attempting to produce. His description of the spheres, except for the part about pain, sounds eerily like orbs:

> They are always invisible, although they emerge clearly on photographic plates in the form of geometric spheres. . . . Their range of activity extends to several meters. . . . The appearance of Xx-rays is always accompanied by severe pain. . . . In fully developed form the Xx-rays have the appearance of somewhat large, apparently rotating spheres, which appear with circumferences of up to 8 centimeters on radiographs.[10] (See figure 56.)

In the 1960s Ted Serios produced his thought photographs with intense concentration on Polaroid film. Jule Eisenbud, M.D., of Boston, spent years studying Serios's talent and concluded the photos were somehow related to out-of-body experiences, partly because most of his photos appeared as if viewed from above. Dr. Eisenbud thought this phenomenon did not obey the laws of optics; the process even worked without light or a lens in the camera.[11]

Figure 56: Spheres produced by Stanislava Tomczyk's thought photography. Julian Ochorowicz, 1909.

Investigator Hans Holzer worked with New York medium Betty Ritter. Large spherical globes of light and streaks that Holzer called rods, and that closely resemble today's light anomalies, appeared around Ritter during séances. Holzer claims the number of people and the amount of psychic energy in the room seemed to determine the intensity of the phenomena.

Holzer says the anomalies are composed of ectoplasm that is pulled from the bodies of emotionally stimulated sitters and mediums. This ectoplasm was studied in London and found to be moist, whitish, smelly, and related to albumen (the white of an egg). It can be molded through the power of thought, Holzer thinks, and the ectoplasm that is not used up in the session is returned to the source(s). Holzer concludes:

> The combination of sensitive camera and sensitive photographer or operator seems to be the catalyst to put this material [ectoplasm] onto photographic film. . . . As the psychic photographer develops his or her skill, the extras become more sophisticated until they eventually are faces or entire figures.[12]

These sensitives do not need to know of their psychic ability. As Holzer points out, most psychic photographs surprised those who took them, since the majority of photographers had no interest in parapsychology or occultism.[13]

Dr. Andrew von Salza, a West Coast physician who originally had no interest in the paranormal, wrote to Holzer a sentiment to which I can relate: "Seeing is believing, but even seeing, so many cannot believe, including myself."[14]

Paranormal photographs certainly are not the rarity they were only a few decades ago, but they are put under just as much scrutiny or more and are often labeled fraudulent or from natural causes, many times legitimately. If I were not the one taking the pictures, I would be far more skeptical. I am not easy to convince. I suspect the early paranormal photos most likely to have been legitimate were those that looked like the orbs and mists of today. They were practically discarded because the public could not tell what these light blotches represented. The same could be true today. People are looking for actual little green men, winged angels, horrible demons, and recognizable ghosts as proof of the paranormal and are not considering what may well be the real thing.

11 Light Forms in Religious Texts

"[O]ur earthly bodies which die and decay are different from the bodies we shall have when we come back to life again, for they will never die. . . . They are just human bodies at death, but when they come back to life they will be superhuman bodies. For just as there are natural, human bodies, there are also supernatural, spiritual bodies."
—*I Corinthians 15: 42,44,45, The Living Bible*

References to light are everywhere in the Bible, but finding any semblance of orbs, vortexes, or ectoplasm requires some imagination. The verses above claim we will have different bodies after death but do not describe the form of those bodies. Some of the Old Testament references to visions, vehicles, and "wheels" in the sky that some speculate were actually UFOs could have been some of the light forms described in this book.

The most likely biblical reference to orbs is the "eyes of the Lord," which appears sixteen times in the King James and Revised Standard versions of the Old Testament. Rather than reading "God is watching us," the phrase specifically mentions His eyes, His orb-shaped eyes. Could orbs be the mechanism through which God sees everything?

"For the eyes of the Lord run to and fro throughout the whole earth . . ." 2 Corinthians 16:9

"The eyes of the Lord *are* upon the righteous, and his ears are open unto their cry." Psalms 34:15

"For the ways of man *are* before the eyes of the Lord, and he pondereth all his goings." Proverbs 5:21

"The eyes of the Lord *are* in every place, beholding the evil and the good." Proverbs 15:3

"Behold, the eyes of the Lord *are* upon the sinful kingdom . . ." Amos 9:8 (all from King James version).

Also, the Catholic definition of angels, "spiritual, intelligent, noncorporeal beings who are servants and messengers of God,"[1] could easily be a description of orbs.

The ancient peoples who talked directly to God and/or angels may have been talking to light forms for all I know. Lights appeared to many biblical prophets. In centuries past, people who had visionary experiences were considered either possessed by a malevolent demon or blessed with a heavenly vision. Today they are heavily medicated, ignored, or called psychic. Psychics were saying they could see and talk to orbs and were describing orbs long before orbs started appearing on film. Who's to say the biblical prophets were not getting their information from God's orbs, vortexes, or ectoplasm?

If you think I am stretching the point with biblical references, less imagination is needed to link other religious texts to light forms. Other texts based upon ancient tradition describe light forms more clearly. Some of my favorites came from a brief study of Tibetan Buddhism, the so-called "highest" level of the many types of Buddhism.

Sogyal Rinpoche wrote *The Tibetan Book of Living and Dying* to explain the wisdom of Buddhism to the Western world and rewrote the Tibetan Book of the Dead, which was originally written by the great master Padma Sambhava in the eighth or ninth century A.D. for Indian and Tibetan Buddhists. Sambhava hid the document and it was rediscovered in the fourteenth century and first appeared in English-speaking countries in 1927. Without delving too deeply into the Buddhist religion, which I am not qualified to do anyway, I will briefly outline the Tibetan beliefs about the process of death and how to avoid rebirth, hopefully with no misinterpretations. Incredibly, the Tibetan Book of the Dead confirms a centuries-old knowledge of what seems to be the same type of lights showing up on film today.

Tibetan Buddhists say death is the most crucial moment of a person's life and an understanding of what happens after death can help one reach enlightenment more quickly and stop the cycle of rebirth. The supreme vision comes at the moment of death, the spiritual climax to life, when many Americans are drugged to oblivion.

(Could that be why many souls get "stuck" here?) One either gains full awareness and is liberated or he must encounter the next of four stages of *dharmata*.[2] Carl Jung said of the instructions for these various stages:

> They are so detailed and thoroughly adapted to the apparent changes in the dead man's condition that every serious-minded reader must ask himself whether these wise old lamas might not, after all, have caught a glimpse of the fourth dimension and twitched the veil from the greatest of life's secrets.[3]

The four stages of *dharmata* and a brief description of the lights encountered in each are:

1. "Luminosity": In this first stage, you "take on a body of light" and "become aware of a flowing, vibrant world of sound, light, and color" which has "no separate existence from the nature of mind."[4]

2. "Luminosity Dissolving into Union": Here the rays and colors form brilliant, blinding, dazzling points or balls of light of different sizes. "Countless luminous spheres appear in their rays, which increase and then 'roll up,' as the deities all dissolve into you.[5]

3. "Union Dissolving into Wisdom": If the soul has not yet recognized the clear light, visions of light unfold before the soul in this third stage. The five wisdoms are manifested in this display of lights to show the soul its potential of enlightenment.[6]

4. "Wisdom Dissolving into Spontaneous Presence": In this final phase you become clairvoyant; know your past and future lives; read others' minds; and know of all six realms of existence. "If you have the stability to recognize these manifestations as the 'self-radiance' of your own *Rigpa* [the knowledge of knowledge itself], you will be liberated."[7]

These four steps are said to take up to 49 days, but these days are outside time and space. Sogyal Rinpoche describes the dim lights surrounding the brilliant light of wisdom as "smoky, yellow, green, blue, red, and white—our habitual, unconscious tendencies accumulated by anger, greed, ignorance, desire, jealousy, and pride. These are the emotions that create the six realms of *samsara*: hell, hungry ghost, animal, human, demigod, and god realms respectively."[8]

Sogyal Rinpoche's description of the Buddhist's view of the death process could have come from nearly any modern-day book on ghosts. During the first weeks after death, Sogyal Rinpoche writes, we don't realize we are dead and return home to find our relatives, who are not aware of our presence. We watch, powerless, as they weep and dispose of our belongings. We may even try to reenter our bodies and we may hover around for weeks or years, still not realizing we are dead.[9]

The Tibetan Buddhist "body of light" shares many traits with orbs, while the "mental body" seems to be a combination of apparitions and orbs. The mental body possesses all its senses; is extremely light, lucid, and mobile; is clairvoyant; and is seven times more aware than when alive. It can go anywhere it wishes in an instant. Being the size of a child eight to ten years old, it cannot be still, is constantly moving, and can pass through walls and mountains. This mental body can see other beings, living or "dead," but only clairvoyants can see it. Its mind is active and can do many things at the same time, but it clings to the belief it is real and retains patterns and habits from its previous existence.[10]

Sogyal Rinpoche also describes an ectoplasm-like light that appeared following the death of his beloved master, Jamyang Khyentse. An "incandescent, milky light, looking like a thin and luminous fog, began to appear and gradually spread everywhere." This light dimmed four large electric lamps outside and was seen by hundreds. One of the masters told him that such a light was a sign of attaining Buddhahood.[11]

Robert A. F. Thurman translated and commented on the Tibetan Book of the Dead in a book of the same name as part of the "Mystical Classics of the World" series. Just as different translations of the Bible sometimes have little in common with each other, Thurman's translation doesn't read much like Sogyal Rinpoche's version. Several of his comments are noteworthy. He writes: "The body in the between is made of subtle energy, like a holographic image. . . . If one has a stabilized and focused imagination, one can reshape the body just by a thought."[12]

Thurman describes the mental body as being able to pass through anything except a mother's womb; it can circle the planet in a split second; it only has to think about any place to arrive there instantly. Between-beings (between death and enlightenment) are visible to those with clairvoyance. What most cultures refer to as ghosts, Thurman maintains, describes the between-state wanderer experiencing the four stages of *dharmata*.[13] Your body's color will be the dull white light of the gods, the red light of the titans, the blue light of the humans, the green light of the animals, yellow light of the hungry ghosts, or the dull smoky light of the hells, depending upon how you will be reborn.[14]

One way the Tibetan Book of the Dead says you can tell if you are existing in this between-world is to look into water. You will not see a reflection and you will not cast a shadow.[15] Thurman claims your intelligence will be nine times clearer than it was in life.[16]

Figure 5: Enlargement of Annabelle's orb.

Figure 6: Taken April 23, 2001, just after Annabelle's last breath. It was Peter's first picture of an orb. © 2001 by Peter Clemmer

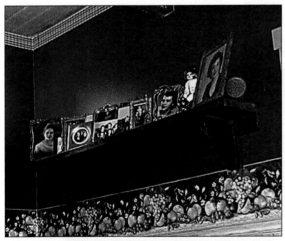

Figure 7: Orb behind Annabelle's picture. The picture frame casts a faint shadow on the orb, so the orb cannot be dust close to the lens. Note this orb's similarity to Annabelle's orb in figure 6. © 2001 by Peter Clemmer

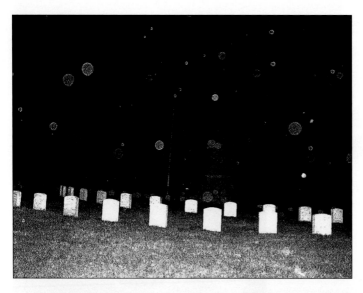

Figures 8–11: These four pictures were taken in various cemeteries during the year 2001. I believe most of these orbs cannot be dust or pollen because of their color, variety, and depth. The graveyards were undisturbed areas on calm, clear evenings.

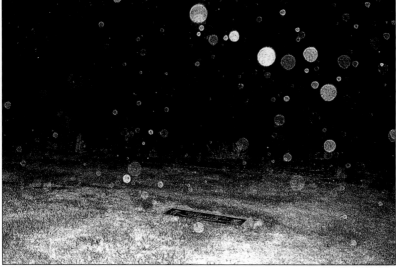

Figure 12: The inside of a swirling vortex on the southeast corner of Peter's house. It appears to be traveling through the house. © 2001 by Peter Clemmer

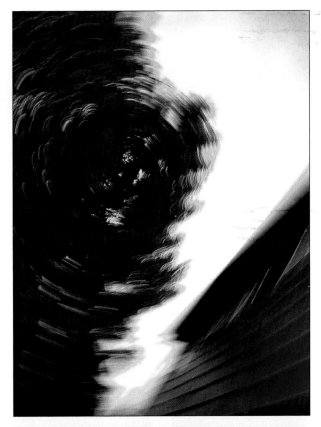

Figure 13: Ectoplasm on the southeast corner of Peter's house. The temperature was too warm for breath to be visible. © 2001 by Peter Clemmer

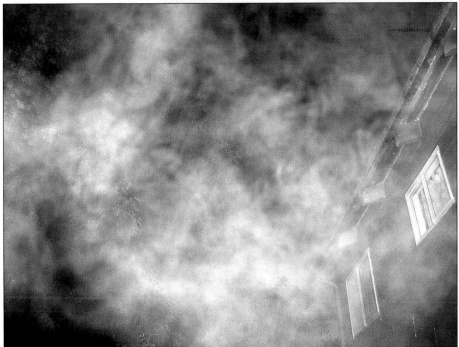

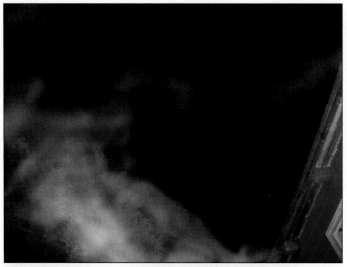

Figure 14: Ectoplasm on the same corner of Peter's house. Taken on a warm day. © 2001 by Peter Clemmer

Figure 15: Nine pictures of Peter's "Big Boy." © 2001 by Peter Clemmer

CS4

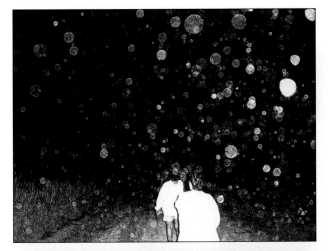

Figure 16: Field trip (literally!) on a crisp, cool, clear, and calm evening on September 19, 2001, in a field behind Peter's house.

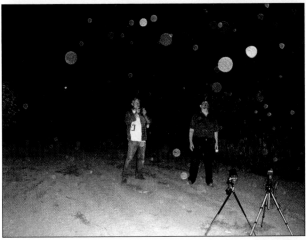

Figure 17: My brother Peter and my husband, Stan, on the field trip. Digital graphics expert Chris Gunn especially liked this shot. He called it "a terrific collection of orbs from less than an inch in diameter to almost two feet in diameter." There is a lot of damage from my saving it at a low-quality JPEG setting. (It was the only way I knew how to do it.) Gunn wrote, "It is impossible to get the same effects with dust, insects, a spray of water, or any other method that I know of, including trying to doctor the film in a photography lab. . . . I would need something over 40 hours to create the same signature appearance of the orbs. I'd also probably have to copy some from a real photograph [grin]."

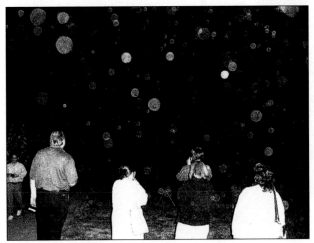

Figure 18: Spiritual group on the same field trip.

Figures 19–23: Orbs seemingly behave like athletes and spectators on two high school tracks in 2001.

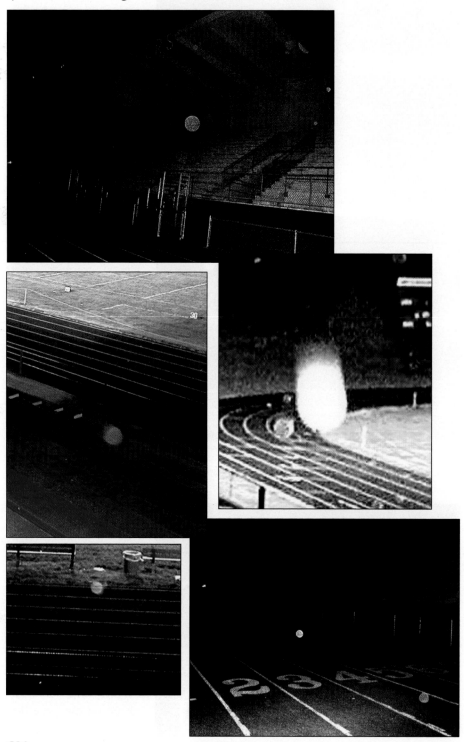

Figure 24: My niece Lindsey took this shot just after my father's ashes were removed from the red cloth. Lindsey made the heart that is sitting under the orb for her grandfather. Notice the pink glow coming from the top of the orb. © 2002 by Lindsey Rhodes

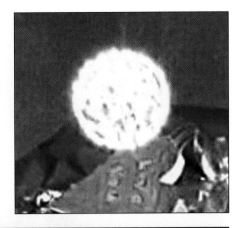

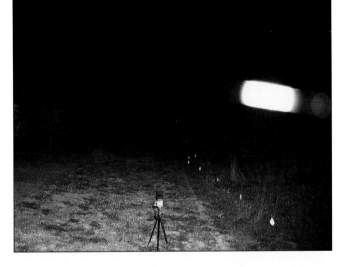

Figures 25 and 25a: Peter took this shot (his favorite) the very day we learned orbs can look much like dust on a photo. It demonstrates several characteristics of orbs. They can move at an incredible speed and can blink on and off while traveling. Peter adjusted the contrast on 25a to show the flight pattern. The white spots are flags, and Peter's extra flash unit is on the tripod. © 2001 by Peter Clemmer

Figure 32: My mother, Edith Clemmer, on her sixtieth birthday in 1980. Since the ends are visible, this double vortex cannot be a camera strap. Taken with a 35mm camera.

Figure 34: My son Ben with piggyback orbs or, more likely, lens flare. Taken at 4 P.M. with the sun behind the house.

Figures 41 and 42: Many videos are capturing orbs breaking apart into two or more orbs. Are these orbs piled up in front of each other, or is the big "Mother Orb" producing young? © 2001 by Peter Clemmer

Figure 43: Orbs, vortex(es?), and ectoplasm before a church service on December 29, 2001. Are orbs traveling within the vortex and ectoplasm, or are vortexes and ectoplasm composed of orbs?

Figure 43a: This is an enlargement of the orb near the center of figure 43. Some web-sites claim no orbs are legitimate because they have never seen a partially obscured orb, which would prove the orb is not dust close to the lens. Part of this orb is definitely behind the light fixture.

Figure 44: Vortex with grandfather rescuing grandchild falling off a toy horse. Taken with a 35mm camera.

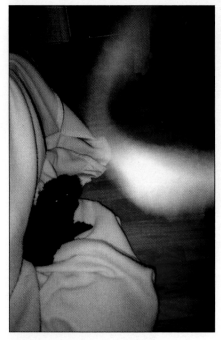

Figure 45: Vortex with a puppy on the day his owner fell ill and decided to return the pup to his former owners. Taken with a 35mm camera. Both this and the previous vortex appeared at a time of need. © 2002 by Pat Beyer

Figures 61a–e: I couldn't help but notice how many times one, and only one, blue orb seemed to be tending one of my flower beds. Helping them grow?

Figure 62: Peggy Keating's family room after Vicky Thompson conducted a spiritual meeting on June 13, 2001. Notice the large pink ball in the upper right corner with energy swirling around it. The white light on top is a light fixture.

Figure 78: The same monument seconds later on the "automatic" setting.

Figure 77: Picture of a rock monument near Cooke's Place in Hawaii taken at dusk on the night setting. This is the only time my camera produced such an effect, and I have no idea what it is or what it means. Indigenous Hawaiians still gather near this spot at dusk and dawn to help spirits travel between dimensions.

Figure 80: A truly gorgeous orb hovering above a Hawaiian-Japanese cemetery. March 2002.

Figure 81: Another tourist took this shot of Stan and me with my 35mm camera on a Caribbean cruise ship leaving Miami, Florida, in 1992. At the time, I thought it was odd because we didn't recall any streamers in front of us. Since I doubt anyone would have posed us behind flying objects, I decided to include this picture even though I have no idea what the bright streaks are other than the most colorful vortexes I've seen. I urge the reader to review old family albums. Photographs in which you are personally involved have a greater impact than my pictures ever could.

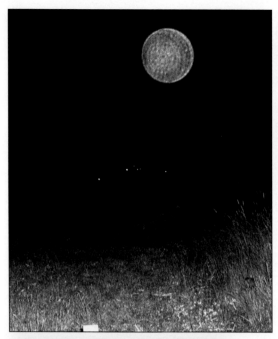

Figures 82–89: When I reviewed all of Peter's pictures, I found at least 40 shots in which orbs were in front of Peter's flash slave unit. Many times they were the only orbs in the picture. Was the flash making them visible, or were they posing? Are the three that are moving (figures 84, 85, and 87) rushing to get into the shot? © 2001 by Peter Clemmer

Figure 82

Figure 83

Figure 84

Figure 85

Figure 86

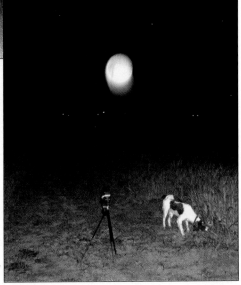

Figure 87

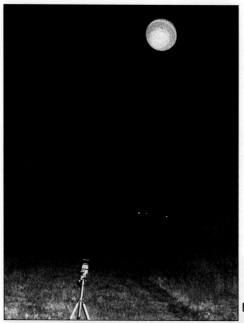
Figure 88

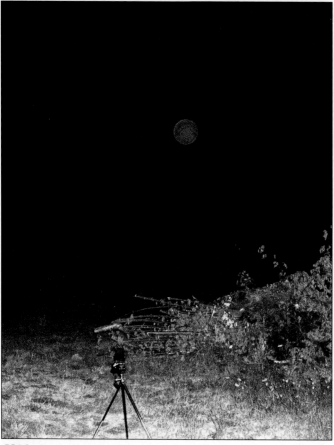
Figure 89

I know of no modern-day religion that teaches that the essence or soul takes the form of a light sphere after death. Buddhists have apparently believed this all along, and those balls of light share many characteristics with the light forms discussed in this book.

In the same series of mystical classics, I found a relevant reference to light in *The Essential Kabbalah*, consisting of wisdom from the twelfth and thirteenth centuries:

> I have seen that all those sparks flash from the High Spark,
> hidden of all hidden.
> All are levels of enlightenment.
> In the light of each and every level
> there is revealed what is revealed.
> All those lights are connected. . . .[17]

My favorite ancient text is the Emerald Tablets of Thoth, which can be found at www.crystalinks.com/emerald1.html. While it took me decades to finally be able to say I had read the Bible straight through, I read all of the Tablets in one sitting, mesmerized and amazed. Some sources say they were written on twelve imperishable emerald-green tablets by an Atlantean Priest-King who built the Great Pyramid of Giza around 38,000 years ago. They are said to be the uncredited source of many of our mystical and esoteric religious traditions.

The Tablets mention nine curved dimensions, spaceships, and the power of belief—all topics discussed elsewhere in this book. But most importantly, the Tablets are also packed with references to light—far too many to list, but a few of them follow:

> Man is in process of changing
> to forms that are not of this world.
> Grows he in time to the formless,
> A plane on the cycle above.
> Know ye, ye must become formless
> Before ye are with the light. (Tablet 8)

Clearly, this implies we will become formless after life on Earth. As ectoplasm?

> Entered I my body.
> Created the circles that know not angles,
> created the form
> that from my form was formed.
> Made my body into a circle. . . . (Tablet 8)

Does this not say that Thoth's body took the shape of an orb?

> Know that thou art the Greater Light,
> perfect in thine own sphere,
> When thou art free. (Tablet 11)

In other words, when we are free of this world and our present bodies, we will be orbs and we will be perfect.

> The Time will come when ye, too, shall be deathless,
> living from age to age a Light among men. (Tablet 12)

I interpret this to mean we will all eventually live forever as lights among men.

> Hear ye now the mystery of mysteries:
> learn of the circle beginningless and endless,
> the form of He who is One and in all.
> Listen and hear it, go forth and apply it,
> Thus will ye travel the way that I go. (Tablet 14)

This verse says so much to me. God is a circle (orb?) and He is in all of us, and when we figure it all out, we will be as God is and realize the we are all One. In John 10:34, Jesus says, "Is it not written in your law, I said, 'Ye are gods'?"

A dentist named Dr. John Ballou Newbrough channeled *Oahspe: A Kosmon Bible in the Words of Jehovih and his Angel Embassadors* in the 1880s. Just one of its references to elementary spirits follows:

> The spirit said: First, then, the air above the earth is full of elementary spirits; the largest are as large as a man's fist, and the smallest no larger than the smallest living insect on the earth. Their size denoteth their intelligence; the largest being designed for human beings. These fill all the air of the earth, and all the space in the firmament above the earth; they have existed from everlasting to everlasting, for they were without beginning.
>
> Now whilst a child is yet within the womb, one of these elementaries entereth in the child, and straightway there is the beginning of the man. And in like manner are all things produced which live on the earth.[18]

Islam also includes light forms in its beliefs. It describes the existence of three intelligent species in the universe:

1. Angels or Messengers (created of Light);

2. Man (made of clay or earth); and

3. Al-Jinn (composed of what is sometimes translated as "smokeless fire" or "smokeless flame").

The name Al-Jinn comes from a verb root, Janna, which means "to hide or to conceal." Some scholars say Mohammad was trying to say that the Jinns existed in the ether or the astral planes. It is thought the Jinns are very close to man, but, at the same time, very far away, as in another dimension. Jinns have variously been called extraterrestrials, ultraterrestrials, or metaterrestrials.

Official Islam has always accepted the existence of the Jinns. Mohammed said he was sent as a messenger to both mankind and the Jinns, so that they may enter into paradise. In their normal state, Jinns are invisible, but they can become physical and visible. They can change shape and appear in any form they wish, including animals. They also have tremendous telepathic abilities and can grant psychic powers to humans. Some of their other characteristics, such as abducting and having sexual relations with humans, are more in line with what we think of as aliens. Jinns can also be mischievous, deceitful liars, which leads others to call them devils and enemies of the Light.[19]

As you will read in chapter 12, light forms are often thought to be aliens, and many Christians today regard the lights as somehow demonic, along with every other unknown. Orbs, vortexes, and ectoplasm are also interpreted to be angels (see chapter 14), which, as mentioned, Islam accepts as one of the three intelligent species on Earth.

Had more of the beliefs of ancient religions been written down and had I more time to learn many languages to delve into the writings that do exist, judging from the few I have read, I am certain this chapter could become a book in itself based on all the references to light forms in ancient texts.

An Experiment of My Own

Finding evidence of orbs in so many religious texts inspired me to do a bit of church-hopping to see if I could learn any more about orbs within houses of God.

In August of 2001 I began an unscientific experiment involving churches and orbs. I attended a different church service each week, taking as many pictures as I could until I feared the church "bouncer" might carry me off the premises. I suppose I was trying to find out if orbs had any religious preferences. I've often wondered which church God would join, were He to live with us on Earth, and I admit I was guilty of suspecting or perhaps wanting to find He would prefer certain churches over others. No matter who or what orbs are, I thought it would be fascinating to see where they would go on worship day.

Renowned ghost hunter Hans Holzer thought churches were often haunted, due in part to energy from the body heat produced by large numbers of people, and he said projections were produced by religious fervor, prayer, and incantations which "charged" the energy. He wrote:

> This "calling forth" of intercession may well create an electromagnetic field within the church, aided in its continuing consistency by the thick walls, the high degree of moisture usually present in churches (especially in Britain and Ireland) and the darkness prevailing in the edifice.[20]

To put Holzer's and my theories to the test, I attended thirteen church services, keeping a record of the number of orbs per shot, and other variables such as number, sizes, and colors of the orbs, size of congregation, and the quality/quantity of music. Much later, I determined the phase of the moon during each photo session. I visited New Thought, Catholic, Presbyterian, Foursquare, Unitarian, Unity, Episcopalian, Lutheran, spiritualist, and community churches, plus a Jewish synagogue. There was no real rhyme nor reason as to when and where I went. All were located in or near Portland, Oregon. Eventually I became discouraged at the lack of method to my madness and stopped embarrassing my poor husband in a new church every week, but my experiment suggested some interesting orb behavior.

I didn't have to get out my old college statistics books to determine I wasn't going to find any significant correlation between what I dubbed good and bad orb days and the phases of the moon. The theory that orbs are easier to photograph for several days before or after a full or a new moon started somewhere and exists to this day in some circles. If anything, I found a slight negative correlation between lunar phases and orbs in churches.

Generally, I got more orb pictures within churches than I have in any other public buildings, such as grocery stores, shopping malls, taverns, and restaurants, with the possible exception of movie theaters. Orbs do seem to like churches, and, with

one exception, they were just as plentiful in churches I would avoid as in the churches I enjoy attending.

I got what I consider to be my best ever shot (figure 43, center section) in the church I attend most often, the Living Enrichment Center (LEC) in Wilsonville, Oregon. LEC is a New Thought church pastored by Dr. Reverend Mary Manin Morrissey. I showed Dr. Morrissey some of my pictures and she assured me they were not the work of the Devil, so the lights may have known they were welcome there. This picture is the only shot I have taken when orbs, vortexes, and ectoplasm all appeared in the same picture. A couple of my other favored churches, though, were practically orbless—so much for expectations (at least conscious expectations) creating my reality.

Figure 57 is another picture taken at LEC on Easter 2002. In both of the LEC pictures there are orbs behind objects, which is an excellent indication of authenticity. I could find no orbs hidden behind anything in any of the other church shots, so I am not including them, lest critics accuse the churches of being dusty.

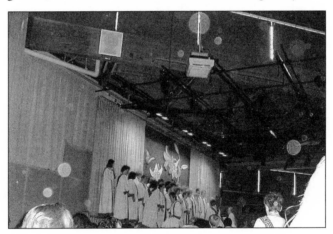

Figure 57: Easter 2002 at Living Enrichment Center. Notice the large orb at the top of the picture appears to be behind a fixture. This eliminates the possibility of its being dust close to the lens.

Two other important factors seemed to be music and mood. I counted more orbs in churches with enjoyable music or enthusiasm. I visited one church twice because I felt the first visit was not a fair example. That particular Sunday there was a substitute speaker, no choir, and a very low turnout. Out of ten shots, I found just three faint orbs hiding up in the rafters in the back of the sanctuary. My second visit to the same church was the Christmas Eve service, complete with choir. Nearly every

seat was taken and, as far as entertainment goes, it was my favorite of the thirteen samples. I sat in the first row of the balcony both times, so the orbs could not be blamed on crowds stirring up dust within four inches of my camera lens. My twenty-nine pictures yielded seventy orbs, including many with a light blue hue. Much better than the first visit but still not what I expected. Six of the other churches had significantly higher numbers.

More orbs were blue or green within my sample churches than in any other settings I have photographed. More church orbs, but not all, tended to hang around rafters and ceilings rather than close to the congregation or near the ground, and, generally, the more people in attendance, the greater the number of orbs. Of course, all of these results could have been influenced by factors of which I am totally unaware. Individual orb experiments may never yield universal results. There are simply too many unknown variables. I believe all experiments are exercises in frustration, since the experimenter's conscious and/or unconscious expectations largely determine the results. More on this later.

12 Invisible UFOs, Aliens

What Are They?

Before reading the next seven chapters, consider the following scenario. Just after dusk one fine summer evening, a light appears in the sky over a city. The light is large but indistinct. It moves about erratically for three minutes, then disappears. A crowd of thousands is looking in that direction, but only half see the light. What would the people who saw it think it is? A large number would immediately call it a UFO or an alien. Yet another group would be just as certain they had seen a ghost or a spirit. Others would feel they have just had a religious experience and interpret the light to be Mary, Christ, Buddha, Mohammed, Shiva, an angel, or some other spiritual figure. (Claiming to see a religious vision reduces the ridicule factor significantly. People fall into silent reverence and consider you blessed. Saying you saw a ghost or an alien places you in the "loony" category.)

The philosopher and spiritually minded person might say the light was a thought-form or what occultists call an elemental. Some might call the phenomenon an interdimensional being, or Satan in one of his deceptive forms. The terminally right-brained spectators might define the light as an earth light, ball lightning, an illuminated balloon that popped in flight, a gigantic mass of fireflies, or perhaps a terrorist's surveillance device. The possibilities are endless.

Where and when lights are seen play a role in defining what people think they are. If this same light had appeared within a church, the majority would have given

it religious meaning. If seen by a group of ghost hunters in a haunted house, it would of course be the ghost of the former owner who was killed in that very spot. If seen hovering over a newly formed crop circle, the light would likely be credited with creating the formation.

Now suppose no one saw the light, but three hundred cameras photographed the same anomaly under the aforementioned circumstances. What would it be then? Whatever this light is, it is precisely the same thing in every circumstance, but I'm afraid no one could give it a label that would satisfy everyone. Use your discretion and decide which of the following chapters comes closest to the truth as you see it.

The definition of "alien" is a foreigner, stranger, or an outsider. Given that, any explanation for anomalous lights is going to seem strange and foreign to modern civilization as we know it. For the purposes of this book, I will use the word "alien" to mean an entity originating from a planet, solar system, or galaxy other than our own, as opposed to being from another dimension here on Earth. I have already described the similarities between UFOs and the other categories of visible light anomalies in chapter 5. In this new discussion here, UFOs can be thought of as the craft the aliens use or as the aliens themselves.

A common argument against the possibility of aliens visiting our Earth is that the SETI (Search for Extraterrestrial Intelligence) Project claimed until very recently it has detected no sign of any intelligent life in space. The agency maintained astronomers had scanned for radio and television emissions within one hundred light-years of the Earth and had found no sign of any signal from space indicating intelligent life. Any planet within fifty light-years of Earth should have been able to detect our signals, but none had signaled back.[1]

On July 30, 2002, the now defunct PAG e-NEWS (vol. 7, no. 22) quoted Dr. Jill Tarter, long-time director of SETI, as reversing decades of SETI official policy by saying: "It's possible that there could be, in fact, within our solar system some evidence of an extraterrestrial technology. They may be here."

Shortly thereafter, the website reported that Dr. Tarter now believes extraterrestrials could be in our solar system and admitted, "Many unusual signals from space remain unidentified." Perhaps SETI should imitate law enforcement and employ a psychic for the task.

The typical person assumes aliens board some craft and spend many light-years to reach our planet, and when they arrive they will destroy us, so we need more weapons for protection. It seems to me that, if aliens are coming or have come to Earth, they are using methods far beyond our comprehension, such as wormholes,

time warps, or space warps, and they also have ways of keeping us from being aware of their presence. They could even be us, traveling back in time, or be visiting us from another dimension here on Earth. If their intention is to harm us, we would not still be here to worry about it. They would have done it long ago.

If it isn't obvious to you by now that all the many forms of light phenomena I have been studying could have been mistaken for UFOs or aliens over the years, then I am doing a lousy job of making myself clear. The visible orbs discussed in chapter 5, however, are more often interpreted to be UFOs than the invisible spheres. Even the first documented photographs of UFOs look like pictures of orbs to me. They were taken August 12, 1883, by Jose Bonilla, an astronomer and director of the observatory at Zacatecas, located 11,000 feet up a Mexican mountain. Bonilla used a camera attached to a telescope and photographed glowing objects as they crossed the face of the sun. Some appeared round or spherical but were actually determined to be irregular in shape. As they crossed the face of the sun, they became opaque and dark against its brightness.[2]

The 5 percent of UFOs that are not eventually written off as IFOs (Identified Flying Objects) are no closer to being identified than they ever were. It seems obvious to me that many could be orbs and other anomalous lights. For instance, Jenny Randles writes in *UFOs and How to See Them* of an Indian reservation near Yakima, Washington, where most sightings are of balls of light. The lights are described as

often orange or yellow, which can split apart, bounce along the ground or turn into peculiar misty clouds. There are reports of lights following cars on the quiet roads and in some cases of both engine and lights cutting out at closest proximity, as in similar encounters all over the world.[3]

She also describes the legends of haunting yellow-orange globes of light that respond to human presence and seem to display intelligence in the Brazilian city of São José do Rio Prêto. This city also has one of the highest number of claimed abductions in the world. The lights are called the "mother of gold" lights;[4] Randles calls them UFOs. I think they could just as accurately be labeled orbs, which can be yellow-orange, intelligent, and unidentified.

Many of these so-called UFOs are also invisible to the human eye but show up on photographs. Randles published what looks like a typical orb photograph with two bright orbs and a light streak, taken in Australia in 1972. T. Nieuwenhuis was reportedly trying to photograph star trails and left his camera pointed at the sky with the shutter open. He did not see the "UFOs" the camera captured.[5]

UFOs are most commonly sighted in the same locations as the visible lights discussed previously, such as at power stations, electricity pylons, ancient sites, and in association with seismic activity. In her book *UFOs and How to See Them,* Jenny Randles claims that Niagara Falls, which generates enormous amounts of raw electrical power, acts like a magnet for UFO sightings. Besides Niagra Falls, she cites the following areas as North American hot spots: Oregon (my home), Washington, Texas, New Mexico, and the Gulf of Mexico from Biloxi, Mississippi, to Pensacola, Florida. All but one of these spots are near large bodies of water, just as nearly every orb photographer I know through the Internet lives near an ocean or a large lake. I personally think orbs and UFOs are everywhere, but if there is ample energy available to them, they can become visible, and water may be one source of energy for them.

The invisible lights that are only seen in photographs are not often thought of as UFOs. To most, they seem too unsubstantial to carry aliens or travel any distance. The visible lights, especially the earth lights, are more often suspected of being UFOs. The apparent face-like quality of some orbs leads some people to believe they are "viewers" sent to Earth to spy on us. They do seem to be watching us carefully, but there are many other possible reasons for monitoring us other than to gather information to take home to other planets.

Raymond Fowler, UFO researcher and author of many books concerning UFOs, writes of Betty Lucas's hypnotically induced recollection of her abduction in 1950 in his book *The Watchers II*. When Betty, age 13 at the time of the abduction, arrives at what she calls "the crystal forest," she notices mist all around and little lights with what looked like energy inside them. A blue light the size of an orange that she had seen in other abductions she recalled under hypnosis follows her through most of this account. She says she thinks the blue ball is protecting her. At one point, Betty finds herself floating inside a huge transparent ball with her companion blue ball inside the larger ball with her.

Spheres figure heavily in Betty's account. She sees all sizes and colors of balls, beings coming out of a metallic ball, light beings rolling up into a ball, balls dancing and making music, and a ball of light that opens up and displays a 3-D movie. She even becomes a ball of golden light and is taken home inside an orb, where she promptly forgets the experience.

Grey alien entities called the Watchers guide Betty and call the crystal forest "home." They call the clear crystal balls "orbs" and tell Betty these orbs are record keepers of all intelligence and they are all around but no one can see them. The alien says the orbs can be as small as atoms or as large as they wish to be.

Of this account, Fowler writes:

Significantly, balls of light are a typical component of many UFO abductee reports. During the Lucas' [sic] shared OBE abduction in 1978, the entities demonstrated they could change to light beings and balls of light. . . . NDErs have also described intelligent balls of light visiting and communicating by telepathy with them on their death bed[7]

If accounts such as Betty Lucas's are accurate, orbs could be craft of some sort. Just as I was making final revisions to this chapter, the Mexican Ministry of Defense released a video taken on March 5, 2004, by Mexican Air Force jets over Campeche Province. As many as eleven lights followed and at one point surrounded the aircraft.[8] Like orbs, the lights were invisible to the naked eye but evident on the video taken with infrared cameras. The jet's radar picked up just three of the lights, and the pilots saw nothing at all. Also, as orbs are known to do, the lights accelerated rapidly and changed course suddenly. This sighting is the first ever to be backed by the armed forces of any country.[9]

As usual, the circumstances led to the conclusion that these lights, which behaved exactly like orbs, were alien craft. They may have been, but please consider the other possibilities before you agree.

13 Crop-Circle Makers

"You demi-puppets [faeries] that
By moonshine do the green sour ringlets make
Whereof the ewe not bites."
 —*William Shakespeare; Prospero, The Tempest, Act 5, Scene 1*

Many researchers believe there is now actual proof, if there is such a thing, that orbs and other light anomalies are the creators of the legitimate crop circles. Like earth lights, ghost lights, and will-o'-the-wisps, crop circles have been sighted for centuries. There are folk tales about crop circles dating back to the Middle Ages. The first known recorded crop circle was reported in an August 1678 newspaper article and was described as mown circles left by the Devil who appeared in a "chariot of fire" in Hertfordshire, England.

On a cane farm near Tully, Australia, in 1966, a crop circle was discovered after a farmer saw a grey, oval mass rise out of the area. Three days later a police sergeant saw several large bubbles of about three feet in diameter floating on the road surface. He drove over them and they disappeared.[1] Since then, balls of light have been seen so often in the United Kingdom that the English have their own name for them—BOLs for "balls of light." There is even an ancient sacred site in England called Golden Ball Hill.

Since the 1980s, there have been more than 10,000 crop circles cataloged worldwide—more than one per day. More than 1,000 crop circles have been found in south-

ern England alone since 1989.[2] They have gradually increased in number and in complexity. The mathematical and geometrical precision is incredible. They have progressed from simple circles to five-, six- and sevenfold geometry, and then to elevenfold in the year 2000 and thirteenfold in 2001. Circles have been found in grain, maize, carrot, potato, mustard, spinach, rice paddies, and tobacco fields; grass; sand, ice, and snow; and other vegetation. The Sri Yantra design, made up of thirteen miles of lines, ten inches wide and three inches deep, was etched onto a dry lake bed in 1990 in Oregon.[3]

At least forty different countries have reported crop circles within their boundaries, including Russia, Japan, the United States, Canada, Australia, New Zealand, Romania, Czechoslovakia, Hungary, Bulgaria, France, Spain, Germany, Holland, Norway, Finland, South Africa, and Israel. Great Britain plays the leading role, with more crop circles appearing within 40 miles of Stonehenge than anywhere else in the world.

The crop circle enigma has much in common with the phenomenon of light anomalies. Most if not all crop circles are formed at night; most light anomalies are filmed or sighted at night, when the Earth's magnetic field is weakest. Both orbs and crop circles have been known to cause mechanical and electrical failures, which resolve themselves when the equipment is moved from the area. Crop circles are cited as the cause of photographic gear failure, overexposed photographs, and visitors' watches malfunctioning. Both orbs and crop circles affect the electromagnetic fields in the area and interact with people according to what they are thinking and saying about them. Both are also associated with a certain sound, variously described as a buzzing, whirring, hissing, ringing, or trilling.

Light anomalies photographed around crop circles appear identical to the orbs, vortexes, and ectoplasm I have photographed. Balls of light seem to play two roles in the making of crop circles—casual and causal. They have been filmed many times cruising casually over crop circles and over open fields, and they have also been seen and filmed in such ways to lead one to believe they indeed cause the formations to appear.

Nancy Talbott is president of BLT Research Team, Inc., in Cambridge, Massachusetts. This is a group of several hundred members in the United States, Canada, and Europe who gather plant and soil samples from crop circles for analysis. Talbot and a boy named Robbert van der Broekes actually saw a crop circle forming in Holland around 3 A.M. on August 21, 2001. They saw what I would call a visible vortex. She called it "a brilliant, intense white column or tube of light—about 8 inches to 1 foot in diameter." They saw two more light tubes and ran out to the field to find a crop circle and steam rising from the ground. Robbert described the tubes as spiraling.[4]

Crop circles, earth lights, ghost lights, will-o'-the-wisps, etc., are sighted most often near ley lines, energy or geodetic stress lines, and ancient sites such as Stonehenge. Also, they often produce photographic light images that were not visible at the time the pictures were taken. I cannot tell the difference between these images and the ones I have taken. They come in many colors, almost always appear on pictures taken with a flash, and are mostly spherical, often with a clear rim around them. Some appear in different shapes, such as hexagonal, diamond-shaped, square, funnel-shaped, and mistlike.

Crop circles have ranged from eight inches in diameter to nearly an eighth of a mile in length in crops and up to 13 miles in other media. They come in a multitude of shapes and seem to originate from more than one source. There appear to be four types of crop circles, with some fitting more than one category:

• Simple circles, which, surprisingly, are more often deemed "real" than the other categories

• Circle, ring, and bar formations with complex, meaningful designs, like some sort of cosmic Rorschach test

• Highly complicated, intricate, fantastic landscape art formations

• Formations with elements that have been decoded into messages

The most consistent problem I have come across in my research is terminology—the many names for the same things that are keeping us from seeing the worldwide picture. Whatever the crop-circle makers are trying to say to us is being done via symbols, including many ancient religious symbols. Nearly everyone who is interacting with lights or crop circles says he senses these mysterious signs are trying to communicate something to individuals or mankind. Crop circles, especially with the attention they deserve in the media, could reach all people through symbols, thereby eliminating the language barrier. Pranksters who have confessed to creating crop circles with planks and ropes are making it difficult to decipher what exactly the actual circle makers are trying to say.

Explanations for crop circles are as diverse as those for light anomalies. I have seen the following:

• Electrical vortexes corkscrewing down from the sky

• Rotating air vortexes called "fair-weather stationary whirlwinds"

• Plasma vortexes or small, local whirlwinds of ionized air

• Wind currents and turbulence (the official cause supported by the British government)

- Lightning or ball lightning
- Stampeding hedgehogs running in circles during a mating ritual
- Landing sites of alien spacecraft
- Electrostatically charged dust and pollen caught in a whirlwind
- Spinning blades of helicopters
- Overdoses of fertilizer
- Artistic creations of art students
- Whirling dervishes
- Underground archaeology
- Probes in the form of orbs programmed to create art forms and ancient symbols to trigger ancient memories

- Greeting cards to Earth from a greater family of Man
- Sound vibrations
- Scorching of the earth from elves, sorcerers, or witches dancing in circles
- Angelic or demonic forces
- Exhalations of a "fertile subterraneous vapour" from the earth or an "earth fart"[5]
- Fungus that forms toadstool fairy rings, causing the phosphorescence of the fungi to glow as lights
- Military experiments with microwaves
- The work of two English drinking buddies named Doug Bower and Dave Chorley

Some of these explanations have some basis in fact. There are fungi that can form rings known as fairy rings. Round configurations can also form when cattle are fed bails of hay and form a circle with their heads in the center, depositing manure around the perimeter. Both of these types of circles, however, are simple, uneven and artless, unlike the crop circles being produced today.

It is mind-boggling how quickly the public wrote off the mystery of crop circles when "Doug and Dave" claimed they had constructed all of the crop circles with some boards and ropes. They said they had been sneaking out, night after night for many years to make crop circles, without their wives ever noticing their absence, in between drinks at their local tavern. Dave died in 1996, yet the crop circles still regularly appear every summer in England. Some of the crop circles are forgeries and, to further complicate matters, some crop-circle hoaxers are quite esoteric and claim they are inspired by some unknown source and do their work in a sort of hypnotic state. Some hoaxers say they have seen small balls of light, columns of light, and blinding flashes of light while they were constructing the circles.

Pictures of the "real" crop circles are seldom seen in the mainstream media, especially in England, and have evidently been dropped into the same folder as UFOs,

alien abductions, cattle mutilations, and light anomalies. When the English country-side was closed off to prevent the spread of foot-and-mouth disease in 2001, heavy fines of up to £5,000 were levied against people trespassing on banned land. Instead of decreasing in number, as those who thought all were manmade predicted, there were more crop circles in those areas than there had been in previous years.

Scientists have found ways to tell the hoaxes from the legitimate crop circles, above and beyond the lack of human footprints to and from the sites. The crops undergo inexplicable biochemical and physical changes similar to a baked potato exploding in a microwave oven from excess energy. Plants within crop circles are affected in the following ways:

- Weaving: Plants are woven together in a particular way when they are flattened. Hoaxers cannot duplicate this weaving effect.

- Elongated nodes: The nodes, or "knuckles" in the stems of grain, are elongated but not damaged.

- Individual stalks are laid down without breaking or any other visible damage.

- Blown or exploded nodes: Genuine circles contain many plants with "blown" nodes.

- Dried ground: Soil in crop circles is often inexplicably dehydrated, even after rainfall.

- Increased size: Plant stems increase in diameter from the intense heat, like the stems I retrieved from a crop circle (see figure 60).

- Bent unbendable plants: Canola or rapeseed is like celery and cannot be bent more than 45 degrees without snapping apart. In genuine crop circles, it has been bent at 90 degrees without breaking.

- Altered seeds: Seeds from genuine crop circles grow abnormally. Some seeds germinate faster and need less water. It appears the cause is from the infrared or microwave areas of the electromagnetic spectrum.

- Crop yield: Some farmers experience increased crop yield where circles appeared. (In some fields you can see the formations year after year by the different growth rates in the area where the crop circles once were.)

- Cellular changes: There are microscopic changes in the plants, such as unexplained cell wall enlargement in a crop-circle wheat plant.

- If the circle forms early in the growing season, the plants continue to mature and bounce back to almost normal height.

- Some plants acquire unnatural radioactivity and burn marks.

- The areas within the crop circles show deviations of the Earth's magnetic field.

- Marshall Dudley and Michael Chorost reported on the Internet that 13 short-lived radionuclides were discovered in crop circle soil samples, including tellurium-119m, lead-203, and rhodium-102. These have a lifetime of only days.[6]

Crop circles also affect people and animals. Some animals, especially horses, are hypersensitive to electromagnetic fields. Dogs become agitated and howl on nights the circles appear. Many animals, including birds, cats, horses, and dogs, behave strangely around crop circles and often will not go inside them. Mice will not eat seeds from inside crop circles, and dead animals have been found flattened within the formations. The effects on human witnesses and visitors are myriad and diverse and seem to depend on which crop circle they visit. The problem is that some visitors, possibly due to the placebo effect, have also experienced some of these sensations in hoaxed formations. The symptoms include:

- Perforated eardrums

- Lethargy or insomnia

- Nausea, headaches, faintness, or passing out

- Heavy, tired eyes

- Unexplained time loss

- Red, itchy blotches

- Healing of arthritis, rheumatism, and other injuries (evidently from an anti-inflammatory effect)

- Increased well-being

- Inability to think, count, or remember things; disorientation and confusion

- Addictive feelings and feelings of wonder and humility

- Changes in hormone levels and abnormal menstrual bleeding

- Increased extrasensory perception (ESP)

- Synchronicity

- Curious dreams

- Positive energy and inability to think negative thoughts (raised consciousness?)

- Feeling of being watched[7]

It is little wonder most cerealogists (crop-circle researchers) treat this phenomenon as a spiritual encounter and claim crop circles cannot be understood rationally but must be experienced on a personal, emotional level. Some claim the circles are created by beings from another dimension, by nature spirits, God, or extraterrestrials preparing mankind for the arrival of aliens. They say the legitimate circles are always constructed on ley lines, which are considered gates to other dimensions. Sacred sites such as Stonehenge have been found to be strongly associated with electric and magnetic field anomalies. We are just beginning to understand and measure the geomagnetism of these "power" spots that the ancients must have understood.

"The Crop Circular" at Freddy Silva's website, www.lovely.clara.net, reported the

brainwave frequency of the average person's brain is set at 30 Hz. When a psychic is doing his thing, his brain works at about 7.5 Hz. Stone chambers and Gothic cathedrals somehow act upon brainwave patterns and send them down to about 7.5 Hz, the same rates found in crop circles. This may help explain why some crop circles heighten states of awareness and even foster psychic abilities.

"The Watchers," a group consciousness channeled by medium Isabelle Kingston, claim the crop circles "are created using a combination of thought processes, electromagnetism, and acoustics, all encoded within a light beam." These light beams have been seen, photographed, and reported to the authorities. The Watchers say, "Individuals can communicate with the energies present in crop circles through meditation and projecting thoughts of love."[8]

For more than two decades, Isabelle Kingston has predicted the formation of crop circles with incredible accuracy and has rarely been more than 24 hours off in her predictions. There are also many accounts of group meditators receiving answers to their requests from the crop circles.

The most important question from my point of view is: Are the balls of light and cloud formations of the crop circles the same phenomenon as orbs, vortexes, and ectoplasm, and do the lights actually create the crop circles?

I found on Ed Sherwood's website, www.cropcircleanswers.com, that Ed started to see "balls of light" with his naked eye in 1992. Since then, he has seen these "etheric lights" every day and has seen them transform into "ball plasma" more than a hundred times. These lights come in many colors, sizes, and forms, and can be seen indoors and outdoors, day and night, standing still or moving. Ed has what he calls "psycho-interaction" with the lights and says they are a "co-created psychokinetic phenomenon, involving Infinite Intelligence, Collective Consciousness, and natural physical forces of the Cosmos and Earth."

Crop circle researcher Lucy Pringle wrote in her book *Crop Circles: The Greatest Mystery of Modern Times* in 1999:

> Luminosities, or balls of bright, moving light rather like ball lightning, have often been associated with crop formations. . . . These luminosities can have a dramatic effect on the brain, due to the electromagnetic fields they generate.[9]

Pringle included the account of a crop-circle visitor, Rachael Martineau, who saw a white light moving across a field, which came within fifteen feet of him while it hovered slowly over the crop. Martineau described it as "a mass of tiny, pulsing lights,

shaped like a doughnut." In Bristol later the same day, he saw four big orange balls of light. They measured about three feet in diameter and were seen bouncing into people and being absorbed by them.[10]

In 1991, James Millen, another crop-circle visitor, photographed "a cloud column [vortex?] coming right down to the glyph, with small, white dots in attendance."[11] He saw this in five of his pictures. Chad Deetken and a colleague observed "a strange white mist, in the shape of a horse, heading across the field. . . ."[12] Pringle noted lights have been seen dancing around the stones of the Avebury stone complex in Wiltshire.[13]

Linda Moulton Howe, an award-winning reporter and author with a master's degree from Stanford University, asks:

> Are the mysterious lights an unidentified natural phenomenon? Or are they supervised by an advanced intelligence that humans have yet to encounter? Could the lights be connected to the same ancient intelligence that inspired other marks around the world in ziggurats, pyramids, mounds and stone circles?[14]

One of Howe's books, *Mysterious Lights and Crop Circles*, includes too many accounts to repeat here of spheres of light being seen or photographed before, during, and after crop-circle formations. Crop-circle watchers, like orb photographers, sense an intelligence in the crop-circle makers and the mysterious lights associated with them. Howe also reports numerous accounts of the crop-circle lights reading the watchers' minds, replying to messages, and following some people while avoiding others.

Howe's book features many pictures, taken with a flash at the scene of crop circles, of vortexes that were invisible to the photographers. She describes these vortexes as mysterious arches with internal structure. These arches seem to spiral like a plasma.

Dr. W. C. Levengood is a biophysicist who has examined thousands of plants from crop circles since 1989. Dr. Levengood has concluded they were made by "a spinning plasma vortex with a microwave component and complex lower-energy ion-electron pulses."[15]

What is plasma? It is called the fourth state of matter, after solids, liquids, and normal gases, and makes up 99 percent of the visible universe and probably most of the unseen world. Wayne Moody wrote that plasmas could be influenced by electric and magnetic fields and other subtle energies. "It is the primary substance of the Universe, akin to Prana," says Moody. "Thought-forms can influence it."[16]

A plasma is a collection of ionized particles that produces light from the movement of its atoms' electrons. It gives off electromagnetic radiation that can be detected. Plasmas are found in our atmosphere as extremely unstable entities, which seek stability by forming spheres for a brief moment before disappearing. There is a man-made plasma inside every fluorescent lamp that converts electric power so that the lamp's phosphor coating can produce light.[17] Lightning and the Aurora Borealis are visible plasmas, but most plasmas on our planet are invisible.

The renowned physicist David Bohm discovered that when electrons were in a plasma, they would interact with other electrons and become surprisingly well organized. Bohm was so impressed with their behavior that he said he frequently felt this electron sea was "alive." Trillions of particles behaved as if each knew what the others were doing. Bohm called the electrons with interconnected movements "plasmons."[18]

Dr. Levengood and John Burke explained low-energy plasmas in Howe's book, saying plasmas are normally invisible since they cannot give off enough light by themselves to be seen, but they can be measured with instruments such as an electrostatic volumeter. They are found everywhere, but especially within the ionized air of a lightning bolt. A camera's flash adds enough energy to move the plasma's electrons on the outer edges into a higher state of energy, which is briefly visible as light to the camera's "eye" but not necessarily to the human eye. This is the reason cameras can record plasma that people nearby it never see. Some well-organized plasmas can be photographed during the day without a flash when sunlight or other sources produce high enough energy states within the plasmas for them to be photographed.[19]

Crop-circle researcher Colin Andrews says there are approximately 70 known eyewitnesses to the formation of crop circles so far. These eyewitnesses agree that some sort of air stream flattens the crops. Sometimes a "ball of light" is seen as the source of the air stream, sometimes not. As soon as the circle is formed, the ball disappears.

Dr. Levengood and Linda Moulton Howe have found similarities between residue found in crop circles, UFO landing sites, cattle mutilation sites, and even in homes of people claiming personal encounters with aliens. The residue is generally mineral in nature.

No particular theme runs through the crop circles. They echo philosophical, metaphysical, and religious symbols used worldwide through the ages. I only have to gaze upon these masterpieces to sense some form of incredible intelligence behind them and to sense they are going to great lengths to tell us something without scaring us witless.

Dr. Eltjo Haselhoff resides in Holland and holds a doctorate in experimental and theoretical physics. He has been studying crop circles for 14 years. He published the book *The Deepening Complexity of Crop Circles: Scientific Research & Urban Legends* in 2001. He stresses: "Ever since crop circles have appeared, anomalous light effects have been reported by many eyewitnesses."[20]

Dr. Haselhoff says careful studies of seed germination indicate formations formed in immature crops produce undeveloped seeds, while formations in mature crops energize the seeds so much that they grow at as much as five times the normal rate. Ninety percent of thousands of tests confirmed this anomaly. Dr. Haselhoff explains the musical diatonic ratios found within crop circle designs, which were discovered by the late Gerald Hawkins. He discusses the hidden math and geometry found within the designs. For instance, the Milk Hill formation of 1997 clearly represented a Koch fractal, a nonnatural, mathematical concept invented by the German mathematician Helge Von Koch in the early 1900s.

Dr. Haselhoff wrote: "[T]he hypothesis that 'balls of light' are directly involved in the creation of (at least some of the) crop formations is no longer a hypothesis, but a scientifically proven and accepted fact."[21]

Dr. Haselhoff studied samples from inside and outside two circles, one formation having been witnessed by a young Dutchman on the night of June 7, 1999. These were both simple circles that could easily have been considered fraudulent. The boy saw a very faint pink light, almost white, that looked like a bright star that transformed into an elliptic shape and hovered at about three meters high. A faint light shone down on the field and the air trembled as if it were hot. After the light faded and disappeared, the boy ran out and found a circle in the field. The crop, the soil, and air were still warm. Less than a week later, another circle formed a short distance from the first. Before its discovery, a short, bright white, slightly bluish flash was seen above the field. Another physically warm circle was found where the light had flashed.[22]

Dr. Haselhoff collected 1,500 nodes (the "knuckles" on the stems) and wrote a computer program with which to evaluate them. The node length of samples from within the circle was considerably longer than the length of the control nodes. Even more significantly, however, he confirms Dr. Levengood's earlier discovery that the closer to the center of the circle, the longer the nodes were, and the lengths were perfectly symmetrical according to how far from the center they were found. The further from the center of the circle, where the ball of light had hovered, the shorter the length of the nodes. The growth of the nodes was clearly dependent upon the distance from the center of the circle. Whatever created the circle obviously also caused

the nodes to lengthen. Heat and thermal expansion of the water-filled nodes caused the swelling.[23]

The generation of heat by the balls of light was new to me. The only other light phenomenon usually associated with heat is ball lightning. Most of the other forms, such as those thought to be ghosts, are said to create cold pockets. Dr. Haselhoff thought the colors could be an indication of the temperatures of the BOLs, according to the laws of electromagnetism. Trembling air around the balls could also be from intense heat. That sounds logical, but I wonder why I have never felt a temperature change while photographing, even when an anomaly was very close to me.

Researcher Nancy Talbott of the BLT team claims to have been an eyewitness to another light display in the Netherlands in 1998. According to her acquaintance, Dr. Haselhoff, she saw balls of light hit the roof shingles of a house at a height of about four meters. The balls left clear burn marks on the painted wood. He found

undeniable perfectly round burn marks, with a diameter of about one centimeter. The fact that the burn marks were concentrated along the sharp edges of the roof may indicate a possible electromagnetic character of the curious balls of light, as would be predicted by electromagnetic theory.[24]

Dr. Haselhoff thought these marks could help explain the narrow tracks of flattened crop leading from the crop circles to the edge of the field they were in. Sometimes there were two tracks, with one directed toward the circle and the other leading from it. The tracks were the width of a handful of stems and much narrower than a human foot. Haselhoff suspects they may be tracks left by balls of light flying into and out of the crop circles.[25]

I already was certain my friendly lights were involved in the formation of these mysterious circles, or were at least extremely interested spectators, when I heard of the videotape, *Contact with the Unknown Intelligence Behind the Crop Circles*, produced by Bert Janssen and Janet Ossebaard in 2001. The video depicts balls of light looking like some of my orbs and behaving just as I suspected they would.

The film also shows one orb splitting into two orbs, another disappearing, and many casually flying around crop circles. It captures a bird chasing after an orb, then avoiding it when it gets close enough to see what it is. The film includes examples of precognition, telepathy, and the orbs performing requests made in a human group meditation. The film clip of orbs actually forming the Oliver's Castle crop circle, which is now widely considered fraudulent, is included, but as so much more incredible evidence is presented, that does not negate the incredible overall impact of the film.

The film's producers claim England's military denies the existence of the lights even though the film shows military helicopters chasing the BOLs. Sometimes these helicopters appear just minutes after crop circles are formed. I suppose it could be possible they cannot see the lights, just as some people in a crowd cannot see orbs while others can, but that still leaves the question of how they could chase something they could not see.

Janssen and Ossebaard consider the possibility the orbs may be ghosts and quote Carl G. Jung as saying, "Ancestors are still in our midst, appearing at times as light spheres." They feel whoever/whatever is behind the crop circles is on the verge of making conscious contact with humanity. I sense "they" are gradually introducing themselves in a nonthreatening manner so that our skittish population won't be frightened of them. Orbs all over the Earth are behaving in the same way. They are obviously capable of harming us if they chose to. If that were their intention, why wouldn't they have done it long ago?

Visit to an Oregon Crop Circle

Just as I was starting to crave a trip to England to visit some actual crop circles, I heard on the news that one had been discovered about a week earlier on July 7, 2002, near Forest Grove, Oregon, about 40 miles from where I live. My husband, Stan, and I were at the site within two hours. We got permission from the farmer who leases the field and lives about a half-mile from there, and walked around in the circle, taking pictures. The perplexed farmer said some visitors said they discovered the circle before he did by "following the energy." The 114'x 96' pictograph (in the shape of figure 59) was located in a ripe wheat field surrounded by paved streets and housing developments. Many power lines are in the area.

The coordinator for the Oregon branch of the Center for Crop Circle Studies (CCCS), Carol Pedersen, had already examined the circle and thought it was more likely the real thing than a hoax. She noted that the circle was perfectly aligned north-south, and, if pranksters had flattened the wheat with ropes and boards, the seed heads would have opened, and there was no evidence of that. The multilayered sprays, fans, and brushed effects within the circle, she felt, were consistent with legitimate crop circles she had investigated. Also, the swirls were created from the outside in, unlike most circles made with ropes and planks.

Pedersen observed elongated nodes in the wheat stems and intact wheat heads on the bent but not broken stalks. She noted the circle resembled ones found in England in the early 1990s and one found in Washington State in 1993. It was only

15 to 20 miles from where two Oregon circles were discovered in 1994. She, the farmer, and the photographer all felt various sensations as they entered the formation. Pedersen gathered approximately 600 stalks and 27 soil samples from the formation and from some "randomly downed" areas from the west end of the field, and more than 200 control samples in 95° F heat to send to Dr. Levengood.

I didn't want to wait for Levengood's report, so, as randomly as possible, I took some stalks from within and outside the circle, cut out the node areas, lined them up and photographed them. As you can see in figure 60, there is a slight difference between the two sets of nodes, especially in the thickness of the overall pieces. I felt no sensations within the circle, but my husband felt tingling, like static electricity, up his back. My pictures did not reveal any orbs around the week-old design, but they almost never do when I shoot during midafternoon in bright sunlight.

A teenager appeared on television reporting that other teens had made it with boards and rope, but he could not reveal their identity. A picture of an extremely rare funnel cloud which had formed in the north section of Forest Grove on Sunday, July 7, was shown on the news broadcast. At least one news broadcast included how the fictitious and fear-based movie *Signs,* about aliens and crop circles, was scheduled to debut a few weeks from then, and that didn't add to the formation's credibility either.

Pedersen determined the circle was first discovered on Friday, July 5, 2002, which was before the rainy Saturday or Sunday the teenager named as the time it was created. Another witness saw it on July 7 and said there was no pathway leading into the formation at that time. On July 8 the same witness noticed a path had formed leading into the circle.

I also checked some websites to see if that field is on a major earthquake fault, as many parts of Oregon are. On www.oregongeology.com, I found a map that showed that general area is on a known fault that has not moved recently. The evidence pointed to authenticity, but I could not get myself to believe a genuine crop circle had formed in my area just as I was writing this chapter!

Imagine my delight when Dr. Levengood completed his analysis and concluded the circle was genuine. He concluded there was a 99 percent probability the node expansion and the magnetic particles in the soil within the crop circle were not due to pure chance. The key bar areas (shaped like an F) exhibited the highest number of expulsion cavities and magnetic particles. (I hadn't taken any of my samples from that area.) Levengood noted it was the first time he had found a high level of node expansion in plants left upright within a crop circle. He has in the past been able to duplicate these effects with a common microwave oven.

In all of my reading I had never learned that many circles have small randomly downed areas in the same field that form no pattern, as if the circle makers had practiced a bit before beginning the real thing. Pedersen included samples from the squiggles of downed wheat found in the west part of the field, and they showed changes that were even greater than some areas of the main formation.

The memory of this crop circle is very special to me. It felt like a message from my lights that they were paying attention to me paying attention to them. The Pacific Northwest seems to have more than its share of paranormal events, UFO sightings, animal mutilations, crop circles (21 on record since 1993), and spiritually minded residents. These add to the region's magnificence, but as we Oregonians like to say, "Please don't move here!"

Figure 58: I took this shot of the largest circle of the Forest Grove formation, facing south.

Figure 59: Design of Forest Grove, Oregon, crop circle, found 7/7/02. Drawn by Carol Pedersen, editor for *Crop Circles Commentary,* October 2002. Reprinted with permission. The design reminds me of a story about The Watchers, channeled by Isabelle Kingston, who told Kingston they would give her "the key." She was anticipating the answer to everything. Two days later, a circle appeared with a part of it in the shape of a key[26]—that marvelous sense of humor again. © 2002 by Carol Pedersen

Figure 60: Nodes I took from the crop circle are on left-hand side; nodes from outside circle are on right-hand side. Nodes are located in the centers of the stems. The crop-circle samples are noticeably larger.

14 Angels, Guardian Angels, Spirit Guides, Higher Selves

> "Every blade of grass has an angel bending over it saying, 'Grow, grow.'"
>
> —*The Talmud*

When one solitary blue orb repeatedly appeared in pictures of one of my flower beds (see figures 61a through 61e, center section), I began to consider the possibility of orbs being angels. Rather than frightening me, my light forms give me a feeling of comfort and protection.

Belief in angels is one of the few things world religions have in common. Zoroastrianism, Judaism, Christianity, and Islam all believe in angelic beings. Christianity divides the angels in half: the evil half are demons, servants of the Devil, and the protective half are guardian spirits. Characters assuming the same roles exist in worldwide mythologies.

The ancient Greeks called angels "daimons" or "daemons" who could be either good or evil. Shinto, a philosophy/religion of Japan, believes in Kami, who are thought to intervene in the affairs of humans for either good or evil, as do demons and angels. Even Wiccan and pagan groups call upon angels in their practices. Gnostics believe angels live in a world of mystical light between the Earth plane and the "Transcendent Causeless Cause." Jungian psychology has the Higher Self, who

looks out for one's well-being and communicates with the waking conscious through intuition. A "vision quest" among Native Americans was the search at puberty by boys and girls to find and meet their own guardian spirits.

Spiritual hunger has been on the increase for the past decade. Even in 1993, a *Time*/CNN poll found that 69 percent of Americans believe in angels and 46 percent believe in the existence of special guardian angels. A poll by Barna Research Group in 2000 found 81 percent of Americans believe that angels exist and influence lives.

Belief in guardian angels (spirit guides or higher selves in some circles) is becoming more en vogue as global communication unites the world. Most of the conflicts around the world have been and are being waged in the name of religion. Hopefully, we are waking up to the fact that if the world does not find some common bond, we are going to destroy ourselves.

I think most Americans would agree they grew up thinking God and Santa Claus knew their every thought and were recording all of their good and bad deeds—and judging them. It is no surprise that so many fall away from their faith so they can be free of that horrible feeling of being critically watched at all times. One can easily decide there is no God, just like she eventually stopped believing in Santa Claus.

Angels, and especially guardian angels, are another story. No one thinks of an angel as a judge. The thought that one or more angels are watching over each of us to protect us is much more comforting than worrying about displeasing an easily angered God. It is also more believable that a personal angel could actually know your every thought and action and still love you and want to help you. I suspect that is why many people believe, or at least want to believe, that orbs, mysterious lights, mists, vapors, and apparitions are angels. Perhaps they are, but we get into another problem with names. Some, including me, have a slightly negative feeling towards the very word "angel." It brings up unpleasant memories of church to some and visions of gullible airheads to others. But the concept is ideal. If people actually believed orbs were constantly watching, helping, and loving them, doing what they've always hoped God was doing, the world (drum roll, please) would be a better place.

Gustav Theodor Fechner, who was a professor of physics at the University of Leipzig, wrote in his book *Comparative Anatomy* that angels are spherical in shape and they speak to mankind with symbols of light.[1]

One of the first persons who saw the photo of Libby's death referred me to a friend of hers who had been collecting those types of photographs for years. I started corresponding with and eventually met the woman known as the "Angel Lady," Reverend Dorothy Leon, in Grants Pass, Oregon. I like to think of her as the pioneer of light photographs. Dorothy channeled "St. Germain," her spiritual mentor, for

eight years. She was guided to build a round church and she pastored it for many years. As part of her ministry in the 1980s and early 1990s, she presented her pictures as a "Light Slide Show" to many organizations, especially the Religious Science churches. A very sweet and generous woman, she offered to give me her entire collection of slides, but I couldn't bring myself to accept. Dorothy has published many books, including one about light photographs entitled *Reality of the Light.*[2]

I noticed immediately in her *Light Slide Show* video that some of her light forms were nearly identical to mine, while some were quite different. I only saw one single ordinary orb, other than small, bright lights, in the entire video. In one of her letters to me, Dorothy, who says she has seen angels from childhood and is aware when they are present, wrote that she had been told the little, bright white circles were the manifestation of angels, while the larger, irregular golden "globs" were guardian angels or masters. She added:

> We only dealt with angels and masters from the higher realms, who are in the spiritual (etheric) realm. Spirits (ghosts) are in the astral plane. Our spiritual guidance was to always go beyond, or bypass, the astral. Whenever you're dealing with the spiritual (etheric) realm of angels and masters, the "Light" seen is not a greyish-colored "ectoplasm," but a golden-colored spiritual radiation. Ghosts do not have access to this fiery Light. Since they cannot manifest it, they draw "ectoplasm" from their "medium" or the group through which they are working. Hence, "ectoplasm" is cloud-like, drifting and nebulous, while "Spiritual Light" is directed to specific areas.

When I sent Dorothy the picture of Libby's death scene, she replied: "Your photo of Light in the pet clinic seems to be healing energy. Perhaps an angel is radiating healing. Such angels often appear in hospitals and clinics."

My translucent and colored orbs were new to Dorothy and had her baffled. If the orbs are angels, she thought they "must now be out in great mass." She showed the orbs to an "elevated, psychic Hindu healer" who said they were astral forms, entities, or spirits. Another view came from a "totally clairvoyant prophet." He told her at this point in history, due to the slowing of the Earth's rotation, we are seeing through the veil into the fourth dimension and the orbs are part of that other world.

The hundreds of pictures in her slide show were taken before the invention of the digital camera, which may account for some of the differences between hers and mine. Some would never stand up to a jury of skeptics, but others are the most impressive pictures I have seen. I don't believe Rev. Leon is capable of deception, but

I don't know which photos she took and which were given to her, so I cannot swear to the authenticity of the entire collection. She had a different language to describe the lights, but what I call vortexes were everywhere, and they looked just like the vortexes being captured with digital cameras today. Dorothy calls the rings inside the vortexes "the thirty three coils to the ascension flame." There were also many cloud-like formations, pillars, and fiery streaks of light.

The spiritual implications of her collection make them most noteworthy. Nearly all of the photos she had taken at her church or her country retreat were Polaroid pictures. One meditator clearly had seven flames on his head. Her pictures featured several healers with fiery lights around them or the person they were healing. At times the light would connect the healer's palm with the place in need of healing. I have very seldom seen this gold-red flamelike light in other pictures. One healer often had dots of light in her hands and a light in the area of her third eye. Forms in the shape of a dove accompanied some subjects. Other pictures showed groups "invoking the Light" or making "thought-forms for peace." Lights, streaks, fog, or clouds came from the participants' hearts, mouths, and noses and formed above the groups, sometimes shining down on them.

Rev. Leon made the astute observation that angels and saints are depicted with wings and halos because of the formations of light around them. She said the momentum of Light radiating from their heart chakras resembles wings while Light from their crown chakras resembles halos. She also came to the same conclusions that many orbsters have as to whom the lights love to be around. "The Light loves babies," she said, and also those who are joyful or in need, weddings, musicians, gardens, art, and artists.

Stan and I have attended several seminars presented by author and lecturer Dr. Doreen Virtue, who is also called the "Angel Lady." She teaches that angels and/or archangels always accompany everyone and that animals also have two or more guardian angels around them. Dr. Virtue feels many pets are on an angelic assignment to give humans solace, comfort, and companionship and to absorb our stress. She believes nature also has its own angels, such as faeries and devas. (Fairies, gnomes, dwarves, undines, sylphs, salamanders, devas, etc. are also known as elementals in some circles and are said to commonly appear as lights.[3])

In 2001 I took pictures of Dr. Virtue "reading" audience members when she was in Portland, Oregon. The majority of the shots had a rather large, faint, white orb above their heads. When she saw the pictures, she said the orbs are angels. A participant at a July 2002 mediumship class told me Dr. Virtue spoke about orbs during the class. She told them the orbs, which she can see and communicate with, are fairies, angelic beings, and spirits of animals.

Ghost hunters insist ghosts are everywhere; others say angels are everywhere; UFOers say UFOs are everywhere; and there are more and more photographers who are finding light anomalies everywhere. Could they all be one and the same thing?

Human nature certainly will not help solve this mystery very soon. Even though most religions and most people believe in angels, as soon as they sense something unseen, many automatically label it "evil," dismiss it, or try desperately to get whatever it is to go away. Even I don't especially like the idea of orbs watching my every movement and hearing my every thought, if that is indeed what they do.

I have heard television exorcists and ghost busters say that hauntings are a result of worshipping or invoking evil. All spirits hanging around are presumed to be fallen from the grace of God. Just how many people do you know who actually worship Satan or ask for evil to come to them? The unknown is not necessarily "bad." That bump in the night could be your guardian angel letting you know she is with you. It's no wonder they don't appear more often!

There are also those who feel the "angels" around us are actually ghosts. Physicist Dr. Friedbert Karger, who studied life after death for at least thirty years, said in an interview with David M. Traina, Jr., that most so-called angels are actually deceased friends and relatives who seem angelic because they are from the Other Side and are infused with light. He said:

> We should be aware of the fact that real angels are much higher than human beings, and what we usually call angels are spirits or souls of people who lived here on the earth but now have other tasks to perform, for instance, to help people.[4]

Emanuel Swedenborg was an eighteenth-century Swedish mystic who claimed to commune with angels in his mystical trances. He maintained angels once lived as men and women.

So-called angels are most often seen in human form, sometimes with wings, or as large balls of colored light. *The Encyclopedia of Ghosts and Spirits* defines angels as supernatural beings who deliver messages and mediate between God and mortals. This encyclopedia also notes that deceased loved ones appearing as a spirit are also commonly called angels.[5] The Bible presents angels as incorporeal (without a body or substance) but with the ability to assume human form or present themselves as beings of fire, lightning, and brilliant light, with or without wings. They also appear to humans in dreams and visions.

Encounters with angels are either becoming commonplace or are just more

publicized. Angels are sensed, heard, or actually seen as apparitions in white robes or as balls of brilliant white light. Stories of angels mysteriously appearing in human form or invisibly interceding in moments of crisis, solving problems and then vanishing, are suddenly everywhere.

Barry H. Downing, a Princeton-educated theologian and Presbyterian minister, has long believed biblical angels are beings from another dimension who have come to help mankind throughout the ages. He explains in his book *The Bible and Flying Saucers* that they may coexist in another universe which might be the Heaven spoken of in the Bible. These angels or "UFOs" may have guided the Israelites out of Egypt as a "glowing pillar of fire," parted the Red Sea, helped Elijah and Christ "ascend," given Moses the Ten Commandments, created the Star of Bethlehem, blinded Paul on the road to Damascus, and appeared to many key figures in the Bible. "We could approach religion from a scientific point of view that (in the long run) would unify the church and reinforce faith."[6]

Early on in my orb-hunting career, I took a picture that still amazes me. At the time, my husband and I belonged to a spiritual group that met in West Linn, Oregon. On June 13, 2001, author and group member Vicky Thompson was leading the group. She ended with a prayer, and I snapped a picture of the corner of the room I was facing (figure 62, center section). No one saw the big, pink ball of light in the corner or sensed the tornado-like energy swirling around it.

I wish that mirror had not been in the corner. Skeptics, I'm sure, would try to call the large, pink orb some sort of reflection from that mirror. I have taken hundreds of shots in that room and have never gotten any out-of-the-ordinary effects from that mirror. Besides, no mirror could produce the effect of swirling energy and the moving orb within it. Orbs very close to the camera can look like this orb, except they normally bleach out to a white color. Also, this would not account for the energy swirling around the orb.

At the time I did not know Vicky gives a description of angelic beings that explains the image in my picture in her workshops:

> Seen with the physical eyes, angelic beings appear as sparkling dots of light, surrounded by wavy lines of energy. Angels look like bubbles in the rain: shimmering, luminescent arcs of light surrounded by moving energy.[7]

In her inspirational book *The Jesus Path: 7 Steps to a Cosmic Awakening* Vicky makes many references to light. In a chapter that describes the spiritual awakening of Jesus, a light orb visits him. Jesus identifies the ball of white light as an angel and refers to pink energy as a sign of love.[8]

In *The Jesus Path*, Vicky channels Jesus:

"When I say I love you, I am love in that moment. And I say to you, I love you all. See now what love is," said Jesus, as a misty pink light began flowing from his hands and eyes, surrounding and filling the entire room.[9]

"From light to light, you are created and so shall you return to the divine as light.[10]

"You exist on a denser, lower frequency. We exist right within your world on a higher frequency. If you take away the barrier of separation, you can see us in your world. The barrier acts as a screen, keeping out the higher vibrations and allowing you to perceive yourself as having a separate experience from the divine. Truly, you are not, for we are always here with you.

"As more people break down the barrier between their human selves and divine selves, more divine energy will filter through and you will begin to perceive the divine world around you. You will begin to perceive your higher spirit-self, your angels, your guides and other ascended beings around you. You will perceive light in a new way, for light energy is the lifeblood of our existence. Light is abundant and great, full of flowing, moving energy that can be shaped to create incredible worlds of great depth. Believe me when I say to you that light energy is the basis of this all. Light moves quickly, changes quickly. When this barrier breaks down, things will change quickly."[11]

You can view a moving Web movie with indirect references to orbs called "The Light of the World" on Vicky's website at www.journeywithspirit.com. In October 2002, Vicky wrote this in an e-mail to me:

Orbs are what we are, truly. As I've journeyed deeper into my own Spirit, I've found that we are no more than orbs of energy, expanding out into the world around us. I've had some meditations when I've encountered millions of orbs on an energetic level. We are no more than orbs traveling together through a strand of space.

Some of the best evidence of people being constantly accompanied by their guardian angels is what are usually called "personal orbs" on the Internet. Orbs with distinctive features are found with the same person or animal over and over again. As I looked through Peter's and my shots, I repeatedly found Peter's Big Boy (in fact, many Big Boys at once)

in his shots (figure 15, center section), an orb with a V on it with our grandson, and an orb resembling a bull's-eye with our dog Max. Nearly all the V and bull's-eye orbs appeared during a six-month time span when I was actively searching for them.

For more than two years I had taken hundreds of pictures of our grandson Christian. Not one orb appeared in his photos until I strategically gave him a flashlight and let him walk outside in the dark. My hunch was right. The orbs appeared, apparently to protect him. I found they were also there for fun or protection when he and his grandfather wrestled, an activity they both love but that sometimes proves hazardous to Christian.

At first I noticed there was nearly always an orb close to Christian with some sort of notch out of the side. As I got more examples, a clear V could be seen in some of his orbs if that part of the orb was turned toward the camera. A clear pattern developed. Christian seemed to have his own personal orb. The next several pages are some of the clearest pictures I got of his V orb (see figures 63–69). Figure 70 shows two orbs guarding Christian closely. One may be the V orb.

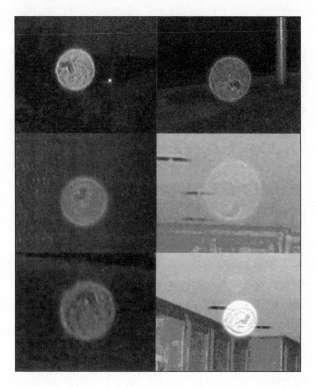

Figure 63: Six enlargements of Christian's V orb pictured in the following photos.

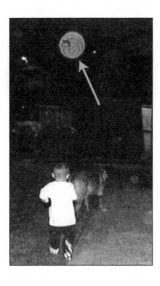

Figure 64: Christian and Max with V orb.

Figure 65: Christian and Grandpa with V orb.

Figure 67: Christian with V orb.

Figure 66: Christian with V orb.

Figure 68: Christian with V orb, bright orb, and other faint orbs.

Figure 69: Christian and Stan wrestling with V orb and pets supervising. The faint orbs admittedly could be dust.

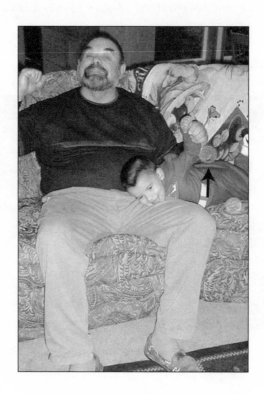

Figure 70: "Superkid" Christian with two chaperones during a wrestling match. The orb under his arm may be the V orb.

When I started looking for "guardian orbs," they obliged. Soon I noticed our dog Max's orb. He often had an orb resembling a bull's-eye following close to him in many pictures. Then again, the V orb sometimes accompanied Max. Possibly the V orb was actually following me.

Skeptics would say orbs with the same features are somehow caused by the particular camera taking the pictures. When the features are nearly identical in each shot, I would agree it could be a fluke of the camera. Christian's V (or whatever it is) and Max's bull's-eye were different in each picture, seemingly dependent upon which direction the orb was turned and which part of the rotating ball faced the camera. Plus, there is only one such orb in each picture. I cannot for the life of me understand how the camera would cause one of these distinctive orbs to appear in the same picture alongside orbs without these markings, especially when they are in a different spot in each shot, have different levels of brightness, and are even different colors at times. Another question for the techies.

Author Brad Steiger also found evidence that personal orbs follow their charges: "Over the past forty years, I have received so many reports from people who have moved across the country only to find that the same strange globe of blue light that manifested in their bedroom in New Jersey is hovering above them in New Mexico."[12]

Members of the Yahoo! group "Universal-Orbs" (http://groups.YAHOO.com/group/universal-orbs) regularly send in pictures of what they consider to be their personal orbs. Recently I found an article about an investigation by the Mon Valley Ghost Research Society (MVGRS) in southwestern Pennsylvania, during which they videotaped what seem to be guardian orbs. MVGRS has five active members who conduct investigations. Rene Kruse, the team leader, holds a Ph.D. in industrial engineering from Texas A & M and has been a professor of applied engineering at California University in Pennsylvania for twelve years. Dr. Kruse has been doing ghost research for twenty-five years.

The household under investigation consisted of two parents and three children. The four-year-old boy experienced night terrors, and the mother thought a ghost was to blame. During the investigation, the boy awoke and started crying. Just seconds later, a monitor caught several orbs going up the stairs and through the boy's bedroom door. In the bedroom, a camera filmed the orbs as they came through the door and moved to the boy, hovering over him. The child then lay back and fell asleep. Dr. Kruse wrote: "It appeared that we had detected a spirit/ghost that had comforted or calmed the boy, rather than awakened him. The people watching witnessed this in real time with the monitors downstairs and the two witnesses upstairs."[13]

I hope I have clearly explained how the orbs seem to behave as we would expect

angels or guardian angels to act. The question of who or what orbs are could merely be one of semantics.

15 Ghosts, Spirits, Souls

"Those who are dead are never gone. They are there in the thickening shadow."

—*Binago Diop, Mali poem, from Indigenous Religions*

"Thine own consciousness, shining, void, and inseparable from the great body of radiance, hath no birth, nor death, and is the immutable boundless light."

—*The Tibetan Book of the Dead*

Written references to ghosts extend back to Herodotus, a Greek historian from the fifth century B.C., who wrote the story of Periander's wife returning from the dead to help Periander find a lost object.[1] Around 2000 B.C., the ghost of Gilgamesh's friend Enkidu was a character in the Babylonian Epic of Gilgamesh, which was etched in clay tablets.[2] If I had to choose which is the most widely held theory as to what all or at least most of the light anomalies are, it would have to be ghosts, spirits, or souls. Evidence also supports this theory.

At funerals, I have taken photographs of orbs, which the grieving instinctively felt were their loved ones, that have comforted those in grief. The photos serve as confirmation of an afterlife to many—a kind of sermon in a picture.

Eighty-five percent of all so-called hauntings and ghost sightings are found to have other causes, but the other 15 percent are still mysteries. Ghost investigator

Hans Holzer claims existence beyond death is firmly established scientifically and evidence is available to anyone who seeks it. He writes:

> Belief is uncritical acceptance of something you cannot prove one way or another. But the evidence for ghosts and hauntings is so overwhelming, so large, and so well documented, that arguing over the existence of the evidence would be a foolish thing indeed.[3]

Some writers describe ghosts, spirits, and even souls as being different entities. Others interchange the three terms. The distinction between ghosts and spirits seems to be how aware they are of their surroundings and how earthbound they are. Ghosts are often described as the surviving essence of people who have died but do not realize they are dead, or who are somewhat aware of their passing but do not want to leave the area. They are almost always harmless, but they may behave like psychotic human beings. Even real-life psychotics are rarely violent. When these earthbound entities do cause problems, experienced ghost hunters call them "ghosts with an attitude" rather than "evil." These ghosts are attracted to negative energy like white cat hair to black clothing. Avoid negative, fearful thinking and I believe you will not encounter these disturbed souls.

Many people fear ghosts because the media broadcast so many stories of people who claim to have been attacked, molested, choked, or tormented by a demonic being. Always skeptical of the paranormal, scientists explain that most, if not all, of these claims could be due to a common sleep disorder called sleep paralysis, often called a "night hag." It has been estimated one in six Americans has had this experience at least once.[4] According to this theory, while you are dreaming, the body normally shuts down the mechanism that allows you to move so that you will not physically act out your dreams as a sleepwalker. Sometimes this system malfunctions, usually just as you wake up or as you go to sleep. You are wide awake, yet still in a dream state, not able to move, with the feeling that you are being held down by some unseen force.

This supposedly stimulates your unconscious mind to invent a dream (called a hypnogogic or hypnopompic hallucination) to fit the situation. From there on, your "nightmare" depends on what your unconscious has invented to explain not being able to move, and the dream can seem terrifyingly real. This experience has been reported throughout the ages in every culture.

Symptoms of a so-called night hag also closely resemble accounts from alien abductees, who claim to have experienced these problems even before they realized

they had been abducted on different occasions throughout their lives. They remembered the symptoms but had evidently been made to forget the parts about the aliens until later abductions. Sometimes for years all that remained was their memory of terror—terror, I think, from experiencing the unknown, not necessarily from being harmed by the aliens.

I have heard some exorcists explain how this period of paralysis is the time a spirit enters and "possesses" the body. The media and the Church reinforce a belief in demons and evil ghosts, so victims are more likely to seek an exorcism than a specialist in sleep disorders when they actually suffer from sleep paralysis. I personally believe exorcisms work only when the "possessed" truly believes in exorcism. If the sufferer believes the explanation that the living nightmares are caused by sleep paralysis, this will eliminate their fears, and the "demons" will depart. My newfound belief that one creates one's own reality works for me. It's an easy explanation for practically everything. You certainly don't have to agree with me. I may change my mind tomorrow, anyway.

Ghosts reportedly cannot tell the difference between day and night. They are usually seen or sensed in the still of the night because there are fewer physical disturbances then and it is easier for them to be noticed by living persons. Ghosts are in trouble; they are not troublemakers. On his website, www.ghostweb.com, Dr. Dave Oester listed the most common pranks of a playful ghost, which account for 95 percent of all hauntings, as:

- Footsteps in the hallway or attic
- Low voices
- Muffled voices
- Objects vanishing
- Objects being moved
- Dark shadows on the wall
- Appliances and lights being turned on and off

- Strange odors
- Dogs and cats behaving strangely
- Your name being called
- Impression someone is watching
- Footprints appearing
- Strong negative emotions felt

Spirits are more often thought to be what are left of those who die in a more normal manner and who accept their passing. They successfully enter into the next dimension, where they can think, reason, feel, and act. They can even return to this dimension if and when they want to. If they come back to protect a living person,

they could be called "guardian spirits," but I feel they are more appropriately named "guardian angels" in that role, so I included that type of spirit in the section on angels.

Psychic imprints have no life of their own and are like photos of an event, but, since they could possibly be creations of the mind, they may not belong in this section either. They could be the electromagnetic field created by the departed person that leaves an imprint in the atmosphere that never dissipates. The second law of thermodynamics says energy cannot be destroyed; it can only change form. The human body is made entirely of energy, so it must change into something after death, whether it be a psychic imprint, a ghost, an orb, or whatever.

Poltergeists (a German word meaning "noisy ghosts") are sometimes defined as manifestations of the excess untapped sexual energies of young children, adolescents, and the mentally handicapped. I have read so many times that ghosts or spirits must use energy from their environment to be seen or sensed that I am effectively brainwashed and believe the activity often seems to originate from these persons only because of the abundant energy they exude for the poltergeist to use.

Lucy Keas, the founder of the Michigan Ghost Hunters Society, says, "Entities are energy-based and have the ability to steal energy." They have drained the power from battery-powered equipment she has used in investigations. "I do my best," she says, "to avoid getting too angry or too scared, so that I'm not providing energy that the entities need to manifest themselves."[5] (Incidentally, Keas thinks orbs are the newly formed souls who haven't learned yet how to manifest in other shapes.[6])

Dr. Alex Docker was my counselor while I was working on my doctorate from American Pacific University. He told me he personally witnessed orbs in the room of his teenage daughter and heard knocks on her door when no other living person was present. Rather than add yet another category, I think poltergeists belong under the heading of ghosts—ghosts that feed off the excess energies of certain people.

And souls—God only knows what they are! Dr. Michael Newton is a past-life regression therapist who has published two books on his clients' existence between lives where souls describe their existence as colored bubbles of light. Dr. Newton gave the following definition of the soul, which I think could be a description of orbs:

[The soul is] intelligent light energy. This energy appears to function as vibrational waves similar to electromagnetic force but without the limitations of charged particles of matter. Soul energy does not appear to be uniform. Like a fingerprint, each soul has a unique identity in its formation, composition, and vibrational distribution.[7]

One of Dr. Newton's subjects, while experiencing his existence between lives, explained how spirits can change shape at will: "The spirit has a diversity and complex fluid quality beyond my ability adequately to interpret."[8]

Most of Newton's subjects described being shaped like ectoplasm or orbs during this period. They had the same vocabulary problems I've had throughout this project. They called themselves and other souls "glow worms bulging out in places," "floating trails of balloons," "clumps of huge, translucent bulbs," "giant bunches of transparent bubbles," "bunches of moving lights," "fireflies," "glowing fragments of light," "kind of cloudy-like . . . blobs of energy," "clusters of bubbles that are smooth and transparent with souls inside," "clouds of cotton candy," and "masses of dots hanging in clumps . . . as hanging grapes, all lit up."[9] Dr. Newton says the "energy of the soul is able to divide into identical parts, similar to a hologram."[10] (Videos of orbs splitting into two or more orbs are becoming commonplace.)

As usual, I found another person who had almost the same answers, but not quite. Dolores Cannon hypnotically regressed a subject in her book *Jesus and the Essenes* to the time between lives, and the subject mentioned "smaller beings of light and essences."[11] The same person later described the beings of light:

> It is those, some of us, who are beyond the need to return again. Who are the next step with being one with God again. They are those who come and help and guide us in many ways, in directing our path.[12]

These results from regression therapy are very strong evidence for the orbs-as-souls theory, except for the possibility that the hypnotic subjects are picking up the answers from some source other than the past, such as from their imagination or from the therapist's mind. If these souls come back to help mankind, though, does that make them angels or are they still ghosts?

Yogi Paramahansa Yogananda, who founded the Self-Realization Fellowship in 1990 to carry on his worldwide spiritual and humanitarian work, wrote of his search for the soul of a favorite student in *Autobiography of a Yogi*: "He was a soul vibrating with unfulfilled desires, I realized—a mass of light floating somewhere amidst millions of luminous souls in the astral regions. How was I to tune in with him, among so many vibrating lights of other souls?"[13]

James W. Eaton of www.ghoststudy.com thinks spirits are more likely to take the form of ectoplasm or full-bodied apparitions, while ghosts normally appear as orbs. He thinks spirits are made of a finer substance than ghosts and are much harder to detect. They will not be evident on ghost-hunting equipment or in photographs, he

writes, unless there is a special reason for them to be. This would help explain why orbs are so much easier to capture on film than the other light forms, but there are differences of opinion on the forms ghosts and spirits assume.

Jason Rich uses the terms "ghost," "spirit," and "soul" interchangeably in his *The Everything Ghost Book* and says all three may appear as floating balls of light, orbs of energy, mist, vapor, vortexes, and as humanlike apparitions.

Dr. Alan Meyer does not waste time quibbling over terminology in his compelling video *Ghostwalker: A Haunting Study*, produced in 2000 (http://alanmeyer.com). Dr. Meyer obviously assumes the orbs are ghosts and, using infrared digital technology, he has videotaped orbs in mausoleums, cemeteries, and buildings with violent pasts. The video clearly shows sequences of orb behavior and the variations in speed, direction, size, and intensity that still photographers have suspected but could not prove. The orbs' movements are lifelike as they demonstrate they have emotions, intelligence, and attitude. Some orbs bathe in the spotlight while others hide from the camera. Some prefer solitude; others travel in groups. They become more active when people and cameras are present.

Dr. Meyer calls orbs "seemingly intelligent, alive entities which appear as moving lights on infrared video." He says orbs are sensitive to the hot center of the infrared beam. He has found the activity is intensified at crossroads, or where two hallways meet. He uses bells, chimes, and music to elevate the spiritual level and attract orbs, and dowsing to help detect the presence of spiritual energies.

The orbs seem to accompany the investigators in this video, even bouncing up steps after them and passing through walls and human bodies. When an orb passes through a person, most feel a chill going through them. Some orbs have a winged appearance, some look like squiggles, but most are small and spherical. Dr. Meyer speculates they may use the energies of people around them, especially young adolescents, to manifest. He recommends using extra flash for outdoors or large rooms. (Extra flash units can be attached to some cameras, or a slave unit, which will flash at the same time as your camera's flash, can be placed on a tripod in front of the camera.) The flash on a regular camera is sufficient for small rooms.

I am sometimes discouraged with the seemingly endless number of natural causes for light anomalies. Dr. Meyer's video dispels all doubt from my mind and presents the best case for the reality and personality of orbs I have found. Similar videos are becoming more and more common. My brother Peter easily captured an orb in his backyard speeding above and through a tree after only a few tries with his Sharp WD-450U camcorder mounted with an ITT 3rd Generation night scope (see figures 71a–d).

At times orbs appear to be trying to tell photographers what they are. Jim and Gretchen Costa were featured in an article entitled "Ghost Orbs Haunt Couple's Snapshots" in *Florida Today* in October 2001. The Costas were getting orbs in their family pictures and could not determine what they were. Then they visited Fall River, Massachusetts, and stayed at the Lizzie Borden Bed and Breakfast, where Lizzie supposedly slaughtered both of her parents in 1892. Their pictures of the floor where Lizzie's stepmother died and the sofa where Lizzie's father was killed revealed one orb, and only one orb, in each spot, leading one to believe the orbs are the ghosts of Lizzie's parents.[14]

Nearly any book of ghost tales describes balls of light, mists, shadows, and clouds associated with the presumed presence of ghosts. Sometimes the animals in the stories act strangely, such as following something with their eyes, batting at nothing, or running from the room.

Lloyd Auerbach, M.S., is a parapsychologist, author, and the founder

Figures 71a–d: Part of Peter's video sequence of orb streaking through his backyard. It is the moving light to the right of the tree. The three lights in the background are house lights. Taken with a Sharp WD-450U camcorder. © 2001 by Peter Clemmer

of the Office of Paranormal Investigations (OPI) in Orinda, California. He defines ghosts as "consciousness or pure mind, created from energy."

Auerbach had the opportunity to speak to a female ghost he encountered. He asked her what it was like to be a ghost and she answered (telepathically, I assume) that she was a ball of energy but she could appear in any way she wished, depending on how she felt about herself that day—an old lady, a child, or whatever. She said she didn't try to communicate with many people because she didn't want to frighten them. The ghost didn't know exactly why she was there, except she hadn't been religious and didn't know if she might end up in hell, so she stayed in the place she knew best.[15]

Medium Philip Solomon's communication with a spirit named Sarah is included in *Beyond Death: Conditions in the Afterlife*. Sarah agrees that we discard the body at death and become "energy and light." The shades and brightness of this light indicate the personality of the individual. Even without a physical sun, the light becomes brighter and more beautiful with each ascending level. This light is "created by the inner spirit, the higher mind essence, which creates all." Sarah notes: "Sometimes, the bright lights people see that look like figures or shapes are individuals with an ability and psychic sensitivity among those in the etheric world who have glimpses of our world."[16]

The general public seems to be losing its fear of being labeled mentally deranged for speaking out about ghostly encounters. They are seeking reasonable answers from scientists and the Church. Biblical scholars claim that in the days of King Solomon it was common practice to summon spirits. It was considered wrong only if you didn't restrain the spirit from harming anyone. Rosemary Ellen Guiley says this about Western religion's attitude towards ghosts:

> In the West, the soul is supposed to depart for an eternal resting place with God in Heaven or with Satan in Hell (or perhaps in between, in Purgatory). Consequently, the returning dead are regarded as unnatural and frightening, and possibly demonic. Catholicism acknowledges that souls in purgatory might return as phantasmal, but not solid, ghosts to ask for prayers from the living. In earlier centuries, Protestants generally believed that the dead could not return, and ghosts were diabolical entities masquerading as the dead. This belief still continues in modern times, especially among fundamentalist Christians.[17]

In 1993, the National Opinion Research Council (NORC) of the University of Chicago, found:

- Four out of every ten people in America have reported having experienced some form of communication or contact with the dead

- Up to 80 percent of bereaved survivors claimed to have had direct communications with a deceased loved one

- Sixty-five percent of widows said they had "witnessed apparitions or had some form of post-death contact with their deceased spouses"

- Seventy-eight percent believed in life after death[18]

In 1999, a poll by Scripps Howard News Service and Ohio University found while 48 percent of the American population believed ghosts may exist, 47 percent thought they definitely do *not* exist.[19] By 2003, 51 percent of Americans believed ghosts not only may but do exist.[20]

While my husband and I were in Hawaii in 2002 studying Huna, an ancient Hawaiian wisdom and healing art, I was reminded how the ancients throughout the world took ghosts for granted and incorporated their respect for the dead in with their spiritual practices. We visited the lava tube near the Volcano House on the Big Island, Hawaii. I photographed both the well-traveled tourist side of the tube and the more secluded section where visitors seldom venture. Even though the entire tube was moist and misty, the pictures of the tourist section were orb free. The other section, identical in dampness, was nearly packed with orbs when I first entered alone (see figures 72–76).

The orbs in the secluded section look like dust orbs, but a piece of dust wouldn't have had a fighting chance in that soggy environment. I debated whether to put these in this book. I sent them to Chris Gunn, a longtime computer programmer, an expert in digital graphics, and webmaster of www.orbstudy.com. He believes they are true orbs but not as clear as they should be. I feel the mist could have been obscuring the view of the orbs.

Showing my usual lack of restraint, I showed my camera's digital screen to passersby. As more people gathered, there were fewer orbs. One of my victims was a middle-aged native Hawaiian named Elswood. He was not in the least surprised by my photos and immediately assumed they were ghosts of the invading armies destroyed by Pélé (the volcano goddess) sending lava flows through the tube long ago. He warmed up immediately when he found we were studying Hawaiian culture and announced that if there were more people like us, the world would have more "mana," which equates to chi, ki, or life-force energy.

Figure 72: Orbless tourist section of lava tube. The next four pictures were taken just beyond the staircase, which is gated off.

Figure 73: The secluded part of the lava tube was filled with orbs when I started taking pictures. If this is mist, why was there no mist in the equally damp tourist section?

Figure 74: As people gathered and I showed them my digital screen, there were fewer orbs.

Figure 75: And fewer.

Figure 76: By the time I left, the orbs were either gone or not showing themselves to the gathering crowd.

Elswood told us some of his uncles still gather near Cooke's Place at a sacred pile of rocks to pray for spirits traveling to and from the next dimension. The Hawaiians believe, he said, that sunset and sunrise are the best times for the spirits to make the journey. I smiled broadly, for my brother and I had independently come to the conclusion that the most productive time to capture orbs on film is right after the sun sets. (The two times I have been awake to photograph at dawn have been productive, but not as orb-filled as at dusk.) I later learned the ancient Celts also watched for spirits traveling between dimensions at dawn and dusk.

Naturally, we went straight to Cooke's Place that evening right after sunset. We couldn't determine which pile of rocks Elswood referred to, but I got an amazing shot nonetheless of a rock monument next to the ancient temple across the bay from Cooke's Place on my night setting. It may have been the pile of rocks Elswood had

mentioned (see figure 77, center section). Figure 78 (center section) was taken seconds later without the night setting.

Spirits of the dead were mentioned several times during the Huna classes. We mentally cut our *aka* cords (attachments) to the dead because we were told the dead use our energy to stay on the Earth plane. Indigenous Hawaiians believe everything, including dirt, is alive and that spirits sometimes live in the rocks. The belief that bad luck can follow anyone who takes a Hawaiian rock home came from the belief the rock could harbor a troubled spirit.

Over the centuries, the Hawaiians became more superstitious and fear-based, but remnants of their ancient wisdom have been preserved by word of mouth and still live on in Hawaii. Gregg Braden, visionary scientist and best-selling author, tells us, "The oldest traditions of humankind describe a time when the 'wisdom of the heavens' was given to the people of this world." But we have lost touch with this ancient wisdom, especially since Braden estimates we have been denied access to more than 530,000 ancient documents.[21] Many ancient traditions were never recorded, and many of those that were carefully written down have been lost, damaged, censored, destroyed, hidden away, or poorly translated. If the light anomalies are actually ghosts, perhaps they are gently leading us back to the wisdoms we lost somewhere along the way.

16 Forms of Unknown Biology

Using a Sharp WD-450U camcorder, my brother Peter tried blocking out the light of the sun and videotaping in that direction. He filmed masses of strange shapes zigzagging and speeding erratically high in the sky (see figures 79a and b, two still pictures from the video).

Peter loosely followed John "Bro" Wilkie's directions for filming rods. He set his video camera on a tripod under the overhanging gutters of his home. He set the zoom on his camera to its maximum setting and aimed the camera towards, but not at, the sun, so the sun was blocked out and the camera was filming the sun's corona. He filmed the sky for some time and reviewed the tape on the slow-motion function and caught the dance of the "sky fish."[1]

Some speculate these apparently living entities could be undiscovered life-forms that inhabit the upper atmosphere of Earth. Others think orbs may spend daylight hours there to soak in the energy from the light. I do not sense that they are orbs, but orbs may be somehow related to the other oddities being noticed in the atmosphere. Here are some of the names they have been given: rods, energy rods, streaming ghosts, swimmers, fourth-dimensional creatures, sky fish, solar entities, ghost rockets, sky monsters, sky creatures, space animals, and undulating shards of lights.

Figures 79a and b: "Creatures" zipping around in the sun's corona. These were tiny—so tiny that these shapes are the best the camcorder could do with the available pixels, which at great distances cannot represent their real shapes. © 2001 by Peter Clemmer

The term "rods" is used to describe both long, squiggly, apparently spinning creatures with many short centipede-like appendages and orb-type anomalies that look like very thin, long rectangles of many sizes. The rods do not look the same as the sun creatures Peter filmed. They are shaped like cigars or cylinders and can hardly be seen with the naked eye. Analysis of videos of rods indicate they can travel from 150 to 1,000 miles per hour.[2] They seem to have fins or appendages along their wiggling torsos as they behave like fish in the sea. Rods derived their name from cylindrically shaped bacteria called rods that can be seen through a microscope.

Jose Escamilla, widely considered the foremost expert on rods, filmed them accidentally in 1994 while he was trying to document conventional UFOs near Midway, New Mexico. Rods can be four inches to a few feet in length, and they have been videotaped not only outdoors but also indoors and under water. Trevor James Constable, author, historian, and investigator, filmed them with infrared film in the 1950s and called them "critters." There are also accounts of people seeing them before the invention of the video camera.

The same controversy exists with rods as with orbs, with some claiming they are alien creatures, others thinking of them as spiritual beings, and still others placing

them in the interdimensional creature category. Just to separate them from the light anomalies, I choose to call them a form of unknown biology.

To me, they are like those hideous dust mites that are crawling all over the place but are only visible through a microscope. They could be what dust mites were before the advent of a machine that could see them—unidentified life-forms indigenous to Earth. The reason they are included in this book is that orbs, vortexes, ectoplasm, and the rest could have been here all along and gone undetected en masse until now. Their disappearing acts could have more to do with the scope of human vision than their reality or dimensionality.

Escamilla has recorded three types of rods, and none of them describe Peter's entities. They are: "The 'centipede' types, which have the appendages across the torso; 'white rods,' which have no appendages, but appear to have a ribbon-like appearance; and 'spears,' which are super-thin and very fast with no appendages at all."[3]

Brian Bessant of www.ufotheatre.com persuaded me with pictures posted on the site that at least some rod pictures are actually camera lens errors. He re-created pictures of rods by zooming in on bugs and "stuff." The distance from the lens determined the look and size of the "rods," and the speed of the bug created the illusion of body length. The speed of the object, combined with the zoom of the camera, creates this lens artifact. However, he notes, "There are objects moving at hyper-speeds through the air, skies, and oceans, but they are not shaped like rods."

Yet another type called "undulating shards of light" was discussed on the Yahoo! Group, "Chem Trail Tracking USA" (http://groups.yahoo.com/group/chemtrail-trackingusa) in 2002. These were described as "bright white tadpoles squiggling around in the air," "thousands of bright pin-pricks of energy or light spiraling down from the sky," and "shooting, wiggling, disappearing shards of light" that can be seen after staring at a blue sky for a minute or so. Someone suggested they were seeing the workings of their blood vessels in the back of their eyes, but the "believers" would not accept that. I plopped myself down in a grassy field and did just as they instructed, and all I saw was the urgent need to take an allergy pill.

We put so much faith in the powers of our five senses, vainly thinking we can evaluate everything by what we see, hear, touch, taste, and smell. We instinctively feel that microcosms and macrocosms do not exist unless we can sense them. Instruments are beginning to perceive much more than we ever imagined existing in our universe, and they will soon become part of our reality. All of these "critters" we are beginning to see through cameras could simply be other species to study and name, just like the many new life-forms marine biologists are discovering on the floor of the ocean.

17 Interdimensional Beings

"Anyone who is not shocked by the quantum theory does not understand it."

—Niels Bohr

The science called quantum mechanics is currently exploring the theory that there are up to 26 different dimensions existing right here in the same space we occupy. They say there is enough space between our neutrons and electrons to accommodate lots of other dimensions. They are also exploring quantum interconnectedness—the concept of the entire universe being connected at the quantum level. The visionaries who have been talking about dimensions for centuries believe these dimensions exist everywhere, and interdimensional beings come into our dimension through "portals" or "vortexes" which are reportedly located in certain geological areas, such as earthquake faults, ley lines, and other "power spots" that contain strong psychic or electromagnetic energies. The light anomalies called vortexes may even be portals to or from other dimensions.

Among the people seeking to categorize strange lights and apparitions, many theorize that at least some of the anomalies are interdimensional beings. The term "interdimensional being" is so all-inclusive, it potentially includes many of the other possibilities. Angels, fairies, devas, ghosts, spirits, souls, demons, and even aliens could all be described as interdimensional since no one really knows where they go at the end of a long day. Aliens, especially, have always been thought to originate far

from Earth. Aliens may never have needed to travel here from other planets and dis-
tant solar systems. They may have always been here with us, residing in one of Earth's
many other dimensions. Some ancient religious texts hint at the existence of more
than three physical dimensions. One example is Kabbalah, a form of Jewish mysti-
cism, which teaches that God is composed of ten dimensions known as *Sefirot.*

Physics professor Michio Kaku at the City College of the City University of New
York claims scientists have discovered at least ten dimensions beyond ours. He has
written the books *Beyond Einstein, Quantum Field Theory,* and *Introduction to
Superstrings.* According to the superstring theory, there are at least ten dimensions,
and possibly 26. These extra dimensions that have been hypothesized since the early
1980s have not yet been observed with any instrument we have, but are thought to
be rolled up into kind of a ball of yarn, so curled-up that they are nearly impossible
to see.

Extra dimensions are like viruses were before high-tech equipment—invisible to
us, and they will remain invisible until our technology catches up to our theories.[1]
According to an article posted at www.upi.com on February 17, 2002, by freelance
science reporter Charles Choi, scientists may prove and observe these extra dimen-
sions by 2005.

The most easily understood explanation I have heard as to why other dimen-
sions are not visible to us compares another dimension to a spinning fan blade.
When the blade spins slowly or is standing still, it is visible to the human eye, but
when it reaches a certain speed it becomes invisible. Another example is a telephone
wire, along which thousands of voices are traveling but are not heard by anyone other
than the two involved in each individual conversation.

To explain how another dimension sometimes becomes apparent to us,
researcher Nicholas A. Reiter and his assistant Lori L. Schillig, both of the Avalon
Foundation in Ohio, described an experiment in an article posted at
www.aliancelink.com. They used two audio oscillators. One was set at a fixed ultra-
sonic frequency of 30 kilohertz. The other was set so that it could vary from 30 to 50
kilohertz. Both were inaudible. When one was set at 30 and the other at 50, nothing
could be heard. When the variable-frequency oscillator was set at 35, a high-pitched
whine could be heard. The whine lowered as it was set down to 30. Then two signals
beyond our hearing range made a sound they could hear.[2]

Other dimensions are just as solid and "real" as our own but are invisible to our
eyes simply because they vibrate faster, slower, or are out of sync with our vibrations.
When these vibrations somehow become synchronized, the dimensions merge, at
least for the two beings from the two different dimensions who are in sync with each

other or are in certain locations. They can then see, touch, or hear each other. A tuning fork will only resonate with another tuning fork that has the same structure, shape, and size. Sometimes fast camera exposures and flash units can capture images that are not vibrating at identical rates and are blinking on and off more quickly than the human eye can see. When the vibration rates are close, but not identical, objects may become translucent and slightly visible and may affect barometric pressure. Every so often, our universe synchronizes or comes close to synchronizing with other invisible universes occupying our same space.[3]

Reiter and Schillig speculated how what I would call ectoplasm, which is not visible to the human eye, could appear on film. They described an anomaly as a "dense swirling, or coiling structure of mist or 'fog.'" Our eyes cannot register visual impressions that appear for less than 20 to 50 milliseconds. Many cameras and films can capture unseen objects that flicker in and out of reality faster than that. If the timing of the flash is synchronized with something that appears for less than 20 milliseconds, they wrote, the camera can record a strange image that was not seen by the operator.[4]

Two classic UFO cases on record occurred in the mountainous area south of Portland, Oregon, less than a hundred miles from where I live. Disclike crafts were photographed in McMinnville and the Willamette Pass in 1950. One seemed to fade in and out of reality in the fraction of a second the shutter of the camera was open. There were three separate images rather than one blur of motion. This motion is similar to what has recently been shown to be occurring at the quantum level of subatomic physics. Physicists say particles fade in and out of reality, which, to us, is our dimension.[5]

Theories about the residents of other dimensions abound, but it is generally agreed that the spirit or astral dimension is the closest to ours and is not a so-called parallel dimension. The dead exist there without their physical bodies but with their former personalities, emotions, and levels of intelligence. The spirits are less dense and vibrate at a higher frequency than we do in this dimension. As usual, though, some people report just the opposite.

M. F. "Chance" Wyatt, a sensitive who wrote the book *Spirits Visit Earth*, says a spirit vibrates at a lower rate than our human energy field. He speculates that humans vibrate at approximately 450 million angstrom units per second while spirits vibrate at about 350 million per second. He says humans can lower their vibrations through daydreaming, meditation, or deep relaxation, and spirits can alter their rates more easily than humans can. Full materialization can occur when the vibration rates match. If it's in a close range, Wyatt says, the human eye can see a faint likeness of the spirit.[6]

Dr. Dave Oester and Dr. Sharon Gill of the International Ghost Hunters Society (IGHS) are ministers of the Universal Life Church and the International Metaphysical Ministry, respectively. They believe souls vibrate at a faster rate than we do and can create their own reality in the spirit dimension and sometimes interact with our dimension. I have learned much from their extensive study of the spirit world. They write in *Magic Dimensions:*

> This Spirit Dimension is very close to our dimension, so our electro-magnetic and geomagnetic fields would directly attract the Spirit Dimension. During times of peak geomagnetic fields, such as near the full and new moons, the Spirit Dimension will overlap into our dimension causing episodes of poltergeist events to occur as voices and sounds of the Spirit Dimension filters into our dimension. Scenes of apparitions walking about in their time period may be observed, again because of the overlapping of the two dimensions. The apparitions are being observed within their dimension as it overlaps into our dimension. This cyclic pattern is also influenced by strong solar storms when charged particles bombard the earth. These charged particles are electromagnetic and generate strong fields that can pull the Spirit Dimension into an overlapping state. It indicates the interconnectedness of all things, of which the change in electromagnetic fields can be seen through the use of sensitive equipment. . . .
>
> Once the negative emotions have been released, the soul will vibrate at a higher frequency, thus allowing it to transcend to the Spirit Dimension.[7]

Jan and John Young, who have a website named "Orbs by Beans" (www.orbsby-beans.com), use dowsing as one source of information and wrote on "Universal-Orbs," a discussion group which they moderated, on March 1, 2002:

> In 2000 we had dowsed that there was a multi-dimensional vibration wave that affected how the Orbs came through the dimensions. It was variable in the number of days apart so it wasn't something you could state as being 15 days or 20 days to complete the wave. It was approximately 9 to 18 days apart, to get back to the high point. At the high part and halfway before and after, we got that the Orbs could come through the dimensions pretty good, or at least we could take clearer shots of them. On the downwards side of the wave the Orbs were very faint.

Mention of dimensions is becoming common, at least in the places I frequent. Sedona, Arizona, said to be home of four vortexes, has long been called an "interdimensional doorway." Native Americans believed Sedona was the actual center of the universe and, when I visit Sedona, I can understand why. They felt it was sacred land, which should be used only for special rites and ceremonies. Sedona has become known as a site where UFOs are often sighted. Lately, however, "balls of light" are seen more frequently than those that look like metallic craft.

Energies of the Earth are thought to converge in Sedona, and Gary Hart, an investigator of "hyperdimensional" phenomena, writes:

> There are places like this where people can actually see into the next dimension. Some of this is very angular in nature. If you stand in one spot, you see things out around it that you cannot see 100 feet away.[8]

Dr. Michael Newton, who hypnotically regresses subjects to their existence between lifetimes, got corroboration for dimensional and apparitional theories in a discussion with a subject traveling through dimensions. This subject was aware of at least a few dimensions from which beings who visited Earth could have originated. The subject enjoyed traveling to both mental and physical worlds while between lives on Earth. He said other beings also float in and out of reality just as he could in other dimensions.

Dr. Newton claimed these beings could only be seen by certain individuals, but not always, depending on their level of perception at that moment. These visitors from other dimensions are "transparent light beings" who "soar through the mountains and valleys, the cities and small towns." They would like to dispel any fear of them by human beings but are not allowed to influence us in any way. They and other beings are just here for a vacation, according to that subject. Newton concludes some souls came back to Earth as a form of recreation, while others return to help and comfort loved ones.[9]

Yogi Paramahansa Yogananda's deceased master described the afterlife to Yogananda in *Autobiography of a Yogi*, describing what sounds like dimensions as "astral planets." "The inhabitants use astral planes, or masses of light, to travel from one planet to another, faster than electricity and radioactive energies. . . . All astral beings are free to assume any form. . . ."[10]

Paranormal photos may not be of ghosts but of living entities from another dimension, or then again, they may be one and the same thing if ghosts live in the dimension closest to ours. I am convinced Earth is going through physical and spir-

itual changes, shifting our weather patterns and magnetics. A dimensional merging may be taking place that is making it easier for ghosts and other phenomena to be experienced in our three-dimensional reality.

Anomalous lights often behave like apparitions, materializing and dematerializing, walking through walls or disappearing mysteriously. UFOs also seem to arrive and depart from some other dimension here on Earth. Our destructive tendencies could be why "aliens" from other dimensions are concerned. They have to live here, too, or perhaps they live in our future—a bleak future they would like to change. Other dimensions could be home to every being discussed in the past five chapters—what we call aliens, crop-circle makers, angels and guardian angels, and forms of unknown biology. They may each be what their names imply—but from one or more different dimensions.

If I haven't raised enough questions to drive you mad, if you aren't flailing your arms and muttering strange sounds, proceed to the final chapter and the last theory.

18 Thought-Forms, Elementals, and Creations of the Unconscious Mind

> "A man is but a product of his thoughts; what he thinks, that he becomes."
>
> —*Mohandas K. Gandhi*

The belief that the light anomalies, especially the orbs, are thought-forms makes all the preceding theories compatible. Thought-forms, which are essentially the same as elementals and creations of the unconscious mind, are whatever they are created as, and could be interpreted as angels, ghosts, aliens, or whatever. It also explains why orbs and sometimes the other light forms are so often described as responsive to the photographer's thoughts. This is the most logical theory but the most difficult to comprehend.

My husband and I spent two yearly vacations studying Huna, the mystical healing arts of the ancient Hawaiians. The workshops were in Kona, Hawaii, presented by Advanced Neuro Dynamics and Dr. Tad James. As with most ancient systems of belief, it was essentially a study of metaphysical law. It is not widely known that most if not all of the ancient religions and indigenous people of the world understood variations of these rules, largely lost to mankind after centuries of political manipulations aimed at controlling the masses rather than enlightening them. These truths are resurfacing now as the Dead Sea Scrolls and other ancient texts are finally available if you search in the right places; as the art of "manifesting" (another name for

"miracles") is being taught by the world's new spiritual leaders; and—surprise, surprise—as quantum physicists rewrite the textbooks on how the universe operates.

Dr. Tad James's forty-three assumptions of Huna, variations of which are found in esoteric systems, define how the universe operates at the metaphysical level. Since I "have orbs on the brain" and have thought of little else for some time, twelve of these rules shouted at me when I studied them. They not only explained quantum physics' string and superstring theories to me in spiritual terms, but they also explained how orbs and all the other luminosities could be actual, physical creations of the mind—not hallucinations, but manifestations as real as anything else in this universe and in this dream we call life. Please bear with me as I try to explain how these assumptions apply to the mystery of the lights.

Contagion: Things once in contact continue to interact after separation. This is because of the *aka* connection which exists. We leave our imprint on everything we touch. Even when we just walk through an area, place or room, we leave our imprint.[1]

One of Huna's healing techniques, *Ho'oponopono*, is to forgive everyone in your life and to cut your *aka* cords to these people, which you can reconnect at any time by simply thinking about them. *Aka* is the "medium of transmission" and one of Huna's truths is: "Everything I touch makes an *aka* connection; even my thoughts can connect me with what I think about."

This assumption and others demonstrate how the ancient Hawaiians must have had some understanding of Bell's theorem and the superstring theory. I can't distinguish the difference between these two theories. In 1964, physicist John Bell theorized that two particles, once they have interacted, will continue interacting forever. The superstring theory, as I understand it, claims vibrations connect every part of the universe to every other part.

To explain the ten-dimensional superstring theory, scientist and author Michio Kaku says the universe is a symphony of vibrating strings, very much like violin strings. He equates the superstring theory with the fabled unified field theory on which Einstein was working when he died.[2] These strings are tiny pulses of light that vibrate throughout the universe, everywhere. They are so infinitesimal that it takes 10 million billion of them to make up a quark, which is so small we can only assume its existence from experiments.

In a recent interview with Dr. Jeffrey Mishlove, Nick Herbert, Ph.D., author of *Quantum Reality: Beyond the New Physics,* defined quantum interconnectedness, the

scientific term for *aka* connections: "[T]here's a kind of stickiness that connects [quarks] together, so they're bound together forever in the theory. They never separate, even though they're not interacting anymore."[3]

Scientist and best-selling spiritual author Gregg Braden describes a superstring as a gigantic, vibrating web that encompasses the entire universe and connects all of creation through this web of an unseen force. Every part of the universe affects every other part, and your inner world affects your outer world. Everything is connected to everything else—even at a distance. Braden quoted the Buddhist Avatamsaha Sutra, which indicates the ancients knew this: "[F]ar away in the heavenly abode there is a wonderful net stretching in all directions."

Besides discovering that ancient cultures were aware of this web of creation, Braden also cites recent experiments that support the web's existence. On July 22, 2001, the *New York Times* reported an experiment in which "two particles of light, 'photons,' appear to be energetically linked, though they are physically separated. When one photon undergoes a change, that change is mirrored in the second photon seven miles away!"[4]

At a Gregg Braden seminar I attended in October 2001, he explained several other experiments that support the concept that everything in the universe is interconnected. In one, water droplets physically changed as the emotions of the viewer directed towards the droplets changed. In another, human DNA was placed in a vessel and into the hands of scientists. When the scientists felt positive emotions, the DNA relaxed and separated into two strands. When emitting negative emotions, the DNA tightened up.

In yet another experiment, scientists took a sample of DNA from the mouths of volunteers. When the donor underwent emotional stimulation in another room, the DNA taken from his mouth registered the same electrical responses exactly at the same time. There was no lag time. Braden said this experiment works when the donor and the DNA are up to 50 miles apart.

Michael Talbot cites two similar experiments in *The Holographic Universe*. The first registered changes in polygraph readings in a subject in one room when an electric shock was administered to a person in another room. The other study found changes in EEG readings during a test in one room when a light was flashed at a subject's eyes in another room.[5] Even one of Dr. Michael Newton's hypnotically regressed patients who was peeking at his existence between lives commented in Newton's *Journey of Souls,* "Our light is attached to the source."[6]

What was called ether in the 1800s is now called the quantum hologram, the mind of God, nature's mind, or the stuff that lives between the nothing. My understanding of the quantum hologram is that its existence proves every minuscule part

of the universe is essentially the same as the entire universe altogether or any of its parts. The same concept was expressed long ago in the Emerald Tablets by Hermes Trismegistus: "That which is above is like that which is below, and that which is below is like that which is above."[7]

The universal hologram is made of vibration and is the mind behind all matter. The universe is made of tiny strings of vibration and an atom is a wrinkle along the string. The wrinkle only looks like a particle of matter because of the scale of our instruments. Physicist Max Planck claimed there actually is no matter; everything is energy. Einstein's $E=MC^2$ defines how much energy it would take to give the appearance of matter. Matter is an illusion consisting of vibrating energy.

Braden explains that all the forces in the web of creation can be spoken to through human emotions. Compassion, gratitude, and love can affect the world around us and transcend the suffering of humankind. Emotions access all the vibrations of the universe through harmonics. In other words, we are all connected through our intentions and emotions.[8] Amazingly, thoughts with intent and emotion are the creative forces of the universe.

Substitute the terms "vibrating string" and "vibrating web" with "*aka* connections" and you can see why I believe the ancient Hawaiians already understood superstring theory.

> **Mind:** All is mind. Mind is the All. The entire phenomenal universe is based on the thought of mind. . . .[9]

This assumption shows the ancients were also aware of the creative power of thought. The strings connecting you to the web of life are for the most part created by you with your conscious, unconscious, and superconscious thoughts. The twelfth-century Sufis used deep meditation to visit the "land where spirits dwell" where one possesses a "subtle body." They claimed this plane is created out of the subtle matter *alam almithal* (thought) through the imagination of many people.[10] In 1987 physicist Robert G. Jahn and clinical psychologist Brenda J. Dunne of Princeton University announced they had "unequivocal evidence that the mind can psychically interact with physical reality." They proved that human beings could influence how certain machines operated through mental concentration alone.[11]

Even with the growing popularity of literal translation of the Bible, this verse is not taken as literally as it could be: "For as he thinketh in his heart, so is he," Proverbs 23:7 (King James version), or, "What he thinks is what he really is." Proverbs 23:7 (Good News Bible).

I mention the names of the translations because in the New International Bible, the Living Bible, the Revised Standard Version, and the Holy Bible published by the Catholic Press, that sentence is omitted. It is either interpreted so differently that I cannot recognize it or it just is not there. I am not a biblical scholar, but this verse appears to be an example of how the Bible has been carefully edited to reflect the beliefs and motives of its many editors. There are three possibilities in my mind: The editors did not understand the significance of that sentence and left it out; they fully comprehended the meaning and deleted it deliberately, probably with good intentions or while under duress; or the editors of the King James and Good News Bibles made it up and inserted it in their versions only.

I vote for the second option. Public knowledge of the power of thought and emotion would have taken power away from the government and the church and was thought to be dangerous in the hands of the wrong people. From my point of view, the power of thought was the backbone of the ancient religions and is returning as paramount in New Thought religions and in the teachings of today's spiritual leaders. The omission of that sentence, and I imagine many more like it, was highly significant in terms of the power of the common man.

In my mind, the gist of the Mysteries is that intent, emotion, and especially love create everything. Each person creates his own personal universe with his directed thoughts. If this is true, then untold damage is being done through unchecked negative thoughts because nearly everyone is unaware of their power. If everything is created by thought, though, then "life *is* but a dream" from which we all will awaken eventually, regardless.

Several other Bible verses speak of the power of thought and belief. Matthew 21:21 and Mark 11:23 basically reiterate the following verse:

> If ye have faith as a grain of mustard seed, ye shall say unto this mountain, Remove hence to yonder place; and it shall remove; and nothing shall be impossible unto you. (Matthew 17:20, King James version)

One more verse refers to the time when the people built the Tower of Babel:

> And the Lord said, Behold, the people is one, and they have all one language; and this they begin to do: and now nothing will be restrained from them, which they have imagined to do. (Genesis 11:6, King James version)

All six Bible versions left this verse in, except the Catholic Bible changed the

word "imagined" to "determined," thus removing its mystical implications. But what did God reportedly do about the Tower of Babel situation? He punished all of the people by making them speak many languages, an obstacle Earth is only recently overcoming through the Internet and readily available translations. The moody, destructive God of the Old Testament did not want the people to use their powers to reach the heavens. Perhaps the Old Testament crowd couldn't be trusted with their incredible powers. In the New Testament, though, Jesus taught quite the opposite and strongly promoted personal power.

It is hard to imagine how differently I would have lived my life had I known that my every intention (conscious and unconscious) was affecting the universe at some level.

The Personal Universe:

1. The world is as you think it is! Reality is relative to the observer.

2. Therefore, every being lives in and creates a unique universe which can never be 100 percent identical to that of another.

3. Every point where any observer is, is the center of the universe.

4. Therefore, one person's reality must be different from another's.[12]

This assumption explains to me why the arguments for the anomalous lights being angels, aliens, ghosts, spirits, or natural phenomena can be equally convincing to different persons, depending on what each considers to be his reality. It also explains how my husband can be satisfied with his definition of anomalous lights. He says they are "energy" and that's all the explanation he needs, even though I keep annoying him with the fact that everything is energy, so he hasn't explained anything!

Other people blissfully ignore the question, but their attitude is just as "right" as mine; it is just different. Everyone cannot be concerned with the same questions, just as every cell in the body has a different role than any other cell. I like to think of myself as one vital cell of the universe, and I cannot judge any of the other cells because their role is not my role, and I am definitely not the "ruling cell." For some unknown reason, the orbs have become real in my world but do not have to be part of everyone's reality.

Pragmatism: If it works, it's true.

Adding this law to the Law of Personal Universes it becomes: "Truth can be defined as a function of belief."[13]

We have all known the frustration of scientists declaring that such and such is so, based upon the results of this or that experiment, only to have other experiments, carried out by different scientists, completely contradict those results. No one knows for certain what is good to eat anymore, with study after study nullifying previous studies. Even after scientists discovered that the beliefs, attitudes, and expectations of the experimenter were shown to affect results, blind and double-blind studies are rarely used in the physical and biological sciences, while the great majority (around 85 percent) of parapsychologists employ double-blind techniques. In double-blind studies, neither the subject nor the experimenter knows which persons are being tested and which, as part of a control group, are not.[14]

There is also some evidence that even a nonparticipating experimenter's consciousness affects double-blind studies. The expectations of the subjects are equally as important, due to the powerful influence of the placebo effect. Normally, 30 to 40 percent, and sometimes up to 75 to 80 percent, of patients given placebo exhibit the same response as patients given the experimental treatment. Drugs are rarely found to be significantly more effective than placebo.[15] In my mind, these influences make the majority of scientific experimental results totally meaningless. I feel if I honestly believe a food is good for me, it will be good for me. (Fudge for dinner, anyone?) When this theory does not seem to work, I blame the discrepancy on what my higher self, unconscious, and conscious mind truly believe.

It's not hard to think of examples where belief creates truth. If a person truly believes their prayers will be answered (consciously or unconsciously—I'm not sure which), their prayers will be answered. Michael Talbot, author of *The Holographic Universe*, wrote: "There is strong evidence that belief, not divine intervention, is the prime mover in at least some so-called miraculous occurrences."[16]

Anything you believe you can do is possible in your personal universe. Have you ever achieved anything in your life that you did not, down deep, believe you were able to do? I haven't. If you honestly believe you can move a mountain, then it will move. But who in their right mind could believe that? That's what makes it such a good example. One cannot do the impossible unless they "think out of the box" to such a degree that it becomes possible. If they believe in the existence of the paranormal, they will experience the paranormal, such as light anomalies. Actually, the lights are not paranormal. They are just following the physical and metaphysical laws of the universe that most people have not yet accepted into their realities.

My sister Ellen recently acquired a new digital camera and a new boyfriend, who has the impression her family is very strange indeed. To prove our sanity, Ellen asked him to take some pictures of anything whatsoever. After he accomplished his mis-

sion, Ellen told him he probably didn't get any orb pictures because he does not believe in them. Then Ellen gave her "believing" daughter Lindsey the camera and had her do the same. His six pictures had no orbs, but three out of Lindsey's four shots captured some large orbs. Belief was the only intended variable. Lindsey just stuck her thumb in her mouth and went to bed, and Ellen's boyfriend upgraded our family from strange to just odd.

Connectedness: Every observer is connected to, and has an influence over the event being observed, always and without exception.[17]

This reinforces the last assumption while adding the influence of group thought or group consciousness to the outcome of any event. Every intentional thought by every person influences that universal web and the interaction of all these thoughts creates the universe. Since we are connected to everything via this web, we are one with the entire universe and responsible for everything that happens in this universe. This assumption explains why the lights respond to the thoughts and desires of the observer(s) and why they never appear in the pictures of certain persons.

Cause and Effect: . . . The Kahuna . . . declares that he is the conscious cause of all that happens in his universe. . . . To gain maximum control in the universe, assume cause for every effect.[18]

Victimhood has finally overstayed its welcome in today's world. No progress is made when all people blame everyone else for their difficulties. You can only change your universe if you understand you are in complete control of it and are not a victim of your circumstances. Your thoughts, beliefs, and emotions are the cause of everything that "happens to" you in your universe. Hence, you have caused the light anomalies you have photographed, evidently by believing in or being open to their existence. If you add the previous assumption of connectedness, then the more people who believe in orbs and such, the more there will be, and they will actually be what people think they are, whether ghosts, angels, interdimensional beings, undiscovered critters, or little green men.

Attraction: You will attract energies to you based on your frequency and vibration. In general, positive beings will be attracted to positive people and vice versa. In addition, the emotions that you usually experience will attract people and events to you that will help you to actualize these

emotions. For example, fear will draw people to you that will help you actualize those fears.[19]

Negative people will encounter negative anomalies. Fear-based persons will be frightened by the negative things they attract. The anomalies will take the form of evil aliens, demons, and scary ghosts. Those who think positively will have pleasant experiences with the lights. Deep-felt love of a deceased mate or pet will bring them to you in some form, depending on how much your belief system can handle. If light forms are creations of our minds, they potentially can be anything we think they are—the good, the bad, or the ugly.

The Call: The appropriate call to the higher levels compels an answer. The desire, even if only at the unconscious level, to know about the esoteric teachings, will draw them to you.[20]

I cannot count the times I cried out to the powers that be for answers, for the truth, for enlightenment, and especially for a sign. It was no coincidence that I was working on a doctorate in esoteric studies when I took the picture of Libby's anomaly, whatever it was. I asked for it and, even though my conscious mind doubted I would succeed, I got it—a picture that seemed to be what I had hoped for and actually asked for out loud in front of witnesses—Libby's spirit.

Even when I see what others call miracles, I often cannot quite fit them into my reality and I choose not to believe them. Hence, they do not become part of my everyday world. For instance, I actually bent spoons into unrecognizable shapes under the direction of Jack Houck at the 2000 American Board of Hypnotherapy (ABH) Convention, but it was so unbelievable, I never even tried it again, even when I was teaching it successfully to others. I was so certain I couldn't do it again that I didn't want to risk failure.

I am seeking the metaphysical and the universe is sending it to me, but I have always been offered just the amount I could handle at the time, or a tad more. It seems one is introduced to as much of the paranormal as one asks for and can accept.

Focus: You get what you focus on, so focus on what you want. If you want light, focus on the light.[21]

I often hear accounts of people who have never gotten an orb picture until they intentionally tried to do so. Still others look back and find orbs they hadn't noticed before. Professional photographers report never getting orbs in their professional

shots, but, as soon as they set out on an orb hunt, the orbs are there for them. When I got bored with plain orbs and had it in my mind that I wanted something more interesting, I began getting personal orbs, ectoplasms, and vortexes. Focus on the light and you can photograph it.

> **Personification:** Any natural phenomena may be considered to be alive and to have godlike personality, almost as if it were an entity. In other words, the universe and portions of it act as though they were alive.[22]

All of the visible and invisible lights are said to be intelligent. In my experience, some are pranksters, some are shy, some will do exactly the opposite of what you request, some will do anything you say. The lights, which scientists say are composed of plasma, do appear to be alive. Even physicist David Bohm used the word "alive" to describe balls of plasma. Ancient cultures revered what we take for granted—the Earth, the sun, the moon, the stars, the animal kingdom, and the plants. The ancients thought everything was alive and possessed distinct personalities. We are all made of the same stuff. This means a rock (just as an orb) is as alive as I am, but vibrating at a different frequency.

> **Invocation and Evocation:** You can conjure up from inside and outside of your model of the world and nervous system energies that can act like entities. They are personifications of energy patterns, or natural phenomena.[23]

From all accounts, orbs behave like these energies or entities. They can behave like personifications of aliens, angels, ghosts, spirits, or interdimensional beings, all of which are outside our model of the world. Orbs could be the dreaded "thought-forms"—things people think about, often on a subconscious level, which somehow come into being. I feel it is better to be aware of their existence than to be unknowingly creating them and sending them out into the world to wreak havoc. They would much better be used consciously and constructively.

Light forms made my years of esoteric studies come to life. I have strong intuitive skills, as everyone does if they would only listen, but I do not normally hear, see, or feel anything from the spirit world. Psychics Annie Besant and C. W. Leadbeater were both theosophists, and Besant, who was also George Bernard Shaw's lover, became the head of the Theosophical Society.[24] Besant and Leadbeater first published a book in 1901 entitled *Thought-Forms*. This amazing little book kept me spellbound and convinced me they could see the forms now being caught on film and more.

"Every definite thought," they wrote, "produces a double effect—a radiating vibration and a floating form."[25] They explained how, with every thought, our bodies throw off vibrations with vivid color, which attract similar vibrations and form "a living entity of intense activity animated by the one idea that generated it."[26]

Besant and Leadbeater claimed the astral body can also produce similar thought-forms that exist solely in the astral world. The power of the thought-form is determined by the mental energy, desire, or passion attached to the thought. Every thought, they wrote, becomes "a kind of living creature" called the "elemental essence" or an elemental with an infinite number of colors and shapes.

If the thought is about the person himself, the elemental hovers around that person, ready to influence him when he is resting or idle, and he may feel he is being tempted by Satan or such, but it is his own thoughts that are influencing him, or the thoughts of someone with similar vibrations. Thoughts directed at others can only affect the recipient if they are receptive, or of a similar vibration as the thought. If the thought is not aimed at anyone in particular, it floats around in the atmosphere and eventually dissipates or attaches itself to someone of a sympathetic vibration.[27]

The authors of *Thought-Forms* maintained that the color of an elemental is determined by the quality of the thought; the form by the nature of the thought; and the clarity of the outline by how definite the thought is.[28] They claim only clairvoyants can see the shapes produced by thoughts.[29] Sounds also produce forms and colors. Music leaves behind an impression on the environment. These can be considered thought-forms only as an expression of the thoughts of the composer.[30] The unseen world, they conclude, is infinitely more important than the visible world.[31]

Harper's Encyclopedia of Mystical & Paranormal Experience gives this definition of a thought-form:

> In occultism, a nonphysical entity created by thought that exists in either the mental plane or astral plane. Every thought is said to generate vibrations in the aura's mental body, which assumes a floating form and colors depending on the nature and intensity of the thought. These thought-forms can be perceived visually by clairvoyants; they may also be sensed on an intuitive level by others. Thought-forms radiate out and attract sympathetic essences. . . . Thoughts that are low in nature, such as anger, hate, lust, greed, and so on, create thought-forms that are dense in color and form. Thoughts of a more spiritual nature generate forms that have greater purity, clarity and refinement. . . .
>
> Thought-forms are said to have the capability to assume their own energy and appear to be intelligent and independent.

It is theorized that thought-forms may arise spontaneously out of the collective unconscious as archetypes which take on phantom or seemingly real form. This perhaps may explain reports of the Devil, supernatural monsters, other non-human beings, and phenomena associated with UFOs.[32]

While explaining how occult forces can produce physical phenomena with "the condensation of etheric energy," psychic and author Dion Fortune wrote in 1930:

Lights may also be seen, usually taking the form of dim balls of luminous mist drifting like soap-bubbles. They may be any size from mere points of light to considerable dimensions, some six feet or more in diameter. In these spheres of dim luminosity psychics can generally see forms, sometimes human, sometimes from the animal kingdom. Whitish-grey clouds can also sometimes be seen, rising pillar-wise from the floor like smoke. These are usually fixed to one place and do not move about the room as do the spheres of light, such movements as occurs being within themselves, like the eddyings of smoke caught under a tumbler.[33]

Another bit of evidence that led me to the idea that light forms are somehow produced by individual and group thought was an experiment undertaken by the Toronto Society of Psychical Research (TSPR). The results were posted as an article entitled "How to Create a Ghost" on http://paranormal.about.com.

Eight people chosen by the TSPR made up the details of the life of Philip Aylesford (a totally fictitious name) and even sketched a portrait of him. Then they held séances beginning in September 1972 to see if they could make contact with their fictional ghost. For the first year of gatherings held in a lighted room, they got no results. Then they dimmed the lights, sat around a table and sang songs as in classic spiritualist séances, and surrounded themselves with objects from Philip's supposed time period. Soon they were communicating with Philip via raps on the table. He communicated details of his life that corresponded to the life they had created for him, but he only revealed what the members knew of the time period.

"Philip" also moved the table across the room on thick carpeting and made it dance on one leg; dimmed the lights; restored the lights; created cool breezes; and formed a fine mist over the center of the table. These antics were filmed for a television documentary. The spirit of Philip, however, never actually materialized. The TSPR and an Australian group conducted several other experiments with similar results. Evidently group consciousness can create an entity or elemental that will behave as expected.

Tibetan monks, Hawaiian Kahunas, many of the ancient practitioners of magick, and others have been known to create entities with their minds. These thoughtforms can take on lives of their own and can be seen by some people.[34] In the years I have been surfing the Internet in search of answers, I have noticed more and more ghost hunters, UFO seekers, believers in angels, and the undecided considering this theory. Dale Kaczmarek, Ghost Research Society president, is one of many who admits it is difficult to eliminate the possibility of thought-forms. He says psychics or mediums may be receiving the projections of the thoughts and emotions from the living and attributing them to ghosts.

The images in science fiction movies of my youth are gradually becoming reality. Were the writers seeing into the future or has the group consciousness changed what we saw on film as youngsters into reality? Could the archetypal, quasi-real entities such as Bigfoot, greys, werewolves, vampires, demons, and dragons have been created by the human collective unconscious?

Consider the possibility that light phenomena could be products of mankind's unconscious where the thoughts of all mankind are stored. Swiss psychologist Carl Jung first suggested the existence of a collective unconscious. He thought group consciousness might be capable of physical materialization, at least for short periods of time, and able to reflect wishful thinking, fears, or hopes of populations. Physical mediums are believed to be able to produce physical forms made out of ectoplasm, and many angels, aliens, and UFOs appear within a misty cloud and behave very much like the traditional apparition.

Orb hunters are coming to the realization they get pictures of what they expect to get, especially in cemeteries. Loyd Auerbach, founder of the Office of Paranormal Investigations, said:

> They don't actually see anything unusual with their own eyes, but they're able to capture orbs or other strange images on film. I think people's expectations cause things to happen using psychokinesis or other psychic abilities they may or may not know they have.[35]

If people fully expect to get pictures of orbs, more often than not they will capture orbs. If they wish to photograph angels, aliens, ghosts, or astral beings, that is what they will get, or at least what they will interpret their photographs to be. I did not get any pictures of ectoplasm until I heard they were basically made of the same stuff as orbs. I believed if I could photograph orbs, then I could also capture ectoplasm, and I did.

My brother Peter once had five guests come to his home who had no knowledge of orbs. He lined them up and took several pictures of them. No orbs showed up. Then he showed the group his light pictures and explained them as best he could. Finally, he lined them up again for pictures and, lo and behold, some orbs were posing with the newcomers. Did that prove that orbs are clever and intelligent, or did it demonstrate the power of Peter's or his guests' thoughts and beliefs?

And finally among the Huna beliefs:

Philosophy: Personal control of the environment must begin with our own self-control. Until we are no longer at the whim of our environment . . . we cannot hope to have a great mental influence over it. Paradoxically, only when our surroundings no longer matter to us, it is then that we gain the power to change them by purely mental means.[36]

The detachment of the highly spiritual person allows for the performance of what are called miracles. As long as one believes this world is real and not just a figment of the collective imagination, one cannot consciously change anything merely through the power of thought. Attachment to the things of this world keeps us bound to it and incapable of experiencing spiritual enlightenment. The people I know who can photograph light anomalies are very young or they are those who are at least somewhat aware of the lack of substance in everyday life on Earth. They have asked the question, "Is that all there is?" and answered no. The spiritual/psychic element of group consciousness has evidently risen to the level where we are willing to see beyond the veil and explore the unknown—if we believe we can. We have asked the questions and may now be getting a glimpse of the answers that we are presumably creating through the power of our thoughts and emotions. Is what we see beyond the ordinary what our collective unconscious has placed there?

Orbs, vortexes, apparitions, ectoplasm, religious figures, angels, fairies, demons, interdimensional beings, psychic events, poltergeists, ghosts, UFOs, psychokinesis, crop circles, and all the rest could be actual, physically "real" products of our unconscious minds. If the unconscious has the ability to change reality, that could explain the physical evidence of these occurrences—photographic evidence, radar findings, military jet chases, multiple witnesses, crop circles, and ground traces from UFOs.

Multiple witnesses to these events attest to the "reality" of group consciousness. It becomes even more interesting when half of a crowd sees a phenomenon while the other half does not. Hypnotized subjects have been known to experience the same

"hallucinated" reality since hypnosis eliminates interference by the conscious mind, leaving the unconscious free to create its own reality.

Some drugs bring about similar results. English UFO investigator and author Albert Budden admitted to an experience of his own which proved to him that multiple witnesses could see the same "hallucination." Budden tried LSD with a friend when it was still legal. He saw two luminous skulls in a corner of the room. When he asked his friend if he could see them, the friend said he saw two "death's-heads" and accurately traced their outline with his finger. Budden thought shared dreams may be created in the same way. Budden feels individuals are triggered into altered states by different frequencies, and there is evidence witnesses must meet each other's frequency to experience the same thing.[37]

Likewise, one or more photographers "create" what their unconscious minds manufacture for the photo session. Professor Robert J. Jeffries of the University of Bridgeport wrote of a psychic photograph that it

> seems to be a mental/physical phenomenon of a paranormal character which manifests in the presence of one or more individuals who are termed to be "psychic" [whether they are aware of it or not], by virtue of the fact that such phenomena appear to be associated with them.[38]

Since persons who admitted seeing ghosts during the twentieth century were so often deemed mentally ill, I was surprised at how three of the century's foremost psychologists and psychiatrists felt about people who "see things."

Sigmund Freud said they were projections of the unconscious mind of people who are afraid of dying. William James thought they were spontaneously produced hallucinations caused by extrasensory perception, telepathy, and clairvoyance.

Carl Jung said visions came from the collective unconscious projecting or manifesting itself. Jung thought ghosts are telepathic images that sensitives can see. He also thought ghosts can project thoughts unconsciously to living persons. He said that myths, dreams, hallucinations, and religious visions all come from a collective unconscious that all people share.[39] Jung thought the shape of the "rotundum" (disk or sphere) is the archetype for the unconscious desire for perfection and completeness. In his book, *Flying Saucers: A Modern Myth,* Jung claims that visions of UFOs are unconscious projections (thought-forms?).[40]

All three seem to agree that a sane mind can produce things that can be seen. (Yet those who heard voices during the past century were quickly drugged or deposited into an institution.) When I was forced to study Jung in college decades ago, I

remember thinking he was definitely over the edge and most likely on drugs himself. How things change.

Well-known UFO author Jerome Clark, after years of investigation, wrote in *The UFO Book* in 1998 that he had come to believe that "UFO[s] and other anomalous manifestations are internally, not externally, generated; the only intelligence involved is that of the individual who has the experience."[41]

Through psychic ability, a deceased person seems to be able to send telepathic messages. If received through the living person's psychic powers, then the deceased's form can be "seen," his words can be "heard," his touch can be "felt," and his scent can be "smelled." Since apparitions can be captured through the eye of a camera, these sensations must be physically real—actual "products of the mind."

The world is coming to believe that the mind can actually create illness—psychosomatic illness that is just as real as any other disease. Take it one step further and it becomes plausible that the mind can also produce physical symptoms of its beliefs or fears, such as ghosts, angels, apparitions, demons, and aliens—and they can take the form of orbs, vortexes, and ectoplasms.

These light forms can be photographed because they actually exist. They are as real as anything else in this realm we call reality. Everything here, it seems, is created in the same way—by the individual and collective thoughts of the universe, fueled by intent and emotion.

Conclusion

I wrote this book as a kind of "whodunit" narrative, fully expecting to be able to announce to the world with confidence what the light forms are and, at long last, I have decided on the one answer that makes total sense. I sought and I found an explanation that accounts for all the possibilities.

My search for answers had grown into a captivating puzzle with unlimited tentacles of possibilities and implications. Without telling you, the reader, I had been wavering between thinking the lights were ghosts, angels, interdimensional creatures, and thought-forms, depending on what I had for breakfast. Only recently did I begin to seriously entertain the UFO/alien theory. It seemed impossible to place all the light anomalies into one category, so I played with the idea of there being as many species of lights as there are forms of life on this planet, but I could not digest that either.

The answer came from the Mysteries I was exposed to in the Esoteric Studies program I had undertaken shortly before I took the photograph that launched me on this illuminating journey—the picture of Libby Lou's passing. As I reviewed my photographs, I realized that the idea of thought-forms created by our unconscious minds and the collective unconscious is the one explanation that makes everyone right.

When I began working on my doctorate, I thought proving an existence after life would somehow point me down a spiritual path I could stomach. I took a camera to the veterinarian's office and announced my *intention* to photograph a dog's spirit. The air in that tiny room was thick with *emotion*. I have no idea what the vet and his

assistant's conscious or unconscious minds were expecting, but my sister Ellen and I were consciously seeking evidence that dear Libby's spirit would live on. We were astounded when our wish came true, but, given what enables thought to create (intent and emotion), it is no wonder I got not just one but two pictures of Libby's spirit (see figures 3 and 4, p. 3).

Peter and all those present in the room when his mother-in-law, Annabelle, passed away were expecting the same thing since Peter showed them my Libby pictures before he started photographing. That group somehow created an orb that fits most definitions of a true orb—with a glowing perimeter and colorful substance inside it (see figure 6, center section). (Don't ask me how the shapes are determined; I don't know.)

With the *intent* of photographing ghosts, I visited cemeteries with my dog Max, and without doubt captured more orb pictures in places of the dead than anywhere else up until that time and for as long as I believed they were ghosts (see figures 26–28, pp. 26 and 27). I would ask Max where the orbs were, and he would turn his head and an orb would appear on the picture in his line of sight. Max may have helped create that phenomenon with his never-ending desire to please.

I was taking pictures all along but I would get my best results when I was pursuing some theory that I believed in, at least momentarily. When I heard emotion helps orbs form, I took Max to high schools, expecting to find the ghosts of emotion-packed adolescent alumni, and orbs appeared in places I would have expected to see spirits of ex-students. The "athletes" in these pictures were my first moving orbs (see figures 19–23, center section).

Peter, in the meantime, was conversing with what he believed to be Annabelle's orb and was receiving answers through his photos. He asked her to bring her friends and soon his home and backyard were packed with orbs. My most successful photo shoot in Peter's backyard happened to be the night our spiritual group, anticipating paranormal photographs, was there to help co-create a magnificent collection of orbs (see figures 16–18, center section).

I forget where I first heard that orbs could be angels, but the single blue orb that began to appear above my flower bed sent me in that direction (see figures 61a–e, center section). For a few months, the V orb followed my grandson Christian, especially when he was in danger, as I had theorized, and the orb behaved as a guardian angel would (see figures 64–70, pp. 139–140). Old and feeble Max also began to have an orb resembling a bull's-eye tag along after him.

When Peter and I grew weary of orbs, orbs, and more orbs, ectoplasms began to perform for us, with an occasional vortex thrown in. The experiments we made up

along the way, as researchers are learning is true for most experiments, came out as we expected they would.

The cover photo of Peter's streaking orb was taken the day we were moping about my first pictures of dust. We were convinced skeptics would call all of our photos pictures of dust, but we knew better. That evening Peter took that phenomenal shot that could not ever be attributed to dust (see cover photo and figures 25 and 26a, center section).

Even the crop circle that formed 40 miles away while I was working on my crop-circle chapter could have somehow been my creation if I accept the thought-form theory.

Do you see where I am going with this? I believe thoughts create the orbs, but that does not make them imaginary. They are actual physical realities, at least as physical as anything in this dream world, or they would not have appeared in photos.

I can carry this even further and say those who believe orbs are dust (or moisture or lens flare, or . . .) will get pictures that look like orbs when they stir up dust. I know several true believers in orbs who have deliberately tried to take pictures of dust and cannot ever get dust to look like orbs with their cameras. I have had my doubts during the past three years, so when I performed dust experiments, I got faint orbs as I expected to, when dust was close to my camera, but none that persuaded me the mystery was solved by blaming airborne particles.

Ed Vos, the moderator of "Universal-Orbs," recently commented how, when one member posts an orb with an unusual shape such as a heart or a pentagon, members' cameras from all over the world frequently start photographing similar shapes within the same week or so.

Thought-forms are the ultimate paranormal phenomenon. The word "paranormal" means beyond normal. The dictionary definition is "unexplainable." Writing this chapter has made me fully aware of how difficult thought-forms are to explain.

Light forms are mysterious and virtually unknown. We instinctively fear the unknown. G. N. M. Tyrrell, a physicist and mathematician (1879–1952), explained long ago why so many shy away from anything paranormal. He found it amazing how we are all convinced that what we can see, hear, and touch is everything there is. He wrote:

[W]e see why it is necessary at the practical level. Without it our world would not be simple enough for us to live in. . . . [O]ne of the features of mental adaptation to our world, in fact to the whole of the universe, is that it seems to be within our grasp.[1]

The ordinary mind tends to close when it comes to the paranormal, no matter how strong the evidence. It has something to do with what psychiatrists call "isolation"—a denial of reality that most people need to use some of the time, lest they go mad. As Dr. Deepak Chopra wrote: "Many things 'out there' don't exist for us, not because they are unreal, but because 'in here' we have not shaped the brain to perceive them."[2]

Isolation is a defensive maneuver that allows our lives to go on as usual despite disturbing facts, such as worldwide suffering, death, and undeniable evidence of paranormal phenomena. Light anomalies and thought-forms can be so alien to some people's realities that they are beyond comprehension, so much so that the unconscious mind protects the conscious mind by preventing them from being perceived in their true form.

We place way too much faith in what we see anyway. When Portuguese sea captain Ferdinand Magellan arrived in Tierra del Fuego at Cape Horn in 1520 with his fleet of ships, the indigenous people Magellan called Fuegans could not see his ships anchored in the bay. The village shaman had to teach the Fuegans how to perceive that which was so far removed from their reality that the sight did not register in their brains.

Also, when beginning biology students look at totally foreign objects through a microscope, they cannot see what is there and think they see things that are not there. They need to be trained to see what they are viewing. All perception is a learned behavior. The mind determines what we think our eyes see.

If we saw the world exactly as the image is registered on the eye, there would be a constant blind spot where the optic nerve forms. We would also see everything on the edges of our vision in black and white. The eyes' cones see color; the rods don't. There are so few cones on the periphery of our eyes that our peripheral vision does not register color, but we think we see everything in our field of vision in color. Ironically, as every judge and lawyer learn, eyewitness testimony is extremely unreliable but is the most believable to jurors.

These examples explain to me why some witnesses to paranormal events do not see what the others see. Ignorance or fear blocks their ability to perceive something that contradicts their beliefs about their world.

This blindness could also be related to the state of mind or vibration level of the witness. *The Encyclopedic Psychic Dictionary* by June G. Bletzer, Ph.D., founder of the Psychic Research Institute of Florida, describes a "thought sphere" as consisting of the fastest and subtlest of all vibrations. She claims one needs to be of the same frame of mind as the thought-form in order to psychically see a vision of it. Emotions charge thought-forms and follow them around, making the forms more visible to psychics, and the more emotion that is directed towards the thought-forms, the easier it is for psychics to tune into them.[3] This dictionary explains:

[A person] feeling a religious high may clairvoyantly perceive Jesus the Christ; what he perceived is the thought-form of Jesus made up of thousands of images of him, held in the minds of the masses. (Jesus is in such a fast vibration, one would not likely be able to "up" one's vibration to that speed.)[4]

Dr. Bletzer could be describing orbs, vortexes, and ectoplasm when she defines thought-forms as

different shapes of ethereal substance, defined or cloudy, large or small, varying in color and density, that float through space or hover over persons' heads; ergs of energy emanating from the head area are charged with degrees of intelligence and emotion. . . .[5]

It appears to me whatever we believe is true becomes our truth, and orbs, vortexes, ectoplasm, and apparitions are whatever we imagine them to be. The arguments for all the major theories—UFOs, aliens, crop-circle makers, angels, ghosts, unknown creatures, interdimensional beings, and thought-forms—are persuasive, each in its own way, and each appeals to different types of people.

Only if we consider the lights as products of thought can the existence of so many beliefs be justified and acceptable, and only then will we realize there is no need to persuade others that their beliefs are wrong, for everything is right in the world that they have constructed for themselves. Instead of hating them for differences in belief we could perhaps learn to love them unconditionally. Easier said than done.

For those who have been waiting patiently for me to do as the title of this book promises, and tell you *how* to photograph the paranormal, I can reduce what I now believe to one sentence:

Believe the orbs and other light forms are all around you, representing whatever you want them to be, and take a photograph.

If you think I am wrong, I agree. In your world I am wrong. In mine I am right. Do you see the beauty of this? It's taking the high road and never needing to become angry or controlling or judgmental. It gives us the freedom to allow others to be as they are and believe anything they desire. The light forms have taught me there are many forces at work in this world, and there is so much we will never know or understand.

So let's keep row, row, rowing that boat. We might as well do it merrily and enjoy the ride, for life *is* but a dream.

Endnotes

Chapter 2
1. Michael Talbot, *The Holographic Universe,* p. 38.
2. www.newscientist.com/news.jsp?id=ns99994174.

Chapter 3
1. Hilary Evans and Patrick Huyghe, *The Field Guide to Ghosts and Other Apparitions,* pp. 12–13.
2. Rob's website is http://groups.msn.com/WickedsWeirdsville.
3. Hans Holzer, *Psychic Photography: Threshold of a New Science?,* p. 75.
4. Sylvia Browne, *Blessings from the Other Side,* pp. 68–69.
5. Nicholas A. Reiter and Lori L. Schillig, "Investigation of Photographic Orb Phenomena: Two Experiments," www.alliancelink.com.
6. M. F. "Chance" Wyatt, *Spirits Visit Earth,* p. 55. This book can be purchased through Wyatt at 2190 Aurora Road, #18, Melbourne, FL 32935.
7. Wyatt, p. 79.
8. N. Reiter and L. L. Schillig, "Investigation of Photographic Orb Phenomena: Two Experiments," www.alliancelink.com.

Chapter 4
1. James Van Praagh, *Heaven and Earth,* p. 94.
2. John Mitchell in Raymond Moody, M.D., *Reunions,* p. 12.
3. Moody, *Life After Life.*
4. Richard Sadler, "Study into Near-death Experiences Supports Theory of a 'Sixth Sense,'" www.scotsman.com/topics.cfm?tid=609&id=999952003.

Chapter 5
1. John Mitchell and Robert J. M. Richard, *Phenomena: A Book of Wonders,* pp. 26–27.
2. Paul Devereux, *Earth Lights Revelation,* p. 203.

3. Ibid., p. 200.

4. Ibid., p. 183.

5. Ibid., p. 165.

6. James Bunnell, *Night Orbs*, p. 147.

7. Devereux, p. 199.

8. Ibid., p. 190.

9. Bruce Cornet, Ph.D., "Evidence for Plasma Light Sources," www.plasmas.com/resources.htm.

10. Massimo Teodorani, Ph.D., "EMBLA 2002: An Optical and Ground Survey in Hessdalen."

11. Readers Digest, *UFO: The Continuing Enigma*, p. 133.

12. Devereux, p. 208.

13. Jenny Randles and Peter Hough, *The Complete Book of UFOs*, pp. 290–292.

14. Jason Rich, *The Everything Ghost Book*, pp. 55, 58.

15. Ibid., p. 74.

16. Devereux, pp. 203–204.

17. Ibid., pp. 222–223.

18. Franz Bardon, *Initiation into Hermetics*, p. 315.

19. Brad Steiger, *Shadow World: Spiritual Encounters That Can Change Your Life*, p. 172.

20. Obiwan's UFO-Free Paranormal Page, www.ghosts.org.

21. www.ecologyasia.com.

22. Randles, pp. 38, 51.

23. This article cited its sources as *Great Mysteries: UFOs* by Robert Jackson; *Above Top Secret* by Timothy Good; *The UFO Encyclopedia* by John Spencer; and *Genesis Revisited* by Zecharia Sitchin.

24. www.unmuseum.org/foo.htm.

25. Randles, pp. 127–132.

26. Wyatt, p. 26.

27. Ibid., pp. 26, 51.

28. Bardon, p. 197.

29. Robert A. F. Thurman, *The Tibetan Book of the Dead*, p. 180.

30. Michael Newton, Ph.D., *Destiny of Souls*, pp. 5–6.

31. Ibid., pp. 171–172.

32. Newton, *Journey of Souls*, pp. 99–100.

33. Newton, *Destiny of Souls*, p. 173.

34. Gary Schwartz, Ph.D., and Linda Russek, Ph.D., *The Living Energy Universe*, p. 159.

35. Joe Klimek, "Electromagnetic Fields, Gaussmeters, and Ghosts," www.haunt.net.

Chapter 6

1. Jason Rich, *The Everything Ghost Book*, pp. 8–9.

2. Rosemary Ellen Guiley, *Encyclopedia of Ghosts and Spirits*, Second Edition, p. 181.

3. Paul Foster Case, *The Tarot: A Key to the Wisdom of the Ages*, p. 170.

4. April Frost and Rondi Lightmark, *Beyond Obedience*, p. 333.

5. Hans Holzer, *Haunted America*, p. 21.

6. Wyatt, p. 14.

7. Vicky Thompson, *Journey with Spirit: Leading a Spirit-Driven Life*, 4-CD workshop set.

8. June G. Bletzer, *The Encyclopedic Psychic Dictionary*, p. 155.

9. Guiley, p.101.

10. Ibid., p. 357.

Chapter 7

1. www.crystalinks.com.
2. Robin Bellamy, "Ectoplasm," www.torontoghosts.org/ecto.htm.
3. "Paranormal Voices," www.xs4all.nl/~wichm/dirvoic3.html.
4. Raymond Moody, M.D., *Reunions: Visionary Encounters with Departed Loved Ones,* pp. 95, 99, 114, 122, 126, 129, 133, 134.
5. James Van Praagh, *Heaven and Earth,* p. 118.
6. Alan McAllister, "Human Spiritual Structure: The Tripartate Yogic Mind," www.dimensional.com/~ahm/matrix/SpSt/mind_yoga.htm.

Chapter 8

1. M. Doreal, *The Emerald Tablets of Thoth-the-Atlantean,* tablet 15.

Chapter 9

1. Rosemary Ellen Guiley, *Harper's Encyclopedia of Mystical and Paranormal Experiences,* p. 25.
2. Ibid., p. 17.
3. Hans Holzer, *Ghosts: True Encounters with the World Beyond,* p. 26.
4. Guiley, p. 342.
5. Ibid., p. 19.

Chapter 10

1. Rolf H. Krauss, *Beyond Light and Shadow,* p. 100.
2. Ibid.
3. Ibid., pp. 186–196.
4. Peter Underwood, *The Ghost Hunter's Guide,* p. 66.
5. Krauss., pp. 111–113
6. Ibid., p. 109.
7. Ibid., p. 52.
8. Ibid., pp. 48–49.
9. Ibid., pp. 59–60.
10. Ibid., p. 84.
11. Ibid., p. 96.
12. Holzer, p. 750.
13. Ibid., p. 3.
14. Holzer, *Psychic Photography,* p. 36.

Chapter 11

1. Newton, *Destiny of Souls,* p. 38.
2. Sogyal Rinpoche, Patrick D. Gaffney, and Andrew Harvey, *The Tibetan Book of Living and Dying,* p. 274.
3. Carl Jung, "Psychological Commentary on *The Tibetan Book of the Dead,*" in *Self and Liberation: The Jung/Buddhism Dialogue,* p. 95.
4. Sogyal Rinpoche, et al., p. 274.
5. Ibid., p. 277.
6. Ibid., p. 278.
7. Ibid., p. 283.
8. Ibid., p. 282.
9. Ibid., p. 289.
10. Ibid., p. 288.
11. Ibid., p. 270–271.

12. Robert A. F. Thurman, The Tibetan Book of the Dead, p. 168.

13. Ibid., pp.168–171.

14. Ibid., p. 180.

15. Ibid., p. 183.

16. Ibid., p. 187.

17. Daniel C. Matt, "The Wedding Celebration," *The Essential Kabbalah,* pp. 59–60.

18. Chapter 27, verses 10 and 11, Arc of Bon book, www.sacred-texts.com/oah/oah/oah374.htm; see more about elementaries and thought-forms in chapter 18.

19. Gordon Creighton, "A Brief Account of the True Nature of the 'UFO Entities,'" www.sacred-texts.com/ufo/jinns.htm.

20. Hans Holzer, *Psychic Photography,* p. 91.

Chapter 12

1. Kaku, *Visions,* p. 319.

2. Randles, pp. 9, 37.

3. Ibid., p. 63.

4. Ibid., p. 69.

5. Ibid., p. 80.

6. Ibid., p. 57.

7. Raymond E. Fowler, *The Watchers II: Exploring UFOs and the Near-Death Experience,* p. 315.

8. Whitley Strieber's *Unknown Country Newsletter*, May 12, 2004, http://www.unknowncountry.com/news/month.phtml/?id=20040419

9. www.ktvu.com/news/3298166/detail.html.

Chapter 13

1. Randles, p. 88.

2. http://thecropcirclewebsite.com.

3. www.cropcircleconnector.com/ilyes9.html.

4. Freddy Silva, *Secrets in the Fields,* pp. 138–139.

5. Gordon Rutter, "Away with the Faeries," http://217.206.205.129/articles/141_faeryrings.shtml.

6. Eltjo H. Haselhoff, Ph.D., *The Deepening Complexity of Crop Circles,* p. 89.

7. Lucy Pringle, *Crop Circles: The Greatest Mystery of Modern Times,* pp. 27–85.

8. www.lovely.clara.net.

9. Pringle, p. 101.

10. Ibid., p. 103.

11. Ibid., p. 52.

12. Ibid., p. 67.

13. Ibid.

14. Linda Moulton Howe, *Mysterious Lights and Crop Circles,* p. 23.

15. Ibid., p. 34.

16. http://fusinanomaly.net/plasma.html.

17. Bruce Cornet, Ph.D., "Evidence for Plasma Light Sources," www.plasmas.com/resources.htm.

18. Michael Talbot, *The Holographic Universe,* p. 38.

19. Howe, pp. 256–257.

20. Haselhoff, p. 85.

21. Ibid., p. 81.

22. Ibid., p. 72.

23. Ibid., pp. 74–78.

24. Ibid., pp. 22–23.
25. Ibid., p. 23.
26. Silva, p. 284.

Chapter 14

1. Gustav Fechner, *Comparative Anatomy*, in Silva, p. 284, note 152.
2. This book and slide show are available through Rev. Leon, P.O. Box 2773, Grants Pass, OR 97528.
3. Christopher Penczak, *Spirit Allies: Meet Your Team from the Other Side*, pp. 39–40.
4. www.newtimes.org/issue/0104/karger.htm.
5. Guiley, p. 11.
6. E. Randall Floyd, *Ghost Lights and Other Encounters with the Unknown*, pp. 94–96.
7. Vicky Thompson, *Journey with Spirit: Leading a Spirit-Driven Life*.
8. Thompson, *The Jesus Path: 7 Steps to a Cosmic Awakening*, pp. 16, 135.
9. Ibid., p. 263.
10. Ibid., p. 279.
11. Ibid., p. 272.
12. Steiger, p. 69.
13. J. Michael Krivyanski and G. Carroll Strait, "Probing the Phenomena Called Ghosts," *World & I*, August 2002, Vol. 16, Issue 8, p. 140.

Chapter 15

1. www.apsociety.com/resources/articles/history_of_ghosts.html.
2. www.crystalinks.com/ghost.html.
3. Hans Holzer, *Ghosts: True Encounters with the World Beyond*, p. 28.
4. Jerome Clark, *Unexplained*, p. xii.
5. Rich, p. 41.
6. Ibid., p. 43.
7. Michael Newton, Ph.D., *Destiny of Souls*, p. 85.
8. Ibid., p. 9.
9. Newton, *Destiny of Souls*, pp. 14, 15; and *Journey of Souls*, pp. 76, 78, 79.
10. Newton, *Destiny of Souls*, p. 2.
11. Dolores Cannon, *Jesus and the Essenes*, p. 173.
12. Cannon, p. 260.
13. Paramahansa Yogananda, *Autobiography of a Yogi*, p. 299.
14. www.floridatoday.com/news/people/stories/2001/oct.
15. Rich, p. 29.
16. Philip Solomon and Prof. Hans Holzer, Ph.D., *Beyond Death: Conditions in the Afterlife*, pp. 176–178.
17. Rosemary Ellen Guiley, *Encyclopedia of Ghosts and Spirits*, p. 150.
18. www.ghostweb.com, October 25, 2001, IGHS newsletter.
19. T. Hargrove and G. H. Stempel III, "Poll Indicates a Haunted Nation," *Nando Times*, October 27, 1999.
20. "Most Americans Believe in Ghosts," *WorldNetDaily*, February 27, 2003. Data poll collected by Harris Poll.
21. www.greggbraden.com/newsletter01.html.

Chapter 16

1. http://paranormal.about.com/library/weekly/aa051302b.htm.
2. http://paranormal.about.com/library/weekly/aa051302a.htm.

3. http://paranormal.about.com/library/weekly/aa061598.htm?terms=rods.

Chapter 17
1. John Malone, *Unsolved Mysteries of Science,* pp. 199–201.
2. Nicholas A. Reiter and Lori L. Schillig, "Photograph M1 and Its Implications: Toward an Understanding of the Invisible," www.alliancelink.com.
3. Ibid.
4. Ibid.
5. Randles, pp. 59, 63.
6. Wyatt, p. 14.
7. Dave R. Oester, Ph.D., and Sharon A. Gill, Ph.D., *Magic Dimensions,* p. 181.
8. http://ufos.about.com.
9. Newton, *Destiny of Souls,* pp. 70–71.
10. Yogananda, pp. 478, 480.

Chapter 18
1. Tad James, *Lost Secrets of Ancient Hawaiian Huna,* Volume 1, p. 75.
2. Michio Kaku, *Visions: How Science Will Revolutionize the 21st Century,* pp. 339–340.
3. Jeffrey Mishlove, Ph.D., and Nick Herbert, Ph.D., "Consciousness and Quantum Reality with Nick Herbert, Ph.D.," p. 3; http://twm.co.nz/Herbert.htm.
4. www.greggbraden.com/newsletter01.html.
5. Michael Talbot, *The Holographic Universe,* p. 143.
6. Newton, *Journey of Souls,* p. 173.
7. Hermes Trismegistus, *Emerald Tablet,* around 1500 A.D.
8. Gregg Braden, "The Secret of Our Reflected Universe" Seminar, Portland, OR, October 14, 2001.
9. James, p. 81.
10. Talbot, p. 260.
11. Ibid., p. 5.
12. James, p. 82.
13. Ibid., p. 82.
14. www.sheldrake.org/articles/gulltext/33_1.txt.
15. Adrianne Lord, "Consciousness and the Placebo Effect," http://serendip.brynmawr.edu/bb/neuro/neuro99/web3/Lord.html.
16. Talbot, p. 108.
17. James, p. 76.
18. Ibid., p. 76.
19. Ibid., p. 75.
20. Ibid., pp. 75–76.
21. Ibid., pp. 78–79.
22. Ibid., p. 82.
23. Ibid., p. 80.
24. www.williamjames.com/folklore/anatomy.htm.
25. Annie Besant and C. W. Leadbeater, *Thought-Forms,* p. 11.
26. Ibid., pp. 8–10.
27. Ibid., pp. 15–17.
28. Ibid., p. 21.
29. Ibid., p. 26.
30. Ibid., p. 67.
31. Ibid., pp. 76–77.

32. Guiley, pp. 616–617.

33. Dion Fortune, *Psychic Self-Defence*, p. 177. (Excerpted from *Psychic Self-Defence* by Dion Fortune with permission of Red Wheel/Weiser, Boston, MA, and York Beach, ME.)

34. Randles and Hough, p. 288.

35. Rich, p. 28.

36. James, p. 83–84.

37. Albert Budden, *Psychic Close Encounters*, p. 183.

38. Holzer, *Psychic Photography: Threshold of a New Science?*, p. vii.

39. Talbot, p. 60.

40. www.100megsfree4.com/farshores/ufoital6.htm.

41. Clark, p. 438.

Conclusion

1. G. N. M. Tyrrell, *Apparitions*, p. 72.

2. Deepak Chopra, M.D., *Quantum Healing*, p. 186.

3. June G. Bletzer, *The Encyclopedic Psychic Dictionary*, p. 630.

4. Ibid.

5. Ibid.

Selected Bibliography

Bardon, Franz, *Initiation into Hermetics*, Merkur Publishing, Inc., Salt Lake City, Utah, 1999 (first published 1956).

Besant, Annie, and C. W. Leadbeater, *Thought-Forms*, Quest Book, abridged edition, The Theosophical Publishing House, Wheaton, Illinois., 1969.

Bletzer, June G., *The Encyclopedic Psychic Dictionary*, New Leaf Publishing Co., Lithia Springs, Georgia, 1998.

Braden, Gregg, *Awakening to Zero Point: The Collective Initiation*, Radio Bookstore Press, Bellevue, Washington, 1997.

————, *The Isaiah Effect: Decoding the Lost Science of Prayer and Prophecy*, Harmony Books, New York, 2000.

Browne, Sylvia, *Blessings from the Other Side*, Dutton, Penguin Group, New York, 2000.

Budden, Albert, *Psychic Close Encounters*, Blandford, Cassell & Co., London, 1999.

Bunnell, James, *Night Orbs*, Lacey Publishing Co., Cedar Creek, Texas, 2003.

Cannon, Dolores, *Jesus and the Essenes*, Gateway Books, Bath, UK, 1992.

Case, Paul Foster, *The Tarot: A Key to the Wisdom of the Ages*, Builders of the Adytum, Los Angeles, California, 1990.

Chopra, Deepak, M.D., *Quantum Healing*, Bantam Books, New York, 1989.

Clark, Jerome, *Unexplained! 347 Strange Sightings, Incredible Occurrences, and Puzzling Physical Phenomena*, Visible Ink Press, Detroit, 1993.

————, *The UFO Book: Encyclopedia of the Extraterrestrial*, Visible Ink Press, Detroit, 1998.

Devereux, Paul, *Earth Lights Revelation: UFOs and Mystery Lightform Phenomena: The Earth's Secret Energy Force*, Blandford Press, London, 1990.

Doreal, M. (trans.), *The Emerald Tablets of Thoth-the-Atlantean*, Brotherhood of the White Temple, Sedalia, Colorado, 2002.

Eisenbud, Jule, M.D., *The World of Ted Serios*, Pocket Books, New York, 1968.

Evans, Hilary, and Patrick Huyghe, *The Field Guide to Ghosts and Other Apparitions*, HarperCollins Publishers, Inc., New York, 2000.

Floyd, E. Randall, *Ghost Lights and Other Encounters with the Unknown*, August House, Inc., Little Rock, Arkansas, 1993.

Fortune, Dion, *Psychic Self-Defence*, Samuel Weiser, Inc., New York, 1971 (first published 1930).

Fowler, Raymond E., *The Watchers II: Exploring UFOs and the Near-Death Experience*, Wild Flower Press, Newberg, Oregon, 1995.

Frisby, Neal, *Capstone Blue Star Album*, Capstone Temple, 20th Century Life, Phoenix, Arizona, 1978.

Frost, April, and Rondi Lightmark, *Beyond Obedience*, Harmony Books, New York, 1998.

Guilley, Rosemary Ellen, *Harper's Encyclopedia of Mystical & Paranormal Experience*, Castle Books, Edison, New Jersey, 1991.

————, *The Encyclopedia of Ghosts and Spirits*, Second Edition, Checkmark Books, New York, 2000.

Haselhoff, Eltjo H., Ph.D., *The Deepening Complexity of Crop Circles: Scientific Research & Urban Legends*, Frog, Ltd., Berkeley, California, 2001.

Holzer, Hans, *Psychic Photography: Threshold of a New Science?* McGraw-Hill Book Company, New York, 1969.

————, *Ghosts: True Encounters With the World Beyond: Haunted Places, Haunted Houses, Haunted People*, Black Dog & Leventhal Publishers, Inc., New York, 1997.

Howe, Linda Moulton, *Mysterious Lights and Crop Circles*, Paper Chase Press, New Orleans, 2000.

James, Tad, *Lost Secrets of Ancient Hawaiian Huna*, Volume 1, Ka Ha O Hawaii Foundation, Honolulu, 1997.

Janssen, Bert, and Janet Ossebaard, *Contact With the Unknown Intelligence Behind the Crop Circles*, Videocassette by Bert Janssen Productions, 2001.

Kaku, Michio, *Visions: How Science Will Revolutionize the 21st Century*, Anchor Books, Doubleday, New York, 1997.

Krauss, Rolf H., *Beyond Light and Shadow: The Role of Photography in Certain Paranormal Phenomena: An Historical Survey*, Nazraeli Press, Tucson, Arizona, 1994.

Leon, Dorothy, *Reality of the Light*, Anchor of Golden Light, Grants Pass, Oregon, 1996.

Malone, John, *Unsolved Mysteries of Science*, John Wiley & Sons, Inc., New York, 2001.

Matt, Daniel C., *The Essential Kabbalah: The Heart of Jewish Mysticism*, Mystical Classics of the World Series, Quality Paperback Book Club, New York, 1995.

Meckel, Daniel J., and Robert L. Moore (eds.), *Self and Liberation: The Jung/Buddhism Dialogue*, Paulist Press, Mahwah, New Jersey, 1992.

Meyer, Alan, Ph.D., *Ghostwalker: A Haunting Study*, Videocassette, http://alanmeyer.com, 2000.

Mitchell, John, and Robert J. M. Rickard, *Phenomena: A Book of Wonders*, Pantheon Books, New York, 1977.

Moody, Raymond, M.D., *Life After Life*, Stackpole Books, Harrisburg, Pennsylvania, 1976.

———, *Reunions: Visionary Encounters with Departed Loved Ones*, Villard Books, division of Random House, Inc., New York, 1993.

Newton, Michael, Ph.D., *Journey of Souls: Case Studies of Life Between Lives*, Llewellyn Publications, St. Paul, Minnesota, 2000.

———, *Destiny of Souls: New Case Studies of Life Between Lives*, Llewellyn Publications, St. Paul, Minnesota, 2001.

Oester, Dave R., D.D., Ph.D., and Sharon A. Gill, Ph.D., *Magic Dimensions: Personal Transformations through Magic, Miracles and Quantum Mechanics*, Writers Club Press, Lincoln, Nebraska, 2002.

Penczak, Christopher, *Spirit Allies: Meet Your Team from the Other Side*, Weiser Books, Boston, 2002.

Pringle, Lucy, *Crop Circles: The Greatest Mystery of Modern Times*, Thorsons, an Imprint of HarperCollins Publishers, London, 1999.

Randles, Jenny, *UFOs & How to See Them*, Sterling Publishing Co., Inc., New York, 1992.

Randles, Jenny, and Peter Hough, *The Complete Book of UFOs: An Investigation into Alien Contacts & Encounters*, Sterling Publishing Co., Inc., New York, 1996.

Reader's Digest, *Quest for the Unknown: UFO: The Continuing Enigma*, The Reader's Digest Association, Inc., Pleasantville, New York, 1991.

Rich, Jason, *The Everything Ghost Book: Spooky Stories of Haunted Houses, Phantom Spirits, Unexplained Mysteries, and More*, Adans Media Corporation, Avon, Massachusetts, 2001.

Schwartz, Gary E. R., Ph.D., and Linda G. S. Russek, Ph.D., *The Living Energy Universe: A Fundamental Discovery That Transforms Science & Medicine*, Hampton Roads Publishing, Charlottesville, Virginia, 1999.

Silva, Freddy, *Secrets in the Fields: The Science and Mysticism of Crop Circles*, Hampton Roads Publishing, Charlottesville, Virginia, 2002.

Sogyal Rinpoche, *The Tibetan Book of Living and Dying: A New Spiritual Classic from One of the Foremost Interpreters of Tibetan Buddhism to the West*, HarperSanFrancisco, San Francisco, 1994.

Solomon, Philip, and Prof. Hans Holzer, Ph.D., *Beyond Death: Conditions in the Afterlife*, Hampton Roads Publishing, Charlottesville, Virginia, 2001.

Steiger, Brad, *Shadow World: Spiritual Encounters That Can Change Your Life*, New American Library, New York, 2000.

Talbot, Michael, *The Holographic Universe*, Harper Perennial, New York, 1991.

Thompson, Vicky, *Journey with Spirit: Leading a Spirit-Driven Life*, 4-CD workshop set, Journey with Spirit, Marylhurst, Oregon, 2002.

———, *The Jesus Path: 7 Steps to a Cosmic Awakening*, Red Wheel/Weiser, York Beach, Maine, 2003.

Thurman, Robert A. F., The Tibetan Book of the Dead, Mystical Classics of the World Series, Quality Paperback Book Club, New York, 1994.

Tyrrell, G. N. M., *Apparitions*, Pantheon, New York, 1953.

Underwood, Peter, *The Ghost Hunter's Guide*, Blandford Press Link House, Pool, Dorset, UK, 1986.

Van Praagh, James, *Heaven and Earth: Making the Psychic Connection*, Pocket Book, division of Simon & Schuster, Inc., New York, 2001.

Wyatt, M. F. "Chance," *Spirits Visit Earth: Documented & Recorded Spiritual Happenings*, Blue Note Publications, Cape Canaveral, Florida, 2001.

Yogananda, Paramahansa, *The Autobiography of a Yogi*, Self-Realization Fellowship, Los Angeles, 1993.

About the Author

"Lee" Sweet is a lifelong spiritual seeker whose pictures of a dog's apparent "spirit" launched her on an incredible journey into the world of paranormal photography. It enriched her life with new meaning and became the topic of her doctoral dissertation in Esoteric Studies for American Pacific University.

Dr. Sweet began writing as editor-in-chief of two student newspapers. After working her way through college and earning a Bachelor of Science degree in psychology from Portland State University, she worked in personnel, mini-farming, legal administration and investigation, and her family's retail furniture business, church-hopping all the while.

Lee has had one near-death experience, is certified in clinical hypnotherapy and Huna (an ancient Hawaiian healing art), and has studied under many of the current spiritual leaders. Better at asking questions than delivering answers, she does not claim expert status in either photography or the paranormal. A lifetime of reading and research has given her an overall view of light forms that needs to be shared. These lights have been with us all along, holding the key to life's greatest mysteries, but now seem eager to be seen and understood.

Dr. Sweet and her husband, Stan, have five grown children, two grandchildren, and are governed by their spoiled pets in Clackamas, Oregon.

Visit her web site at www.photographingtheparanormal.com.

Hampton Roads Publishing Company

. . . for the evolving human spirit

Hampton Roads Publishing Company
publishes books on a variety of subjects,
including metaphysics, health,
visionary fiction, and other related topics.

For a copy of our latest catalog, call toll-free
(800) 766-8009, or send your name and address to:

Hampton Roads Publishing Company, Inc.
1125 Stoney Ridge Road
Charlottesville, VA 22902

e-mail: hrpc@hrpub.com
www.hrpub.com